THE
NEW GUIDE
TO
GRAPHIC DESIGN

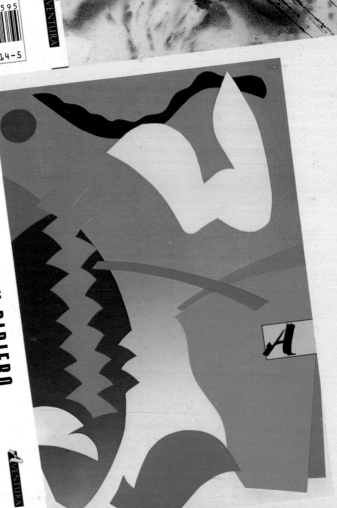

NEIL JORDAN

FICTION

THE DREAM OF A BEAST

THE DREAM OF A BEAST

NEIL JORDAN

In this phantasmagoria of
apocalyptic intensity, as a
storm breaks over a city—the
world—the beast achieves
an apotheosis both frightening
and heartrending.

$5.95

50595

9 780394 758145

ISBN 0-394-75814-5

AVENTURA

DARCY RIBIERO

MULE

FICTION

MULE

DARCY RIBIERO

"This document, penned
in my own hand, is my last
will and testament.
It is also my confession.
Here I will…"

$12.95

51295

9 780394 758152

ISBN 0-394-75815-3

AVENTURA

THE
NEW GUIDE
TO
GRAPHIC DESIGN

Editor
Bob Cotton

PHAIDON · OXFORD

A QUARTO BOOK

Published by Phaidon Press Limited
Musterlin House
Jordan Hill Road
Oxford OX2 8DP

First published 1990

A CIP catalogue record for this book is available from the British Library

ISBN 0 7148 2627 8

This book was designed and produced by
Quarto Publishing plc
The Old Brewery
6 Blundell Street
London N7 9BH

Senior Editor Sally MacEachern
Project Editor Susan Berry
Editor Richard Dawes
Writers Fay Sweet (Typography), David Brittain (Photography),
Susan Berry (Illustration, Packaging, Corporate Identity)
Index Connie Tyler
Designer Hazel Edington
Picture Researchers Prue Reilly, Deirdre O'Day
Picture Manager Joanna Wiese
Illustrators Ed Stuart, Dave Kemp
Photography Martin Norris
Publishing Director Janet Slingsby
Art Director Moira Clinch
Assistant Art Director Chloë Alexander
with thanks to Graham Davis and Robert Chapman

Typeset by Ampersand Typesetting Ltd, Bournemouth
Manufactured in Hong Kong by Regent Publishing Services Ltd
Printed in Hong Kong by Leefung Asco Printers Ltd

CONTRIBUTORS

Bob Cotton (General Editor, Section One and DESIGN AND TIME-BASED MEDIA) runs the Computer Graphics Workshop at London's Newham Community College. He designs courseware for the *Design Awareness for DTP* courses; is a director of Synergy A.I., a company that designs and produces programmes combining interactive video and expert systems, and author of *Designing for Desktop Publishing*, the *DTP Graphics Index*, and *High Bandwidth Panning*.

Martin Colyer (DESIGN AND ILLUSTRATION – Magazines) is a magazine designer. From 1982 to 1985, he was Art Editor of the *Listener* and then, until 1988, Art Editor of the *Observer Magazine*. He has served on the judging panels of various international illustration awards.

Margaret Donegan (DESIGN AND PHOTOGRAPHY) is currently Art Director of Conde Nast's *GQ*. She has been Art Director of *Building* and *The World of Interiors*, and redesigned the *Telegraph Sunday Magazine*.

Amelia Edwards (DESIGN AND ILLUSTRATION – Children's Books) started working in children's books in 1959. She is now an Art Director at Walker Books.

Richard Head (DESIGN AND PACKAGING) co-formed Siebert/ Head in 1972 as the first specialist package design consultancy outside the USA. He spent nine years in advertising and a year in New York at Newsweek International studying American marketing, research and selling techniques.

David Hughes (PROFESSIONAL PRACTICE) is Founding Director of The Fine White Line, a design consultancy that started as part of the Collett Dickenson Pearce group in 1984 and was bought out by management in 1990.

John Sorrell (DESIGN AND CORPORATE IDENTITY) is chairman of Newell and Sorrell, a design consultancy specializing in corporate identity, which he founded in 1976 with Frances Newell. He is a Fellow of the Chartered Society of Designers, a member of CSD's Design Management Group and the Executive Committee of the Design Business Association, Chairman of the DBA's Development Committee, and a member of the Strategic Planning Society.

Nicholas Thirkell (DESIGN AND TYPOGRAPHY) is a partner of the design firm Carroll Dempsey & Thirkell. He avoided art school and specializes in design for print. He was responsible as a consultant for the design of *The Independent* and *The Independent on Sunday* newspapers and has won many awards, including the coveted Design & Art Direction Gold Award.

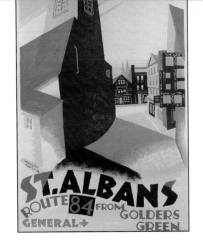

CONTENTS

FOREWORD
8

PRINCIPLES AND
PROCEDURES

INTRODUCTION
12

PART 1 DESIGN TOOLS AND
EQUIPMENT
26

PART 2 DESIGN SKILLS
50

PART 3 DESIGN, REPRO AND
PRINT
62

THE DESIGNER AT WORK

PART 4 DESIGN APPLICATIONS 86

PART 5 PROFESSIONAL PRACTICE 92

PART 6 DESIGN AND TYPOGRAPHY 104

PART 7 DESIGN AND PHOTOGRAPHY 116

PART 8 DESIGN AND ILLUSTRATION 134

PART 9 DESIGN AND TIME-BASED MEDIA 150

PART 10 DESIGN AND PACKAGING 164

PART 11 DESIGN AND CORPORATE IDENTITY 178

GLOSSARY 186

INDEX 188

ACKNOWLEDGEMENTS 192

FOREWORD

This book is written, designed and produced by graphic designers. The diversity encompassed by the profession is clear from flipping through the pages. No longer a range of skills applied only to print media, graphics now include design for television and other audiovisual media. As a discipline, graphic design is central to the problem of processing and communicating the vast and increasing flow of information in a global economy – an economy that depends on quick and precise access to data from all over the world. In publishing, in packaging, in broadcasting and narrowcasting, in computer interfaces and in advertising, the graphic designer is an increasingly important link in the process that joins the information transmitter to the information receiver.

The essential attributes of a graphic designer operating in the closing years of the twentieth century are in outline the same as those of the first printer/publishers in the fifteenth century, but they now must include a far wider range of media than just books, and a correspondingly wider range of reprographic technologies. To make the most of these new opportunities the designer is to some extent required to specialize. At the moment, this is more the result of practical necessity than the reflection of any change within the further and higher education sector, where the notion that designers should be encouraged to be generalist in their approach to design problems is still happily paramount. But the range and variety of media, and their associated production technologies mitigate against any single designer becoming at one and the same time an expert in both packaging (for example), and video graphics.

This is only, I believe, a transitional phase in the evolution of the profession. All the pointers are towards a convergence of the means of production, a situation where the designer is able to use the same tools for the processing of information

whether it is eventually printed, or distributed electronically. The convergence is already happening, as the same computer graphics technologies are now increasingly used in the production of work for both print and video. Desktop publishing (DTP) and its related "desktop" media are a spin-off from this "top-end" technology, but the requirements of producing a system that is easy to use (as well as being relatively cheap and therefore accessible to most designers) has, in turn, led to a simplification, and to some extent a standardization of machine interfaces throughout the profession.

The next century promises even more exciting developments. One example is the graphic design "expert system" – an "intelligent" resource to help the designer at every stage of the design and production process. Such systems will amplify the designer's control and relieve him or her of many mundane tasks – preliminary general research, searches of picture libraries, the search for specialists such as illustrators and photographers – and provide detailed expositions of current techniques in all the related areas of graphic design.

But, despite all these revolutionary changes in the technologies of information processing, graphic design remains a profession that is primarily about helping human beings to communicate with one another more precisely. Success depends upon the designer being able to apply inspiration, logic, intuition and common sense – as well as technical expertise – to this rewarding task. This book will guide you through the processes and the techniques of designing with type and images, and I hope provide you with insights into the day-to-day practice of the profession. It's an invaluable resource for graphic designers, and an ideal starting point for students.

1 PRINCIPLES AND PROCEDURES

The professional graphic designer must possess a wide range of skills and knowledge, in addition to motivating interest in the visual arts and the acquired talents he or she has in communicating visually. These include the ability to analyze problems, solve them and present them visually, and to specify reprographic and printing techniques and materials for their successful reproduction. This first section of the book will examine these

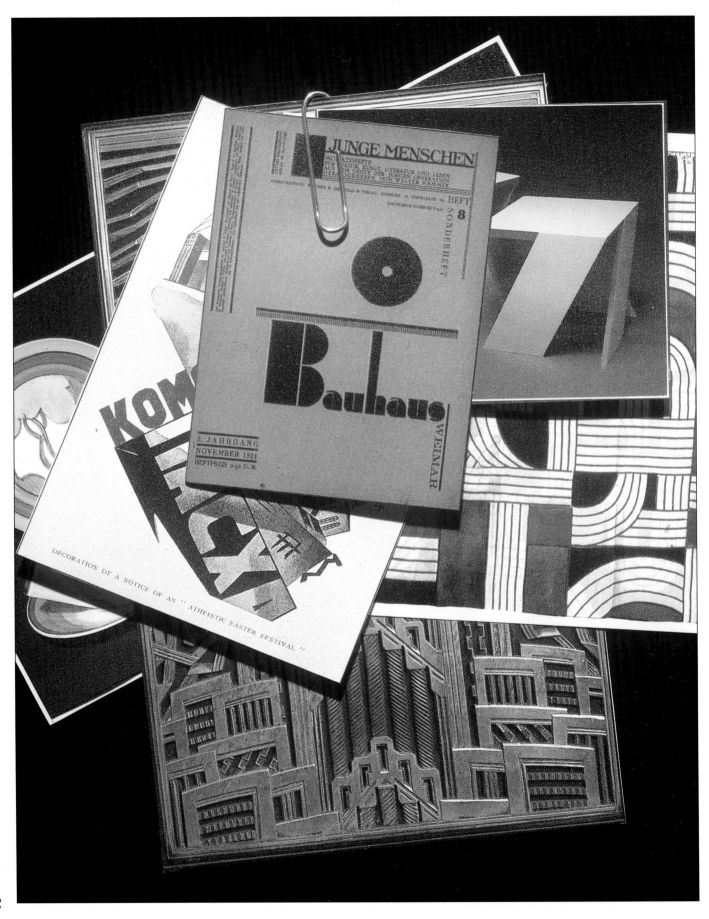

INTRODUCTION

We are living in the Future. Back in the early 1960s the media analyst Marshall McLuhan forecast the establishment of a global village as a result of advances in electronic communications. Now, the infrastructure for that village is already in place. Information can be broadcast or narrowcast around the planet in a few seconds. Holograms are everyday artifacts. Personal audio cassettes, portable compact discs, videodiscs, satellite TV, portable digital phones, personal computers – all this information technology is now part of the Western environment – an environment where there is an increasingly fuzzy divide between leisure and work, between education and entertainment.

The future now

Information becomes useful only when it is communicated to the right people, at the right time and place, in a form that they can interpret, and when presented in a logical and consistent manner. Much depends on the interface between sender and receiver. The graphic designer is working in the oldest mass medium. Over 500 years of accumulated experience in the design of an interface – the printed page – and the presentation of information within that format – places graphic designers at the very centre of the communications revolution. The graphics interface is now the established method of communicating text and images, not only in books, magazines, and other printed media, but on the TV screen and computer monitor also. Fields as diverse as interior and shopfront design, television and video, packaging and corporate identity, computer graphics and educational courseware, comic strips and company reports all depend to some extent on the input of the graphic designer.

The accelerating revolution in graphics technology that began in the 1960s with phototypesetting and xerography, and then went digital with the adoption of computer typesetting, electronic page-makeup and laser scanning, is having two major effects. It is providing ever more powerful tools for the creation and manipulation of text and image; and, because of the economics of microchip mass production, it is making these tools accessible to all designers.

The immediate future will see more sophisticated

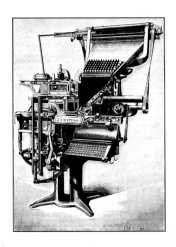

◄ **Linotype composer**
The Linotype was a "hot-metal" composer, the keyboard selecting brass female matrices of type characters that were composed into a "line of type" and cast as a single lead slug.

▼ **Mechanized paper manufacture**
What was to become known as the "Fourdrinier" process of paper-making stemmed from French and English prototypes of the early 19th century.

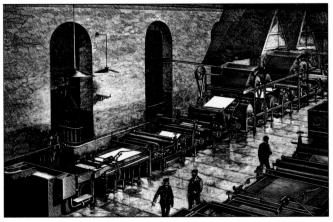

graphics technology, greater use of graphics in satellite, cable and interactive television, intelligent expert design systems, instant data retrieval from global picture archives, desktop digital production of printing plates, new methods of storing and marketing graphics media, and much more. Computers will converge hitherto disparate media, placing text, audio, still, and motion-image processing, programming, scripting and authoring tools at the designer's fingertips. Graphic designers are living through the most exciting and challenging period ever for their profession. New technology, instant digital communication, and limitless 25 frames per second picture data, have resulted in a design environment that is quick to respond to changes in style and fashion. It is an environment where the designer has immense freedom to experiment, but also a growing responsibility to bring order out of the electronic Babel.

How did all this happen? What factors have changed graphic design from a largely unknown, esoteric adjunct to printing to a central and increasingly public driving force?

The industrialization of graphics
After 450 years of manual printing, the rapid development of new typesetting and press technology during the last few

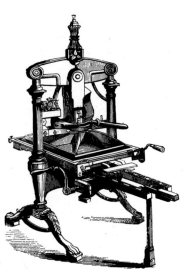

◄ **Albion Press**
Effectively based on the same technology as that used by Gutenberg, the hand-operated relief press was the mainstay of print production until the introduction of power presses in the 19th century. Albions are still used by artist printmakers.

▲ Daily Graphic
By 1915 the use of halftone photographs in popular newspapers was commonplace. The first newspaper halftone had been published by the *New York Daily Graphic* in 1880, heralding a quiet revolution in pictorial communications. Photomechanical methods replaced hand engraving.

The printing of the last century was largely of two sorts – large-volume, low-quality printing for the mass market, and low-volume, very high quality for the connoisseurs' private press market. It was not until the late 1880s that these different market areas began to influence each other. As education became a universal right, demand for printed materials grew. The growth of advertising fuelled that of newspapers and magazines, and reinvented an older medium – the advertising poster.

Full-colour, large, illustrated posters appeared on the streets of big cities in Europe and the USA in the 1880s. A new generation of designers, influenced by the concern for the fast-disappearing craft-based design skills of the old Guilds, and excited by the alien imagery and perspectives of the newly arrived Japanese colour woodblock prints, began to look for inspiration in the present – rejecting the prevailing taste for historical styles (neoclassicism, neo-Gothic and so on). These trends began to coalesce in the last decade of the century, emerging as a new art: Art Nouveau or "Jugendstil" – the New Style.

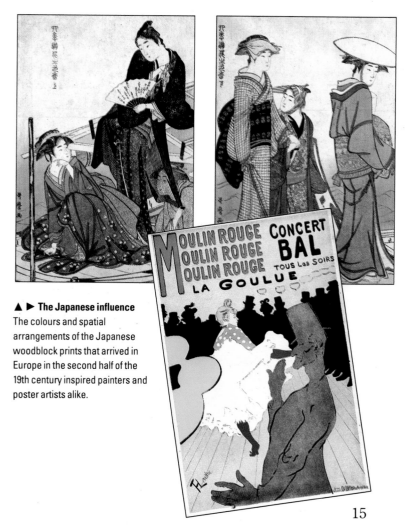

▲ ▶ The Japanese influence
The colours and spatial arrangements of the Japanese woodblock prints that arrived in Europe in the second half of the 19th century inspired painters and poster artists alike.

decades of the nineteenth century (as printing caught up with the Industrial Revolution) caused a major shift in work patterns within the graphic arts environment. These new patterns were the effect of automation and specialization. The typographer could no longer concern himself with the detail of the entire range of print production, from type design to print, as had been possible 100 years before. Specialists emerged to deal with each stage. Type designers, type founders, typesetters, papermakers, printers, binders, publishers – the skills of all these were hived off from the typographer. This reduced his role, while at the same time extending his responsibilities.

During the nineteenth century, the number of printing presses in Europe increased by factors of hundreds. Technology moved from the manual to the mechanical to the automatic, from monochrome to colour, from small-scale, low volume to large-scale, high volume, from a limited and specialist market to a mass market.

◄ PETER BEHRENS
AEG Logotype c. 1908
In many ways Behrens was the prototype of the modern graphic designer. His corporate-identity work was the graphic component in a body of work that also included architecture and product design.

► AUBREY BEARDSLEY
***The Yellow Book* 1894**
Influenced equally by William Morris and the Japanese style, Beardsley was the first major illustrator to use to advantage the line-block photo-mechanical platemaking process.

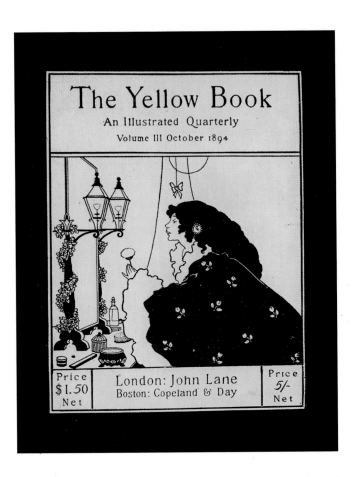

Developments in avant garde art and design accelerated in the period 1890-1930. Art Nouveau established "graphic" design (as opposed to purely typographic design) as a medium not only for the communication of new ideas, but also for their expression. Artists such as Toulouse-Lautrec, industrial designers such as Peter Behrens, architects such as Frank Lloyd Wright and Charles Rennie Mackintosh brought the "new style" to graphic design, in their various ways establishing graphics as a serious medium.

The design and art magazines that were seminal channels

► KOLOMAN MOSER
***Ver Sacrum* 1902**
In this exhibition poster for the Vienna Secession movement in which he played a leading part, Moser combines geometrical patterns within an art nouveau style influenced by the Scottish architect Charles Rennie Mackintosh. *Ver Sacrum* was the Secession magazine published from 1898 to 1903.

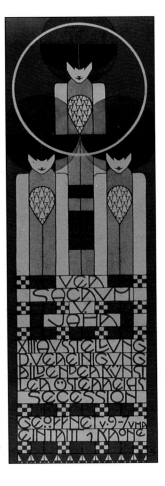

of communication for designers and artists before radio and television, began to reflect a design ethos relevant to the new ideas that were being discussed. These ideas included a wide range of philosophies of art and design practice, many of which were to coalesce into the dominant style of the twentieth century – Modernism. They included ideas evolving from all the design and art disciplines – predominantly from architecture, but also from painting, furniture, ceramics and jewellery design, industrial design, construction engineering, film and photography, the newly emergent telecommunications media (telegraphy, telephone, and wireless telegraphy), as well as from the popular print media of newspaper, poster, magazine and paperback.

Science and technology had an increasingly direct effect on art and design – from the theories of Young, Helmholtz and Maxwell, which provided a basis for Pointillist painting, colour photography and colour printing, to the effect of steam power, gas and electric light on artists as diverse as Turner, Degas and Toulouse-Lautrec. Technology also provided illustrators and designers with new graphic media. For example, between 1850 and 1910, the typewriter, line block, halftone block, colour process printing, colour photography, automatic typesetting, flexography, stereotyping, stop-motion and time-lapse photography, high-

speed photography, X-ray photography, the motion picture, the animated film, lantern slides – all acted to expedite visual communications, and to inspire the designer.

The Modernist influence

The effects on graphic design were threefold: the radical, anarchistic, nihilistic style of Dada and the "typographic" experiments of the Cubists and Futurists served as a watershed. Traditional styles of typography and layout were dismissed out of hand. A period of anarchy rejuvenated mainstream graphic design – first by throwing away the rule book, then by encouraging the development of an alternative and appropriately modern style of layout, with new machine-age type styles, and lastly by initiating a re-examination of the whole process of typographical communication – what it is for, how it is taught, and how it is practised.

These new principles were inspired by the revolution in industry, architecture and construction; by industrial machinery, the motorcar, the skyscraper, the Eiffel Tower, the giant Exhibition buildings, the grain silos, the factories, the railways. The modular, gridded construction of steel-frame buildings became a metaphor for the construction of the page. These architectonic principles were applied directly to graphics, providing the basic structures within which to develop the asymmetrical, non-traditional styles of Modernism.

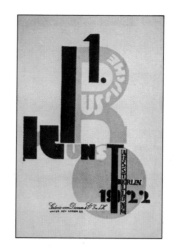

◄ EL LISSITZKY
Exhibition catalogue 1922
The Russian Revolution created a revolution in graphic design in which El Lissitzky was in the forefront.

▼ VILMOS HUSZAR
Cover for *De Stijl* magazine 1917
The De Stijl group applied the principles of geometric layout to their two- and three-dimensional work. The resulting designs were severely modern, and became a major influence on commercial graphics.

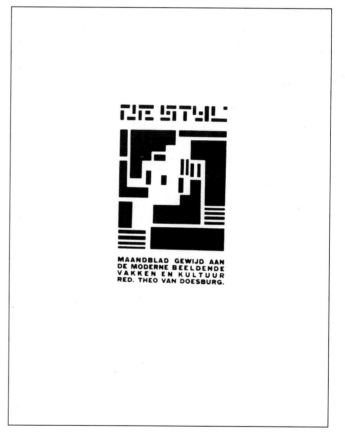

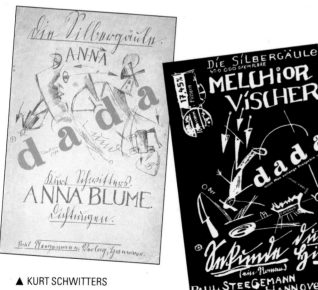

▲ KURT SCHWITTERS
Dada
These two magazine covers by Kurt Schwitters show the nihilistic influence of the Dada movement. Coming together in Zurich during the 1914-18 war, the Dadaists developed a visual style expressive of their disgust with the war, and with the culture in which it had fermented. The rules of typography and traditional design were summarily dispensed with. The Dada "style" of graphic design was based on a language of protest and anarchy.

The de Stijl group, comprised of architects and designers under the spiritual guidance of the painter Piet Mondrian, was influenced also by Frank Lloyd Wright, and soon realized the potential of the architectural, gridded drawing style. This gridded construction became an essential tool of the graphic designer, and a motif of modernist practice.

The Bauhaus

During the 1920s, the developments in layout and type design initiated by the de Stijl group, and paralleled in revolutionary Russia, were integrated within a formal struc- 17

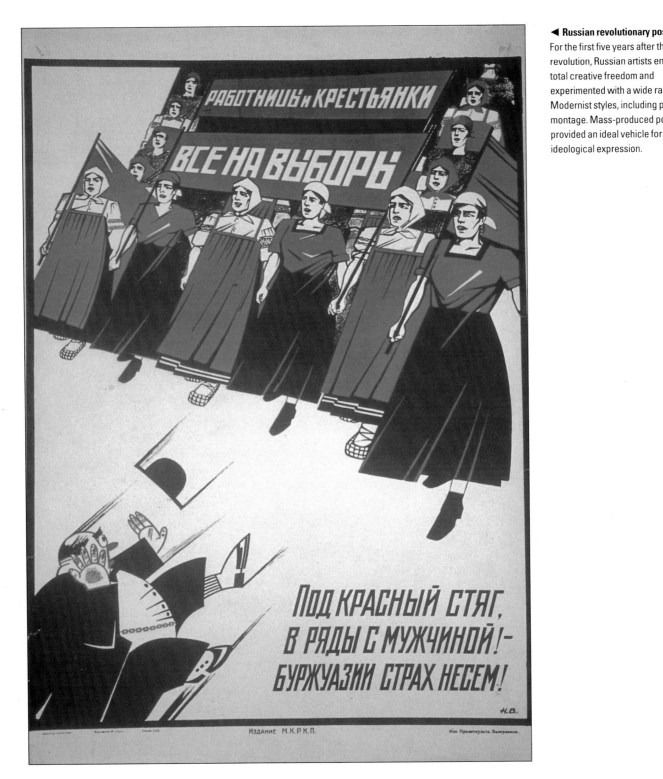

◀ **Russian revolutionary poster**
For the first five years after the
revolution, Russian artists enjoyed
total creative freedom and
experimented with a wide range of
Modernist styles, including photo-
montage. Mass-produced posters
provided an ideal vehicle for
ideological expression.

ture for the teaching of graphics, leading inevitably to the establishment of graphics as a new design discipline. This integration took place largely at the Bauhaus, the art and design school founded by the proto-Modernist architect Walter Gropius in 1919. The Bauhaus is among the most important sources of inspiration for the stylistic development of graphic design in the twentieth century. The integration of avant garde graphic styles was informed by the adoption of a quasi-scientific teaching programme – a programme that still forms the basis of most design foundation courses.

The Basic Design course at the Bauhaus aimed to equip students to answer three questions: what basic elements (lines, shapes, typefaces, etc) should be used to construct an

▲ Bauhaus graphic design
In the 1920s, under the direction of Herbert Bayer, the graphic design school in Germany's Bauhaus laid the groundwork for what was to become the "International" style some twenty years later.

► E. MCKNIGHT KAUFFER
Poster 1929
Kauffer's use of dynamic perspective and innovative hand-lettering introduced modern art styles to the streets of London. This poster was produced with a simple stencilling technique.

► Du Maurier cigarette pack
Modernist asymmetrical grids and "cool" typography reached the general public through advertisements, posters and packaging. In the thirties, the sparse abstraction of the du Maurier pack was in great contrast to the pictorial illustrations that were a feature of cigarette packaging up to the sixties.

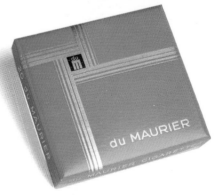

image; what media and materials would be most relevant to the task; and how should the various components of the image be organized relative to each other and to the image area? These aims resulted from a belief in the possibility of a "universal" language of visual communications, a belief shared by many of the Basic Design course lecturers. Attempts were made to justify this belief by recourse to current scientific or quasi-scientific theories. The ideas of Gestalt psychology in particular were used to support the theory of a universal visual language, and to corroborate the argument for the Modernist approach to graphic design. None of these arguments has stood up to scientific investigation, but in one sense they were proven accurate; for over 50 years the Bauhaus style of graphic design became a truly "International" style.

During this same period (1900-1930), the growth of advertising provided new markets for the designer. No longer was typography an art exclusive to the book publisher. To be competitive, and to be seen to be "modern", advertising demanded an endless search for new, fashionable, and more powerful ways of communicating in print. The new technologies of the halftone and line block (full-colour) process printing, and the wide variety of display types – types often inspired by the hand lettering of poster artists – provided the designer with a far wider palette. Modernist styles infiltrated the mainstream. The spiritual severity of Mondrian inspired the layout of chocolate boxes (Black Magic) and cigarette packs (du Maurier) in the 1930s,

while the avant garde Surrealists provided what amounted to an alternative language of advertising.

By the end of the Second World War, Modernist graphic design was becoming the international "ruling taste" – just as modern architecture had become an international style. Designers fleeing from Nazi Germany (the Bauhaus had been closed by the Nazis in 1932) took the message of Modernism to Britain, the USA, and Switzerland.

19

The International Typographic Style

During the 20 years following the Second World War the most important influence on graphic design was the growing dominance of the International Typographic Style, a style that integrated all the important Modernist characteristics, including asymmetrical layout using a mathematically derived grid, sanserif type, and the use of ranged left, ragged right text settings, within a broad philosophy of design that stressed the objective use of type and image for clear and factual presentation of graphical information.

This style emerged first in neutral Switzerland, where the ex-Bauhaus student Max Bill developed precisely articulated typographical grid layouts, and combined these with a logical, hierarchical structuring of information to produce an harmonious and highly legible asymmetrical style. In the Bauhaus tradition, Bill used sanserif typefaces such as Akzidenz Grotesque. The work of Bill, and of other practitioners of the Swiss style, such as Emil Ruder, Armin Hoffman, and Josef Müller Brockmann, was promoted internationally through the medium of the magazine *Graphis*, first published in 1944. The influence of the Swiss style was reinforced by the impact of two sanserif typefaces produced by Swiss designers in the 1950s, both of which have become universally popular – Univers by Adrian Frutiger, and Helvetica by Edouard Hoffman and Max Miedinger. The style influenced designers in Britain and the USA throughout the fifties and sixties.

The International Typographic Style not only encompassed widely accepted standards of typography and layout, but also included several methods of pictorial and graphical communication developed in the interwar years. These new methods of representing complex statistics and spatial relationships stemmed from the work of Otto Neurath's Isotype Institute (first in Vienna, later in London) and Henry Beck's pioneering work on schematic mapping for London Transport.

In 1924 Otto Neurath was commissioned to design a range of exhibition displays to inform the population of Vienna of the economic and demographic facts that shaped their lives. The problem of representing large amounts of often confusing data in a form that was easily understandable led to the foundation of the Isotype movement, which developed a system of explanatory charts using simple graphic pictograms to symbolize the components of economic, social, scientific and demographic data. Neurath was to adopt the new typeface Futura (designed by Paul Renner in 1927) to provide the legends and labels for his pictographic charts. The effectiveness of "isotypes" as a means of non-verbal communication has led to the development of international sign systems (for airports, stations – and

▶ OTTO NEURATH

Isotypes

Inspired by the establishment earlier in the century of a universal graphic code for electronics diagrams, and by the power and beauty of Egyptian hieroglyphs, Neurath developed a new pictographic "language" that has influenced later generations of information designers.

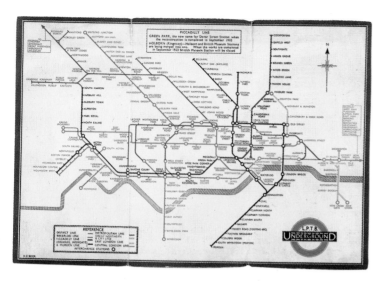

▲ HENRY BECK
London Transport Underground map 1933
Beck's brilliant use of colour coding and schematic mapping established conventions that were later adopted throughout the world.

▶ LESTER BEALL
Radio poster 1927
A self-taught designer, Beall successfully integrated and reinterpreted Modernist styles and in turn influenced a generation of American designers.

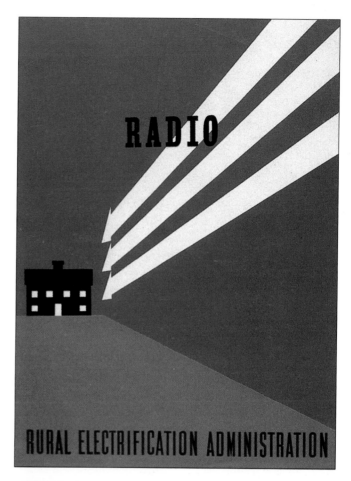

for international events such as the Olympics), and to their use (as "icons") in graphical interface design for personal computers.

Similarly, Henry Beck's map of the London Underground (developed from 1933 onwards) has become the model for urban transport and travel maps throughout the world. By simplifying complex geographical representations of the routes into colour-coded schematic maps – employing only horizontal, vertical and diagonal lines – and by devising a set of symbols for interchanges and terminals, Beck produced an easily understandable map in a format that has been internationally adopted.

American developments

During the late thirties and early forties a large number of artists and designers escaped the war in Europe by emigrating to the USA. Ladislav Sutnar, László Moholy-Nagy, Gyorgy Kepes, Herbert Bayer, George Giusti, Will Burtin, and many others brought first-hand experience of the new typography, enriching and supplementing an already dynamic indigenous profession. Commercial pressures in the USA ensured the importance of graphic design in advertising, packaging, corporate identity, film and (later) television, as well as in its enormous publishing industry. Native designers such as Paul Rand, Saul Bass and Lester Beall had already absorbed the lessons of the European modernists, and enlightened industrial corporations, such as the Container Corporation of America, Westvaco Paper Co, IBM

◀ **Record sleeve: 1950s**
The new long-playing 12-in vinyl records (introduced in the late forties) were packaged in glossy, colour sleeves that provided a perfect format for designers. Jazz sleeves in particular, aimed at a "hip" and style - conscious audience, introduced Modernist styles into mainstream packaging.

and CBS provided the commercial impetus to disseminate modern design in the marketplace.

Sixties diversity

While the two dominant influences on graphic design during the forties and fifties were the designers working in the USA and in Switzerland, during the sixties the first generation of postwar youth in Britain, Europe and the States – designers, photographers, artists, musicians, film makers – began to exert a new stylistic influence.

With the popularity of Pop Art and the growing influence of sophisticated popular music in the sixties, graphic design became far more eclectic, drawing on a wide range of source

21

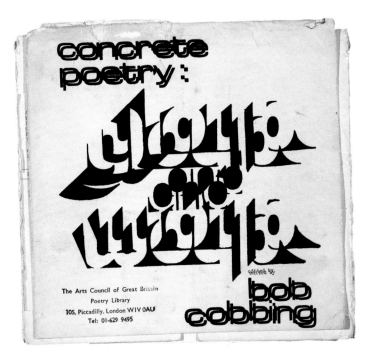

◀ **"Concrete" Poetry**
The sixties produced a fusion of type, text and image. "Concrete" poetry drew on ideas from writers and poets like Lewis Carroll and Guillaume Apollinaire to create *gestalts* of meaning, which in turn influenced advertising design.

▼ **Sixties psychedelia**
By 1968 the influence of hallucinogenic drugs on the new youth culture could not be ignored. Emerging first in San Francisco, psychedelic graphics became the major visual expression of "flower power".

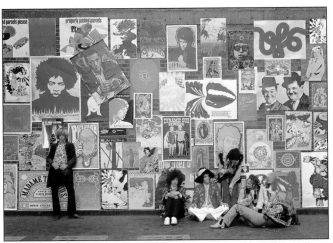

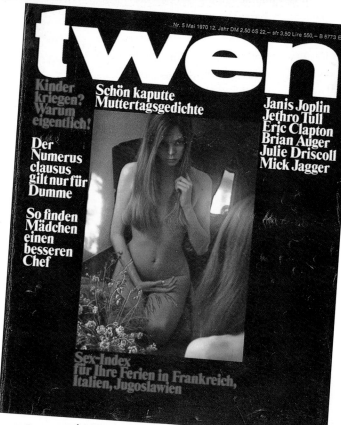

material, from Victorian advertising to comic strips and Art Nouveau. The "Concrete" poets re-examined the calligrams of Apollinaire, and developed a fresh and technically sophisticated poetic medium, combining word puzzles, anagrams, palindromes and other word-plays in a typographical setting that also used type as illustration. In the USA, master calligraphers such as Saul Steinberg also fused words and pictures, and as this fusion was also taking place in American advertising (in, for example, the ads produced by Doyle Dane Bernbach), and in other facets of graphic design (the work of Herb Lubalin and the Push Pin Studio), as well as in Pop, it became a dominant motif of sixties graphics.

The diverse influences on graphic design during the sixties included the inspired anarchy of Will Elder's *Mad* magazine; the *nouvelle vague* cinema of Godard, Resnais and Truffaut; the Pop Art of Paolozzi, Warhol and Rauschenberg; the fine-art minimalism of Richard Hamilton (the Beatles' *White Album* in 1968); the fashion photography of David Bailey; the album covers of jazz and popular music; photorealism and the airbrush; the historicism and nostalgia of painters such as Peter Blake (who designed the famous *Sergeant Pepper* album cover in 1967) and in a different way the style of Art Nouveau (informing the psychedelic posters of the late sixties). All this, married with the ruling taste of the International Typographic Style, the powerful protest posters, underground comics and magazines (for example, *OZ* and *Rolling Stone*), led to a flowering of diversity within one decade that is without historical parallel. Several magazines of the time successfully integrated the dominant modernist typography with this eclectic mix, the most

▲ ***Twen* magazine**
A major source of inspiration in the sixties and early seventies, Willi Fleckhaus' *Twen* influenced magazine design in Britain and America. It was a major vehicle for innovative illustration and photography, and one of the first popular consumer magazines to successfully use Modernist graphics and typography.

notable being Willi Fleckhaus's *Twen*, the early issues of *Town* magazine, David Hamilton's *Nova*, and, in the USA, *Esquire* (under the art direction of George Lois) and Mike Salisbury's *West* and *Rolling Stone*.

Post-Modernism in the 1980s

In the seventies and eighties the range of graphic styles continued to expand. Designers encompassed and absorbed influences as diverse as Dada and classical eighteenth-century typography, and reiterated these in a variety of post-modernist styles. The entire history of graphic design became potential source material for a new generation of designers (designers well schooled in Art and Design History). Modernist and classical styles were re-evaluated and transformed by contemporary fashion, and by new typesetting and image-making technologies. The expressive limitations of the International Typographic Style were examined by Wolfgang Weingart, whose typographic experiments were to influence a new generation of designers in Europe and the USA.

In the mid-seventies, Jamie Reid's album covers for the punk-rock band the Sex Pistols used Dada techniques to graphically illustrate the group's nihilism, and gave birth to the anarchic style of punk graphics. During the late seventies and early eighties both the punk style and Weingart's post-Swiss typography were gradually absorbed into the graphics mainstream, ultimately reinvigorating typography and spawning mixes of diverse typefaces and upper and lower-case characters in unconventional settings.

In the eighties the reworking of post-punk and modernist graphic styles by designers such as Peter Savile, Neville Brody, and, in the USA, April Greiman (a student of Weingart), revealed just how valuable a strategy this can be in the hands of highly competent practitioners. This creative eclecticism, combined with the influence of the post-apocalyptic style of films such as *Mad Max*, *The Last Battle*, and *Blade Runner*, of sculptors/furniture makers such as Tom Dixon, of animators such as the Brothers Quay and of comic strips such as *Judge Dredd*, illustrate the dominant styles of designers grappling to express visually the spirit of the times. The next decade will see the emergence of radically new media forms, many of which will depend upon ability to apply established skills to new technologies.

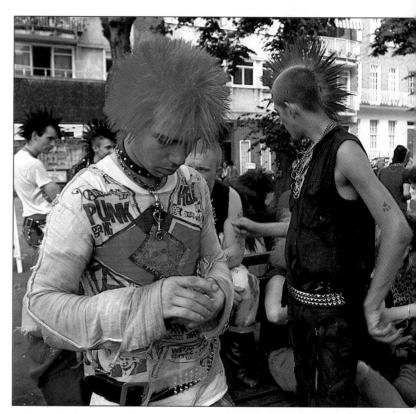

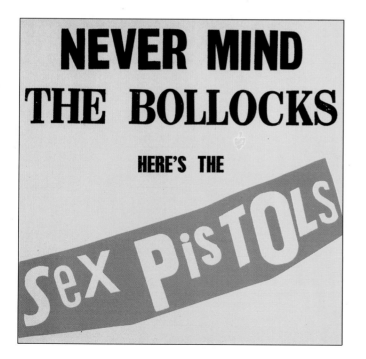

◄ JAMIE REID
Sex Pistols record sleeve
Echoing the anarchism of the Pistols, Reid uses a blend of styles derived partly from Dada, partly from the anonymous "ransom" letter, and combines these elements with the colours of cheap supermarket "sale" posters. Punk graphics were quickly adopted, adapted, and anaesthetized by the graphic design status quo.

▲ **Punk fashion**
In the mid-seventies the new tribalism of Punk rejuvenated street fashion and gave expression to the emerging "post-Apocalyptic" spirit of the age. Costume became a visual and tactile collage of graphics, badges and T-shirts.

23

The changing role of the graphic designer

An important aspect of graphic design over the last 30 years has been the change in the public's awareness of the profession, with a resultant change in status for the designer. The increasing professionalism of designers has led to a more general acceptance of the importance of graphic design within the business community, and to an increasing "visual literacy" among the young – the latter development largely due to the effect of bright, innovative graphic design in popular music, television, and in the high street. This advance in general awareness and appreciation of good design is due in no small way to the increased number of high-quality courses, themselves a response to the

▲ PETER SAVILLE
New Order record sleeve
Saville art-directed for Factory Records during the late seventies, producing stunningly innovative designs that combined different stylistic motifs culled in part from the history of Modernist graphics. This "post-Modern" attitude to style, combined with Saville's broad technical expertise, exemplifies the "Gutenberg Approach".

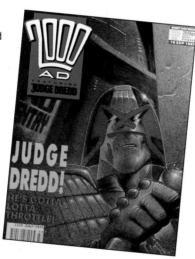

▶ **Judge Dredd**
The post-Apocalyptic style emerged from science fiction movies like *Blade Runner* and *La Dernière Bataille*, and from comic strips like *Judge Dredd*. In graphics it took the form of Punk collage – a style explored formally by Wolfgang Weingart as early as 1974.

expansion of the profession; and of course to the popularity of desktop publishing (DTP), which has introduced a much wider public to the fascination of graphic communications. One of the most noticeable results is the cult status of the more innovative designers. Compare this situation with the years immediately before and after the last war, when "commercial art" was considered rather demeaning work, and it is obvious that major changes have occurred.

The recent evolution of the graphic designer's role is due in part to the professionalism of educationalists in the design colleges, in part to the growing number of designers who teach one or two days a week, bringing with them essential knowledge of the changing technologies, working practices, and fashions. Better secondary education has resulted in an appreciation by a much broader swath of the young of the

role of the graphic designer. Record covers, videos, posters, T-shirts, badges – everything associated with the world of pop music – have created a new type of visually literate consumer, to whom the graphic designer has become a glamorous contributor to popular culture. The availability to non-graphic-arts professionals of sophisticated design and print production tools in DTP systems will continue to generate a new wave of interest in the graphic arts that will in turn create a more critically appreciative climate for the work of the designer.

▶ *The Face* **magazine**
Neville Brody, one of the most gifted of contemporary graphic designers, restyled *The Face* in the early eighties, setting the style of radical graphic design that helped make it the most popular lifestyle magazine of the decade. Brody is another example of "a Gutenberg Approach" designer. A complete professional, he has recently completed the design of two new Postscript typefaces.

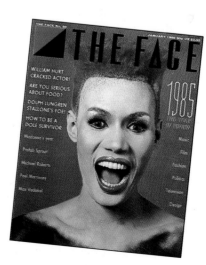

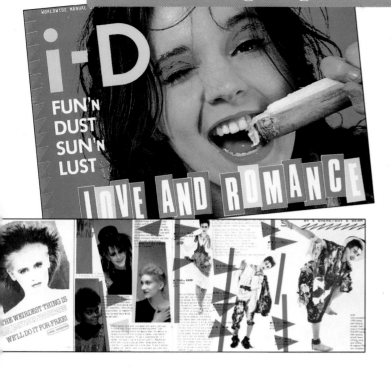

▲ ID magazine
A popular lifestyle magazine, *ID* is innovative in its landscape format, and is representative of a new style of graphics, with its eclectic mix of styles and its typography that makes much use of the microcomputer typestyles familiar to DTP users.

Graphic designers also now have access to an enormous range and depth of information about the history of graphics, and of the related areas of publishing, advertising and packaging. This information is constantly referred to, represented and informed by the designer's own experience and taste, and by the subtle demands of fashion, to produce new hybrids that seize the modern imagination.

But one of the most pervasive educators in graphic design has been television. Particularly since the sixties, the quality, range and variety of both news graphics, broadcasting company "idents", titles and credits sequences, as well as the consistently high quality of advertising graphics, have had a profound effect on the public sensibility. More recently, the retail industry has at last come to realize that good graphic design, especially when it is integrated within an identity that includes packaging, shopfitting, interior and fascia design, makes sound commercial sense.

The Gutenberg approach

Compared with even 30 years ago, the new technology of graphic design is complex. Whether this technology is controlled by specialist technicians, or is in the designer's own hands, the modern graphic designer must not only be creative in conceptual and aesthetic problem solving, but also act as the pivotal guiding spirit in coordinating the various sophisticated technologies used to produce the final printed work. Just as the film director oversees and informs the disparate processes of film production, so too the graphic designer must master and direct the new technologies of graphics production. The inspirational German designer Wolfgang Weingart calls this the "Gutenberg approach" to graphic communications, believing that, like the early typographic printers, the designer should be conversant with all aspects of the design and print process.

To be truly the "soul" of the new machines, the designer must understand how they work, and what are their capabilities and limitations. We have reached a point where we can glimpse the future of graphic technologies – of expert design systems, artificially intelligent online research, critical-path problem solving aids, massive memory storage, networks and satellites for global commissioning and delivery of soft art, of the fluid interface between the designer and the means of graphics production, of the totally desktop control of the whole process from research and roughs through to repro and printing. The future promises at the same time an increasing complexity of technology and ever greater simplicity of control and ease of use. New technologies have introduced a seamless fluidity of graphics inception, research, production and printing, together with integrated studio management, scheduling and accountancy. It is up to the designer to employ the most appropriate tools and processes for a particular task, and to mould both traditional and digital methodologies into a style of working that best suits his or her personality. The aim is to use the new technologies to shorten the distance between idea and artifact, allowing the freshness and verve of an original concept to be carried through to the audience/reader unsullied by the processes of production.

▼ Channel 4 ident
Martin Lambie-Nairn's 1983 ident for Channel 4 introduced computer animation to the general public.

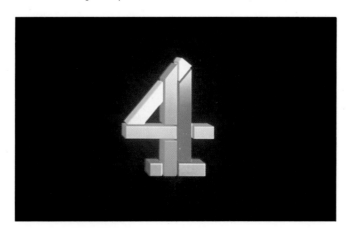

25

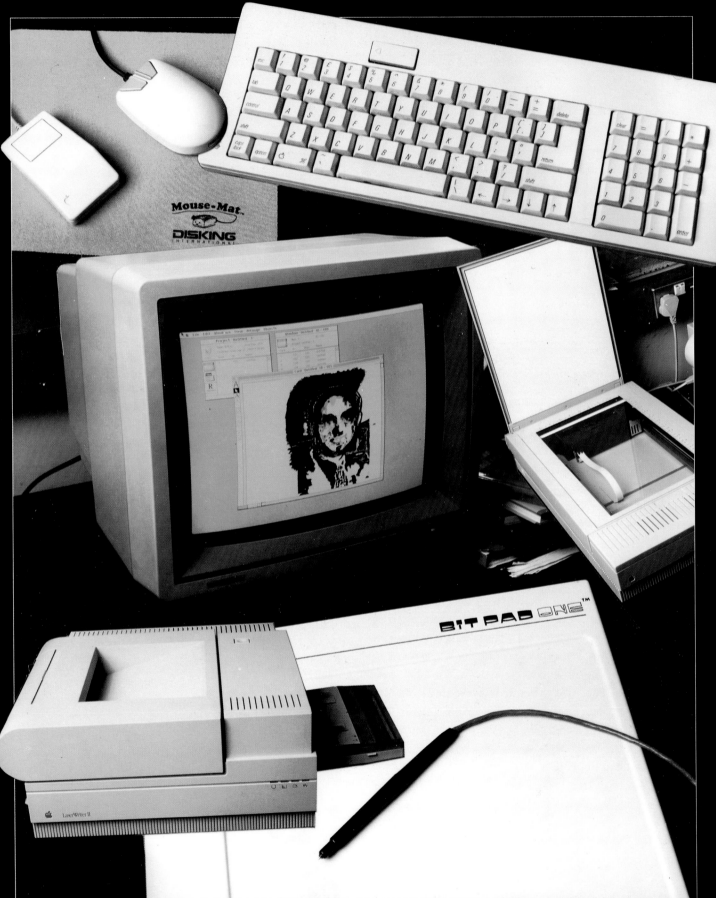

DESIGN TOOLS AND EQUIPMENT

The new graphic arts materials that are a feature of the twentieth century are a reflection of the rapidly developing technologies of reproduction and print during this period. The first half of the century was dominated by the letterpress, hand-setting, and hot metal typesetting machines. The introduction of commercial high-speed litho presses in the 1920s offered designers the freedom to work directly from the drawing board, rather than the type room. In the last 20 years, new digital technologies have revolutionized graphic design production.

Basic equipment

Some of the basic tools of the graphic designer have changed little since the beginning of the century. For example, type mark-ups and layouts – the basic components of graphic design – have always been produced using rulers and pencils. With the introduction of litho presses, new "mechanical" drawing tools were developed – the ruling pen, the pantograph, the airbrush, and the capillary action technical pen. These drawing tools were supplemented by tools for layout – the parallel action drawing board and the Grant Projector. The latter was an enormous breakthrough, allowing designers to trace accurately scaled pictorial images, sample type sheets and other graphics, as well as to visualize the effects of enlarging and reducing an image, a logotype, or an entire layout. The photo-mechanical transfer (PMT) camera allowed the designer direct control over the preparation and scaling of line and halftone images for inclusion in paste-ups. Although the range and sophistication of the means for creating artwork and typesetting have increased vastly, the basic principles remain the same – the production of camera ready artwork.

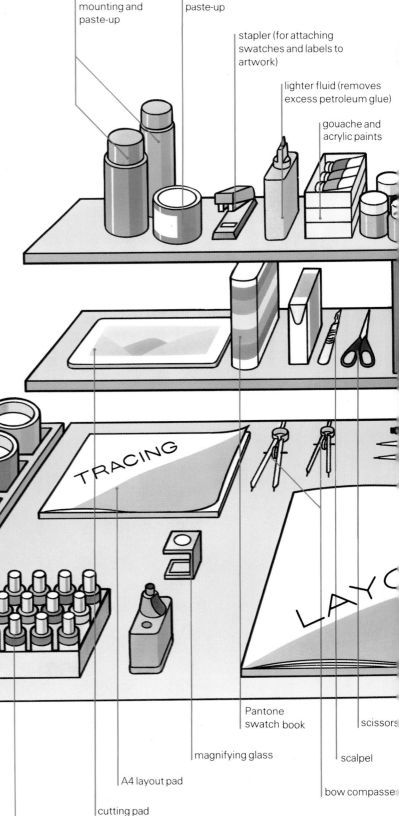

aerosol glues for mounting and paste-up

petroleum glue for paste-up

stapler (for attaching swatches and labels to artwork)

lighter fluid (removes excess petroleum glue)

gouache and acrylic paints

TRACING

LAYO

Pantone swatch book

scissors

magnifying glass

scalpel

A4 layout pad

bow compasse

storage tubes for paper, tracing film, acetate

cutting pad

felttip markers for visualizing, producing roughs

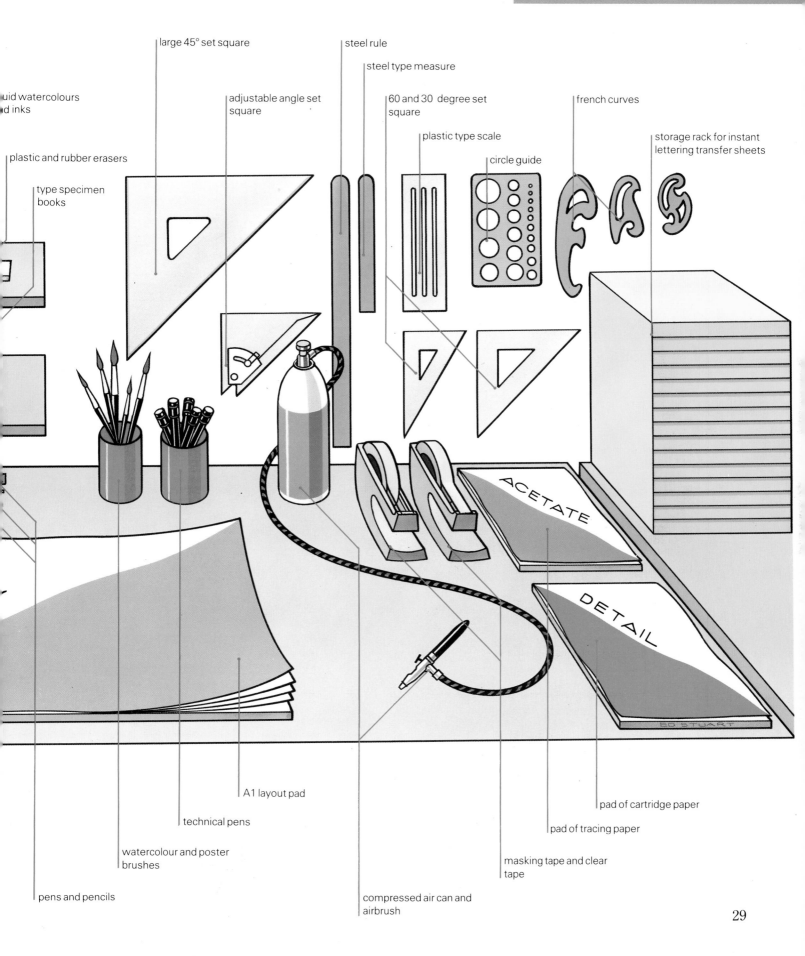

large 45° set square

steel rule

steel type measure

uid watercolours
d inks

adjustable angle set square

60 and 30 degree set square

french curves

plastic type scale

storage rack for instant lettering transfer sheets

plastic and rubber erasers

circle guide

type specimen books

ACETATE

DETAIL

BD STUART

A1 layout pad

pad of cartridge paper

technical pens

pad of tracing paper

watercolour and poster brushes

masking tape and clear tape

pens and pencils

compressed air can and airbrush

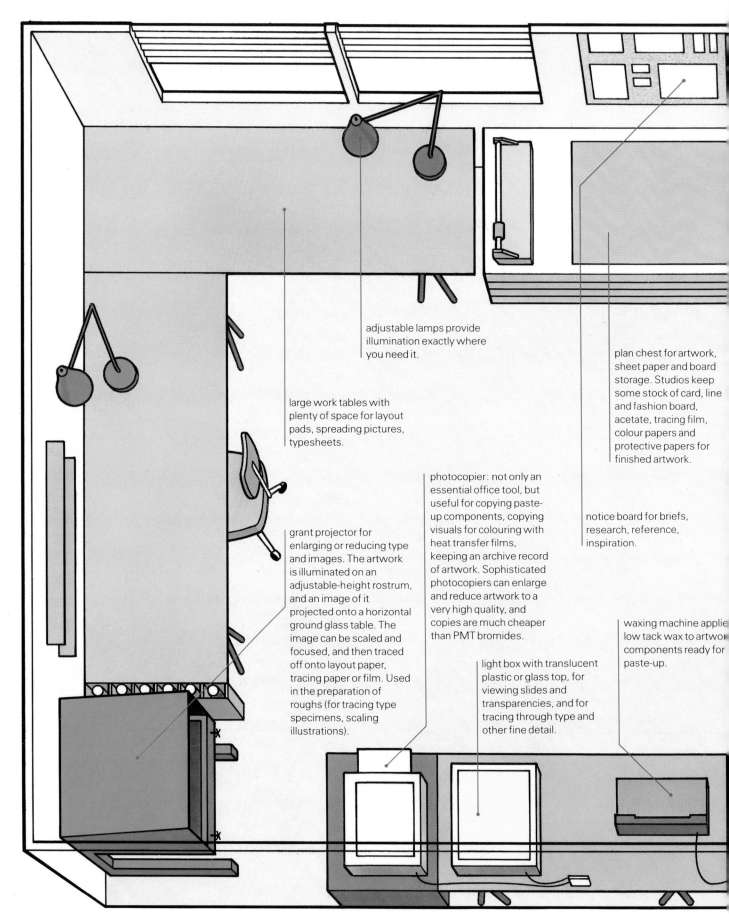

adjustable lamps provide illumination exactly where you need it.

large work tables with plenty of space for layout pads, spreading pictures, typesheets.

grant projector for enlarging or reducing type and images. The artwork is illuminated on an adjustable-height rostrum, and an image of it projected onto a horizontal ground glass table. The image can be scaled and focused, and then traced off onto layout paper, tracing paper or film. Used in the preparation of roughs (for tracing type specimens, scaling illustrations).

photocopier: not only an essential office tool, but useful for copying paste-up components, copying visuals for colouring with heat transfer films, keeping an archive record of artwork. Sophisticated photocopiers can enlarge and reduce artwork to a very high quality, and copies are much cheaper than PMT bromides.

light box with translucent plastic or glass top, for viewing slides and transparencies, and for tracing through type and other fine detail.

plan chest for artwork, sheet paper and board storage. Studios keep some stock of card, line and fashion board, acetate, tracing film, colour papers and protective papers for finished artwork.

notice board for briefs, research, reference, inspiration.

waxing machine applie low tack wax to artwor components ready for paste-up.

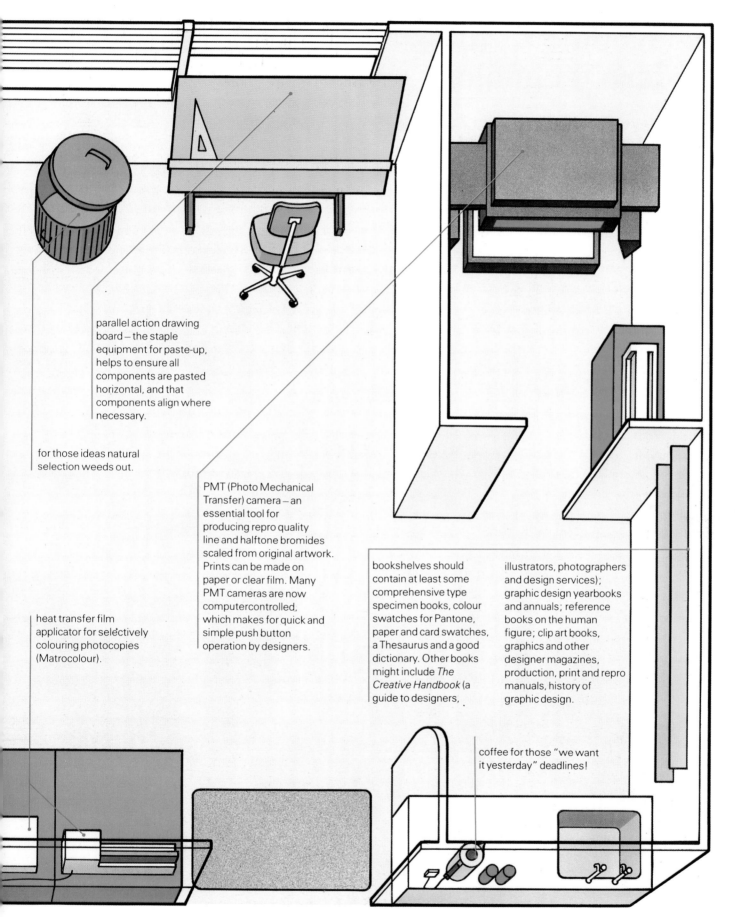

parallel action drawing board – the staple equipment for paste-up, helps to ensure all components are pasted horizontal, and that components align where necessary.

for those ideas natural selection weeds out.

PMT (Photo Mechanical Transfer) camera – an essential tool for producing repro quality line and halftone bromides scaled from original artwork. Prints can be made on paper or clear film. Many PMT cameras are now computercontrolled, which makes for quick and simple push button operation by designers.

heat transfer film applicator for selectively colouring photocopies (Matrocolour).

bookshelves should contain at least some comprehensive type specimen books, colour swatches for Pantone, paper and card swatches, a Thesaurus and a good dictionary. Other books might include *The Creative Handbook* (a guide to designers, illustrators, photographers and design services); graphic design yearbooks and annuals; reference books on the human figure; clip art books, graphics and other designer magazines, production, print and repro manuals, history of graphic design.

coffee for those "we want it yesterday" deadlines!

Developments in modern technology

During the nineteenth and early twentieth centuries, the demand for printed communications forced the pace of new technologies – first in mechanizing printing and papermaking, then in mechanizing the setting of type. In the last 50 years these processes have been constantly refined to produce higher quality output combined with greater economy of means.

The 1970s digital revolution in typesetting offered designers an entirely new range of creative options. Once stored in digital form, typefaces could be electronically programmed and processed to create a wide range of letter, word and interlinear spacings, slanted, expanded and condensed forms, and shadow, outline, halftone and reversed effects. The digital integration of type and images was offered by a new generation of electronic page composition (EPC) systems in the late sixties and early seventies. These expensive machines took input from high-resolution laser scanners and from digital typeface databases, and allowed the designer to compose these elements (on screen and in real time) into complete page layouts.

Desktop publishing (DTP) heralds a new era in typesetting and print production for the simple reason that it places the control of these technologies directly in the hands of the designer, focusing in one workstation a range of typesetting, page-composition, image-making and processing media.

TV, film and video graphics

The late seventies and eighties also witnessed a revolution in film, TV, and video graphics, a revolution fired by the demands of broadcast television. In the video-based media, graphics are always "soft" – that is, they only appear as fluorescing traces on the surface of a TV monitor screen. Because the output resolution is limited by the various national broadcasting standards (for example, the PAL system, 625 lines), TV graphics do not have to have the fine resolution of print graphics, but the designer working in TV must consider aspects of design foreign to the print-based media. The most important of these is that TV, like film and radio, is a time-based medium. Images must communicate serially, with all the possibilities of two-dimensional graphic layouts amplified by sequential movements in time.

The technologies developed for the production of TV graphics went through three distinct phases: conventional (painted and typeset) placards and animations using cells, montage, and other film animation techniques; video-tape and disc-based systems, using computers to generate type

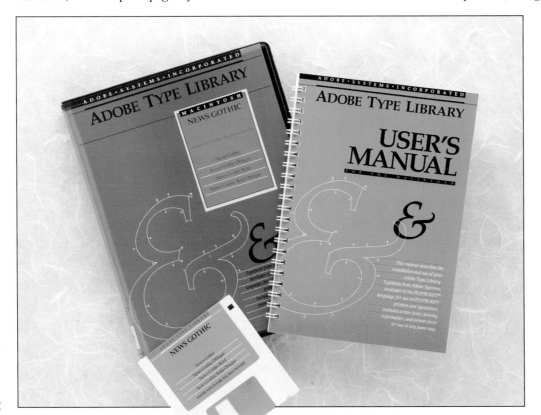

◀ **Fonts**
Fifty years ago the fonts stored on this 2oz diskette would have weighed several hundred pounds and occupied the space of a large desk! The fonts are now effectively weightless, held in magnetic traces on the diskette as digital code. Postscript fonts such as this are supplied in two modes: coded for Postscript output devices, such as a laserprinter or imagesetter; and as a set of "screen" fonts – bitmapped versions that are displayed as screen images within page make-up and graphics programs.

▲ **Paintbox**
The Quantel Paintbox is a key medium for developing video and print graphics. Images can be input from video cameras or tape, or directly through the digit pad. The Paintbox also stores hundreds of digital fonts for on-screen typesetting.

▲ **Computer graphics**
The 1980's saw the emergence of design groups who utilized the power of graphics computers to design for a variety of media, including print, audiovisual presentations and video. Some of the possibilities of digital image processing using the paintbox and videographics software are shown above. Graphics for print and for video can be produced on the same types of machine, opening up a wide range of opportunities.

characters directly on video; and thirdly, completely digital systems that use powerful computers and immense storage capacities to digitize video signals and to caption, title, animate and distort these signals in real time (i.e. at 25 frames per second). These expensive video "paintbox" systems pioneered the technology for synthesizing still and motion images in full colour to broadcast-standard output. This technology is now available to a much wider range of designers through computer-based "desktop video" systems offering the same facilities as the professional paintboxes of a few years ago at a tenth of the price.

The convergence of desktop video and desktop publishing puts an enormous range of image-processing tools into the hands of the graphic designer. The designer now has fingertip access to almost the entire range of print and video imaging technologies. This availability in one system of graphics, sound and animation tools will fire a revolution in graphic image-making (one of the first results of which is desktop "presentation" graphics). This revolution will feed both print and television, and the new wave, already in sight, of interactive media using digital-optical discs, lasercards and chips.

Electronic publishing

Apart from purely "desktop" systems, DTP technology and software ideas are making an impact on the entire spectrum of publishing industries, from typesetting through to repro. We have used the term "electronic publishing" to describe this rapidly growing area. Electronic publishing systems differ from desktop publishing in two major respects: they are designed for large-scale production of corporate documentation, books and magazines and so use more powerful computers; and they offer the designer extensive typographic control over typesetting and page-make-up components within an integrated production system servicing many different users.

Unlike DTP systems, which are based around the personal microcomputer, electronic publishing systems usually depend on a powerful workstation, (see glossary) generally running under the UMX operating system, that caters for multiple users and is able to process several operations in parallel.

DTP systems

Desktop publishing (DTP) was invented in 1985, when for the first time a relatively cheap system that integrated word processing, typesetting and graphics handling capabilities became widely available. The first DTP system comprised a personal computer (the Mac), a laserprinter (the Apple Laserwriter), and innovative software (Pagemaker by the Aldus Corporation).

During the development of the Pagemaker program, Aldus realized that for it to become a professional graphic design tool, it would need to output to high-resolution typesetters as well as the 300 dots per inch (dpi) Laserwriter. In order to do this, it is necessary to use a special code called a page description language (or PDL), that is capable of transmitting a complete description of the page (as it is laid out on the monitor screen) to any suitable printing device. Aldus adopted "Postscript" from Adobe Systems. Major type founders and typesetting equipment manufacturers such as Linotype were quick to realize the potential of an industry-standard PDL for desktop publishing, and Postscript is still the most dominant.

The personal computer

Before the Apple Mac was introduced, most computer operators had to communicate with their machines by typing in sets of coded instructions. The importance of the Apple breakthrough was in providing a commercially successful machine that almost anyone could use. Instead of coded instructions, the Apple used a variety of screen graphics to show what was happening inside the computer. These included having different "windows" – movable and resizeable frames which contained the different programs available (such as word processing and painting and drawing packages), as well as "pulldown" menus from which instructions could be selected, and graphic symbols called "icons" that were used to represent other options available to the user. Instead of relying on keyboard instructions, the user could operate the computer by means of a "mouse", which was used to manoeuvre a screen pointer into position for moving windows around the screen, selecting icons and items from the menus, and so on. This method of using the computer

COMPUTER MEMORY is based on an ancient system of counting. Computers, in fact, are very simple machines. At their most basic, they are devices for inputting information, storing it, processing it, and outputting it. To process information the computer must translate it into binary code.

Binary is a code made up of two digits, 0 and 1. These equate to on/off or high/low (power) in the computer's circuits of switches, and it is by sequences of 0s and 1s arranged in "words" of 8, 16 or 32 binary units (or bits) that the computer encodes the alphanumeric characters we type in. Single alphanumeric characters are represented by 8 bits, and this 8-bit unit is called a "byte". A standard method of writing this code has been adopted so that information can be shared between computers of different makes. This is called the American Standard Code for Information Interchange, or ASCII.

In ASCII, each letter of the alphabet (and all the punctuation and exclamation marks, plus the digits from 0- 9) is given a unique 8-bit code of 0s and 1s, and these codes are stored in arrays of memory cells inside the computer – memory cells are groups of tiny switches that are turned on or off by the binary code. By organizing these bits of data (using a control code), the computer is able to store words and numbers in such a way that they can be recalled by the user at a later date, modified on screen, then restored (or printed, or sent to another computer via a network or telephone line). ASCII is a very efficient code. For example, an A4 page of 10-point text will contain about 6,000 characters, and as each character requires 8 bits, the computer will have to devote some 48,000 bits of memory storage for each page.

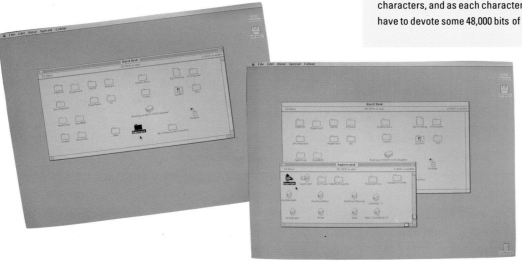

◀ **The Mac "WIMP" interface**
This simple method uses small icons of folders to represent the various data, such as files and programs, stored in the computer's memory. Here we can see two stages in the opening of an application called SuperEdit. First the Supercard folder is opened (by pointing at it and double-clicking with the mouse), then the same process is repeated to open SuperEdit.

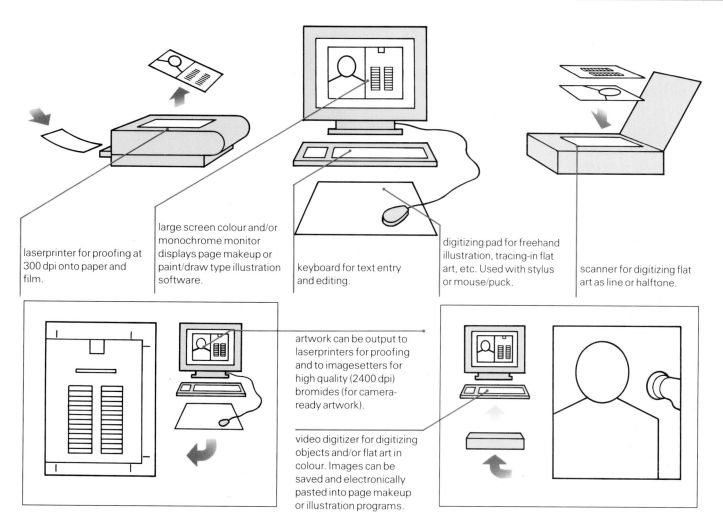

laserprinter for proofing at 300 dpi onto paper and film.

large screen colour and/or monochrome monitor displays page makeup or paint/draw type illustration software.

keyboard for text entry and editing.

digitizing pad for freehand illustration, tracing-in flat art, etc. Used with stylus or mouse/puck.

scanner for digitizing flat art as line or halftone.

artwork can be output to laserprinters for proofing and to imagesetters for high quality (2400 dpi) bromides (for camera-ready artwork).

video digitizer for digitizing objects and/or flat art in colour. Images can be saved and electronically pasted into page makeup or illustration programs.

was called the WIMP (windows, icons, mouse, pointer/pull-down menus) "environment". It is a method that has been adopted by most other personal computer manufacturers.

Apple's other major innovations in computer use were to develop the means for displaying a wide variety of different typefaces and type sizes on screen, and to arrange the layout of the screen so that it became a metaphor for the desktop. The screen was laid out much as a businessman might lay out his desk – with accessories (such as a calculator, diary and calendar) arranged along the top, piles of different jobs in little "folders", and a clear working surface.

How images are stored

Images and text are stored in the computer in different ways: text as ASCII code (see box), and images as "bitmaps" (certain types of image can be stored in code, and these are discussed later.) When a black and white image is scanned into the computer, it is separated (digitized) into hundreds of individual units that can be described as being either black or white (on or off). The number of such units gives us the "resolution" of the digitized image. Most DTP

systems are capable of storing scanned images at 300 dots per inch (dpi). An A4-size image would therefore require over ten times more memory than a page of text in ASCII.

Image resolution and halftones

The individual dots that make up a digitized image are all the same size, while the dots that make up halftone images vary in size to reflect the tonal variations of the original image. To construct a halftone image (for instance, to digitize a photographic print) requires the use of 6 digital dots for each dot of the halftone, so that the highest halftone resolution available on a 300-dpi system would be 60 lpi. (The re-solution of halftone screens (see Design, Repro and Print) is usually described in terms of lines (of dots) per inch, or lpi). So the quality of halftones available from a laserprinter would be the same as that of a crude newspaper photograph. To achieve acceptable standards of halftone for book or magazine work (i.e. 120-150 lpi) requires at least 800 dpi.

Even more data is required to encode a full-colour tonal image as the computer must also store a description of the colour values at every dot.

35

Working the computer

Input devices are used to control the programs in the computer, and to enter information. There are several different methods of inputting text and images, and these require a variety of different computer "peripherals", such as a keyboard, digit pad and scanner.

Inputting text

There are three ways of entering text into the computer:

● Using a keyboard and an appropriate word-processing or page-make-up program. In this case, the wordprocessing program displays the text on screen as it is keyed in, and allows complete control of text editing, from running spelling checks, to performing "cut and paste" operations on words, sentences or large blocks of text; arranging tabulated columns, and simple typesetting and formatting.

● Keying it into a computer that is not equipped to run a DTP program, and transferring it to the DTP system by means of a floppy disk or through a computer network or telephone modem. (Wordprocessed text can be sent directly to a typesetting facility in the same way).

● Scanning it into the computer. To do this, your scanner must be equipped for Optical Character Recognition (OCR). Most OCR scanners can recognize a wide variety of typefaces, including "typewriter" faces such as Courier and Pica. The text is scanned, and the letters are recognized and encoded into ASCII before transfer to a wordprocessing program for storage and any subsequent editing. OCR scanners enable text that has been prepared on a typewriter or that has been previously typeset or printed, to be input without rekeying. Note that scanners not equipped with OCR will only scan text in the same way that they scan images – i.e. in a non-editable, low-resolution bitmap.

Inputting images

This is effected either by preparing graphics in a drawing or painting program, or by scanning images using a flatbed, gravity-feed or video scanner. Images can also be "grabbed" from video tape.

Drawing and painting programs: There are two main types of software: bitmap or "paint" programs and object-oriented or "draw" programs: these are both discussed in more detail later (see section "Graphic Design Software").

◀ ▼ **Image input**
There are two main methods: video digitizing (left) through a video rostrum camera, and using a flatbed scanner. The image (below) shows how the software for the Apple Scanner allows different windows on the scanning operation.

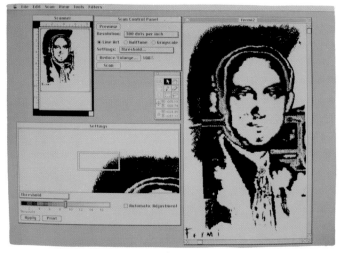

Paint and draw programs can be used to produce original art, or to trace-in existing material by digit pad and stylus.

Scanning images: The only way to input photographs and existing illustrations is by scanning. There are two main methods: by digital scanners or by video digitizers, and they use different techniques to produce the same result; converting the original image into a set of binary digits. This process is called "digitizing".

Digitizing scanners work in a very similar way to a photocopier. The image to be scanned is laid onto the glass platen of the scanner, and a light source travels along the length of the image, moving from left to right as it does so, illuminating every part of the image at a typical resolution of 300 dpi. As each tiny part of the image is illuminated, the light reflects from the white areas, and is absorbed by the black areas. A signal of 0 or 1 is recorded. This is repeated until the entire image has been digitized. Scanners comprise the hardware that does the physical scanning, and the software that resides in the controlling computer. The software stores the digitized image and displays it on screen so that it can be edited with a variety of painting tools. The finished image

36

can be saved in a number of different formats suitable for different applications.

Video digitizers achieve the same result, but use the electron scanning action of the video camera instead of a moving light source. The video image is made up of a number of horizontal lines that trace the path of an electron beam, scanning the image from top to bottom. Each line is made up of a large number of picture elements (pixels), and these can display black or white (or colour) data. Video digitizers will record flat art or three-dimensional objects – anything, in fact, that can be put in front of a video camera.

For simplicity, only black and white digitizing is discussed

above. Colour scanners and video digitizers are available also, and work on the same principles, but require large memory storage and high processing speeds in the host computer (see also page 68).

Digit pads and mouse: Various techniques can be used to "draw" on the screen. The two that are dominant are the digit pad and the mouse. Although the mouse is clumsy compared with a stylus and digit pad, it is much cheaper. It operates best when it meets some surface resistance, and so fibre "mouse mats" are really worth having for the extra control they give the user. The mouse quickly becomes an extension of the hand, and is fine for program control and graphics manipulation, but it does have considerable limitations when it comes to freehand drawing; digit pad and stylus allow much more precise control.

Digit pads or tablets are electronic "drawing boards". They are linked to the computer and monitor, so that by moving an electronic stylus across the surface of the pad, you are able to draw on screen. The pad works by having a grid-like array of sensors under the smooth drawing surface. The finer the grid, the higher the resolution of the drawn image. Digit pads, unlike the mouse, can be used to trace existing line illustrations into the computer – you simply use masking tape to hold the illustration in position on the pad, and use the stylus to trace it in. Because of their more sophisticated technology, digit pads are roughly seven or eight times more expensive than the mouse. They are of course the standard "interface" to dedicated computer "paintboxes". (Note: to overcome the problem of tracing with a mouse, many of the more sophisticated "draw" type programs have an "autotrace" facility, where bitmapped images from paint programs or from the scanner are automatically traced and converted into draw-type graphics.)

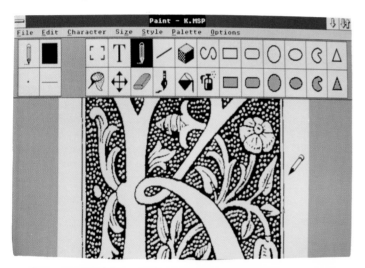

▲ Paint programs
Two paint programs for P.C.s. Microsoft's Windows Paint can be used to create artwork from scratch, or (top) retouch scanned images. Publishers Paintbrush (above) is a more sophisticated colour package. Programs of this type are very easy to use.

► Draw programs
The professional Adobe Illustrator 88 program allows bitmapped artwork to be scanned as a template and autotraced to produce an encoded draw-type image. This can then be edited, coloured, scaled and output at a very high resolution.

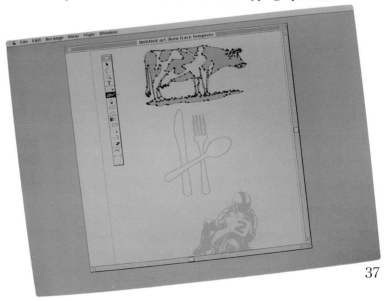

37

Page-makeup and graphics software

Now that we've seen how to get text and images into the DTP system, we'll examine how these components are integrated and processed to produce graphic design artwork. Apart from word processors, there are two main types of software that the designer will use in the DTP system. These are page-makeup software (for the assembly and pasteup of all types of graphics components)

an imagesetter or laser typesetter. Page-makeup programs are an example of how digital computers are encouraging a convergence of hitherto separate processes. In one software package, the designer will find tools for preparing a layout grid; processing images in monochrome and colour; scaling, cropping and reproducing them; typesetting from direct keyboard-input copy and from word processor files; drawing graphic diagrams, borders and rules; laying all these components out on the page as an electronic paste-up, and finally printing them as hard copy at a variety of scales and resolutions.

Although there are dozens of programs currently available, ranging from top-end word-processing packages that

◀ **Agfa Press**
This is a top-end integrated page makeup system. The large monitor shows a complete double spread. Images are input through the flatbed scanner and positioned with text from word-processing programs. Systems like this offer the designer a complete set of professional graphics and typesetting tools – all on the desktop.

and graphics software (for the separate production and processing of illustrations, diagrams, lettering and typeface manipulations, etc).

Page-makeup programs are designed to take input from the computer keyboard, word processing programs, painting programs and scanners, and to allow the designer to manipulate these components on a page size of his or her choice, on screen and in "real time". They employ various software techniques to generate an accurate representation on screen of the graphic components that are to be integrated and produced as camera-ready artwork through

allow a considerable latitude in page layout, through crude page-makeup programs designed for less powerful personal computers, to sophisticated professional programs, most offer the same basic facilities (see box).

Graphic design software
As well as page-makeup software, an electronic studio needs specialist programs for the production of illustrations, graphics (combining both illustration and type) and display lettering. The latest generation of software combines tools for painting (using bitmapped graphics), and drawing (using

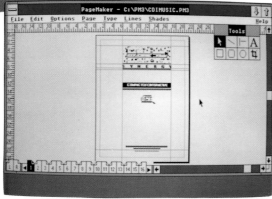

◄ PageMaker on the PC
Page makeup is possible on small monitors, as the page can be viewed at various scales. The 200% view (top) allows detailed adjustments, while the "fit in window" shows the whole page.

▼ Quark XPress on the Mac
XPress allows typographic control down to one hundredth of a point! Colour images can be input through a video digitizer or colour scanner, and graphics and text colours selected from the Pantone range.

PAGE-MAKEUP programs generally offer the following:
- Define page size and orientation in a variety of units of measurement, including picas, millimetres and inches.
- Determine the number of pages, and add and subtract pages at will.
- Define an overall layout grid.
- Number pages automatically in a variety of styles.
- Input and edit text direct from the keyboard, or from previously word-processed files, or through OCR scanners.
- Typeset text in a wide and expanding range of typefaces and styles, including emboldening, italicizing, drop shadow, reverse out, etc, and including precise control of interlinear, word and letter spacing, and text alignment.
- Define paragraph indents and tabulated columns.
- Input line and halftone images from painting and drawing programs and from scanners.
- Process images by copying, scaling, distorting and cropping.
- Produce rules, boxes and areas of tone for the creation of borders, diagrams and other graphics.
- Lay these components out on the screen representation of the page and electronically paste them up.
- View the current page or spread at various scales (up to around 200 per cent of required size).
- Input and process colour images and graphics, and ascribe process colours to display or text type components, and to print these as colour-separated art (on some programs and systems).
- Correct errors and change layouts and graphics at any stage in the design process.
- Output to a variety of scales and resolutions as hard copy (including crop marks) via laserprinter or imagesetter.

"object-oriented" or "draw-type" graphics), as well as facilities for the automatic tracing of scanned images. Also available is special display lettering and font design software that includes powerful typographic manipulation devices.

"Paint" or bitmap software

For the designer, this is the simplest and most intuitive illustration software. Inspired by the original "MacPaint", a wide variety of painting programs are now available. Bitmapped programs treat the screen as a fine grid of pixels that can be "painted" individually or in blocks by means of a mouse or a digit pad and stylus. The designer has a range of tools available, generally including the following: a "pencil" for drawing freeform lines of one pixel width; a "paintbrush" for drawing freeform lines at a variety of thicknesses, and with a variety of brush shapes (these can also be customized); a "ruler" for drawing straight lines (also known as rubberbanding); a "compass" and ellipse tools; tools for the creation of rectangles and other polygons, an "airbrush"; a tool for filling defined areas with colour or patterns, and tools for the selection, cutting, copying and pasting of parts of the screen

◀ **Bitmapped images**
These can be edited by magnifying
the image up to pixel level, where
individual bits can be recoloured
easily. The new generation of image processing software caters
for montage and collage
techniques with all the retouching
tools the designer requires.

"draw-type" programs allow very precise editing, and can be
enlarged and reduced with no loss of detail. "Draw" images
are stored as a string of code, and therefore use much less
memory than bitmapped files.

Automatic tracing software

Some programs combine both "paint" and "draw" modes,
using an "autotrace" facility to enable bitmapped images
(either created in the program or input through a scanner)
to be converted to a "draw-type" graphic. These programs
offer the best of both worlds, combining the ease of use of
"paint" bitmaps with the editing control and scaling advan-
tages of "draw-type" software.

Display lettering software

Certain software programs offer considerable type manipu-
lation functions alongside their drawing and painting capabili-
ties and these tools are also available in special display
lettering software, such as LetraStudio by Letraset. In
these programs, the designer can set type; adjust the
baseline setting to conform to a circular, freeform or
geometric line or predetermined shape; skew or rotate the

image. The designer has control over colours and patterns,
and is able to enlarge, reduce, flip, and angle parts of the
image, zoom in for greater detail and set simple bitmapped
typefaces. Paint images have two major drawbacks: enlarg-
ing or reducing a bitmapped image affects the size of the
component pixels and therefore can drastically reduce the
readability of the scaled image; and because the computer
has to store data describing every pixel, a lot of memory is
consumed.

"Draw" or "object-oriented" software

In these programs, the designer can create marks on screen
that are defined geometrically, using techniques developed
by the mathematician, Pierre Bézier. These define any curve
by means of control points – points that can be adjusted
interactively to change the shape of the original mark. Apart
from freehand drawing, many geometrical drawing tools,
including compass and ellipses, rectangles and polygons, are
available from the toolbox. Although more difficult to use,

▲ **Display lettering**
LetraStudio is a sophisticated type
manipulation program, allowing
type to be set in a wide variety of styles and distortions. These
facilities were previously only
available at great expense through
specialist photosetters.

▶ ▼ Conventional and electronic
Octavo is a magazine for typographers and graphic designers published in an edition limited to 3,000 copies per issue. The innovative typography and use of colour tint, spot varnishes, foil blocking and embossing demonstrate what can be achieved by a combination of conventional production techniques and electronic page make-up.

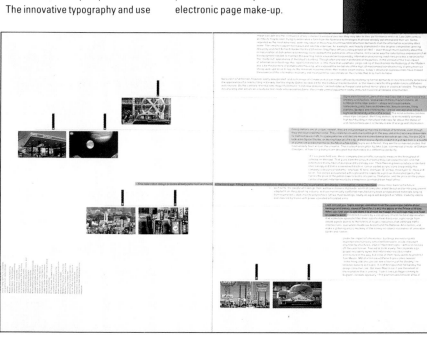

type to achieve an endless variety of perspective distortions, produce mirror images, and control the monochrome or full-colour solids or tints that define each character. Furthermore, some programs allow the designer to "texture map" a display setting or logotype onto a previously defined "three-dimensional" object, such as the model of a bottle, book jacket, or other product package. This facility not only allows the designer to create innovative artwork, but also makes it possible to see how display lettering will look in situ – whether on a building or a matchbox.

Font design software

Available in both bitmap and "draw-type" (Postscript) modes, font design software offers a set of tools for the origination of new font designs, for the editing of existing fonts, or for the creation of special logotypes or display settings. Some programs provide a set of draw-type tools for the creation, manipulation and editing of characters using Bézier curves. Ligatured or combination characters, logotypes and display settings with a variety of typographical special effects (rotation, skewing, scaling) can be produced, and 256 character fonts designed with control over letterspacing and kerning. (Kerning is the precise visual adjustment of letterspacing between certain character pairs, such as Ta, WA and LT, which would otherwise appear badly

spaced.) These programs encode the designer's work as a Postscript font file that can be installed and used within page-makeup programs.

▼ Font design software
Fontographer allows the design or modification of complete Postscript encoded fonts. This type of software is also useful for designing logotypes, special type characters and display lettering.

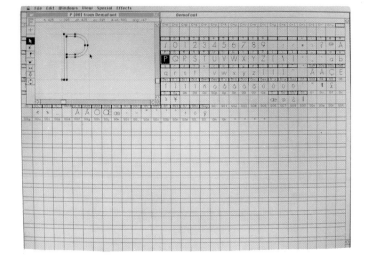

The DTP design process

There are many similarities between conventional graphic design practice and the methods of work that are evolving for design work on DTP systems, but there are also differences in approach – and it is in these differences that the advantages of DTP become very apparent. Let us clear up a popular misconception first: DTP systems will not of themselves improve the quality of your design work. As you become proficient in working with DTP, the systems will improve your productivity, and many short cuts through the conventional design process are possible, but DTP is like all other computer software – if you put rubbish in, you'll get rubbish out. The DTP system provides a powerful set of professional graphic design tools, but if you are not a trained graphic designer, you will not be able to use these tools to the maximum of their potential (although you'll still enjoy using DTP, and will discover much about graphics in the process).

The major differences in procedure between conventional and DTP practice lie in the elimination of successive generations of working roughs (as in DTP the work evolves through a succession of design decisions, at each stage using the actual text and images that will form part of the final job). So while most DTP designers will still initiate a design with conventional thumbnails and crude working roughs, thereafter they will work on the computer, scanning in images or using specialist graphics software (such as drawing or font manipulating programs) as and when necessary, but working mainly within a page-makeup program.

There are other advantages for the designer working in DTP. One of the main attractions for most designers is the ability to try several different layouts, typefaces, styles and so on in the same time that a designer working conventionally will take to typeset and artwork just one version. The DTP designer need never repeat work (by using copy and paste commands), and can save work as a set of progressive stages – meaning that at any time he or she can experiment to the point of "testing to destruction" without the fear of having to start all over again at the beginning should the design idea not work out.

Conventional designers spend a considerable amount of time in preparing "presentation" visuals – visuals that are used to show the client how the job will look when it is finally printed. With DTP there is often little difference between the presentation visual and the actual artwork – the visual may only be 300 dpi, rather than the 2,450 dpi of typesetting, but most clients will not notice this.

Page printers and plain-paper typesetters
The trend in DTP output devices is towards higher resolution. Although the 300 dots per inch (dpi) resolution of the first wave of laserprinters has been an acceptable standard for proofing, designers always knew that for quality typography, for halftones, and for long print runs it was necessary to output to an imagesetter. However, it is not always necessary to output in the 1,200 – 2,400 dpi range offered by imagesetters. In fact for some purposes (for

◄ WYSIWYG
True WYSIWYG is only possible if you have a screen resolution that matches your printer resolution exactly, and with most DTP work it is best to work from laserprinted proofs. However, the latest screen font technologies can give a very accurate idea of the final printing image.

A ABCDEFGHIJKLM NOPQRSTUVWXYZ

A ABCDEFGHIJKLM NOPQRSTUVWXYZ

DTP design process

Most designers work through a job in their own individual way. What follows is an overview of how they usually work:

1. After the initial briefing – produce roughs, design grid, choose typefaces (this can be an interactive, on-screen process, working directly in a page-makeup program).

2. Input text to word-processor files.

3. Proof text onto laserprinter and correct.

4. Commission illustrations (these can be digitally produced) and photographs.

5. Obtain prints and digital artwork, digitize into computer using a video image digitizer or flatbed scanner, scale, crop to size, retouch, manipulate colour balance, etc.

6. Prepare layout grid in page-makeup program.

7. Electronically paste-up complete pages, placing text, typesetting, and adding tints, specifying Pantone or process colours (if required), adding rules, boxes, line artwork, etc. at the same time, checking results on high-resolution monochrome or colour monitor as design is developed. For speed of processing, add full-colour images last, if necessary using a monochrome version of the image as a working guide.

8. Output to laserprinter or colour postscript printer for hard copy proof.

9. Make corrections to design and output monochrome or colour-separated artwork via imagesetter. If many colour transparencies are required for the finished artwork, it is often better and cheaper to have these separated electronically by a repro house (see Design, Repro and Print section).

10. Specify inks, paper and quantities and order printed proof from the printer.

11. When litho printing, check printer's proofs for correct imposition, colour balance, registration, etc.

12. Order print run.

13. Supervise any extra print processes, such as varnishing, blocking, die stamping, etc.

14. Supervise collating and binding, etc.

15. Deliver to client.

example, in newspaper production) it can be counterproductive. Some newspaper proprietors have calculated that 600 dpi resolution for type is quite adequate for newsprint and allows a significant saving on ink. New laserprinters and page printers using non-laser technology (light-emitting diodes (LEDs), for example) now offer output devices that fill the gap between first-generation laserprinters at 300 dpi and imagesetters at 1,200-plus dpi.

High-resolution page printers

The term "laserprinter" ceases to be an accurate generic term for high-resolution printers as they can use different imaging technologies, such as LEDs. The term "page printer" or "plain-paper typesetter" is more useful. This new generation of printers currently operates in the 400 –

600 dpi range, though it is possible that printers of up to around 1,000 dpi will be developed. The latter is probably the maximum resolution of printers using toner powder. This is because, at slightly higher resolutions, the technical problems of creating and maintaining a static charge of less than 1/1,000th inch in size become very demanding, as does the problem of refining toner particle size. So, 1,000 dpi, (incidentally, the approximate resolution of the early phototypesetters) is likely to be the upper limit of resolution for page printers outputting to plain paper, and is the point at which they overlap with photographic imagesetters. Like some of the current imagesetters, these page printers will have the ability to output in a wide range of resolutions, using 300 or 400 dpi for proofing, 600 dpi for the majority of typesetting, and maximum resolutions for halftones.

Laserprinter
The minimum quality output device (300 dpi) for DTP proofing, and for short-run (in-house) jobs, presentations, etc.

Dot Matrix
Low resolution output device for text galleys.

Imagesetter
High resolution (1000–2400 dpi) bromide output device for camera ready art.

MANAGING MEMORY involves two main methods of storing files in a typical DTP system computer: on an internal or external hard disk, or on floppy disks. For large-scale storage and for backup purposes there are also digital optical WORM (write once, read many times) drives and magnetic-tape streamers. Whatever options are available, it is obviously important to be able to find any particular file with a minimum of searching, and this means organizing your files into folders (or directories). Creating a new folder is a simple process, and will enable you to locate all the different page-makeup, drawing, painting and text files and so on, that you will need for a specific job in the same place.

It is essential to make backup copies at least once a day. Backups are made onto floppy disk, digital optical disk, or onto magnetic tape streamers. Backups should be clearly labelled with their job number or client's name, file names, and the date. It is important to save all the relevant files with the backup (for example, original text and image files should be saved together with the version produced in a page-makeup program. If special or unusual fonts have been used in any of the files, these should also be noted on the backup label. There are many filing systems available for disc storage, and these can be compartmentalized and labelled, ensuring easy retrieval.

▼ Imagesetters
Professional quality output requires high resolutions. The latest generation of imagesetters offer resolutions from around 600dpi to over 2400 dpi. High resolutions are necessary to give results with halftones.

► Halftones
Halftone dots vary in size according to the tone they represent – to achieve this variable-size dot requires six of the uniform-size laserprinter dots. This means that a 300 dpi laserprinter will only produce a 50 dpi halftone. Acceptable halftones need the 600 dpi+ resolution of plain paper typesetters and imagesetters. Photographic halftone has dots that vary in size, but are always regular in shape (left). Laserprinter halftone dots are formed from a fixed bitmap, and are therefore irregular shapes (right).

Colour postscript printers

Full-colour output of Postscript files is possible by using either a Postscript-compatible thermal-wax printer, or an inkjet printer with suitable software "emulation" of Postscript. Full-colour prints from these machines have four main uses: as colour presentation visuals; as original artwork (for illustrations where the distinctive inkjet or thermal-wax printer effect is required); as initial proofs for full-colour DTP programs; for short, low-budget, full-colour print runs.

Thermal-wax printers

These comprise two main components: the print engine itself, and its controller. The printer uses the thermal wax transfer process in which the image is built up by layering the four basic CMYK (cyan, magenta, yellow and black) colours on top of each other in four sequential operations. Each colour is printed one line at a time (at a resolution of 300 dpi) by means of a film ribbon composed of alternating bands of cyan, magenta, yellow and black wax on a clear plastic base. The printer head melts the wax, transferring it from the film to a specially coated paper. Each of the CMYK colours is transferred sequentially while the image paper is held in place to ensure exact registration. When one line of full colour has been transferred, the ribbon and paper are progressed to print the next line, and so on until the complete image has been printed. The controller is actually a dedicated computer, comprising a fast processor chip and several megabytes of memory to store image data and the resident Postscript fonts (generally the same set as on the Laserwriter). Extra fonts can be downloaded from the host computer as required. The image data is sent to the printer

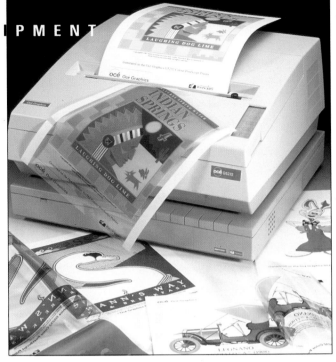

▲ Colour Postscript printers
These machines can output full colour art from page makeup, bitmap or draw-type programs.

Output is usually to 300 dpi and can be produced on paper or acetate. Colour printers like this are an invaluable first proofing tool.

encoded as Postscript, and converted into separated colour bitmaps, which are used to drive the print head.

Inkjet printers

Inkjet printers use Postscript emulators to process colour Postscript files prepared in page-makeup or drawing programs. Inkjet printers use fine jets which spray coloured inks onto the paper under computer control. The resolution is lower than that of thermal-wax printers (around 180 dpi), and for this reason inkjet printers have a very limited use as a

Thermal wax printer
This is used for colour proofing. Top end (Postscript) thermal printers give almost repro quality proofs, good for presentation visuals.

Inkjet printer
These are relatively low resolution, but cheap and good for initial colour proofing and for art which has a computer style.

colour-proofing tool. However, for illustrators working in Postscript, compatible software inkjet printers provide a cheap and acceptable form of colour hard copy.

Desktop repro

Within the wide but nevertheless converging range of graphics production tools for DTP, a new range of image-processing and separation software, designed for use with colour printers, is beginning to open up the prospect of "desktop repro". These software techniques are embodied in colour manipulation and retouching programs that allow

pre-press colour correction, separation and proofing. While these tools will not be of a standard to compete with high-resolution photographic systems for some time, they fill a gap in the repro market for low-cost colour origination.

Such software may include means for the precise control of CMYK colour percentages, picture sharpness and screen angles, and in some systems a densitometer. This sort of sophistication is not cheap. However, for a studio with sufficient throughput in colour DTP work, such a system is very cost-effective compared with laserscanning and photographic pre-press proofing.

THE ADVANTAGES OF DTP EASILY OUTWEIGH THE DISADVANTAGES, but consider the following:

● DTP systems are expensive.

● DTP systems are not portable – but then nor are Grant projectors or PMT cameras.

● It takes time to become proficient in operating page-makeup software. This depends to a large extent on the quality of initial training, and the time it takes for individuals can be anywhere between one week and two to three months. DTP programs are structured in an "intuitive" way, and subsidiary programs, like word-processor and paint programs, are structured in the same way – in other words, once you have learned how to use the mouse to pull down and select from menus, you can perform the same action in any of the other programs. If possible, get your initial training from designers, rather than a computer salesperson – designers speak the same language as you! Initially jobs will take longer to process through DTP, but after a couple of months you should be cutting costs by anything up to 10 per cent per job, and after six months by factors of up to 50 per cent per job.

● It is easy to make corrections to text and layout at any stage in the design process – this is because the digital graphics components (text and images) and the page- makeup file itself always remain "soft" and editable.

● The benefits of reduced typesetting costs. A considerable percentage of the cost on any graphics job is for typesetting. DTP gives you precise control over typesetting and page-makeup. You can check laserprinter proofs before committing to typesetting, and there is no re-keying for the typesetter.

● Reduced paste-up times. Because the DTP design process integrates typesetting and layout with the paste-up operation, the latter is no longer a separate, time-consuming task.

● The benefits of WYSIWYG. Because DTP systems operate on the principle of "what you see is what you get", the designer is always in total control of the design – from grid design to typesetting and electronic paste-up. You can alter the design and its component parts at will.

● The problems of WYSIWYG (see diagram on p42). True WYSIWYG is not available for most DTP systems yet. Display Postscript and other truly WYSIWYG screen systems will become the norm within two to three years. Currently, what you see is almost what you get – this makes the instant availability of laserproofs (to check against the screen image) an essential aspect of DTP.

● The advantages of memory. The computer can be used to store jobs at various stages, and in various files. For example, a range of stationery can

be produced by preparing the basic "skeleton" letterhead with a grid design first. Then, by calling up this file, it can serve as the basis for an invoice, order form or statement, merely by adding the extra components required and saving each graphic as a separate file. Similarly, forms can be saved in their basic linear form, and additions, retitling and labelling done and saved for each separate application that uses the same basic layout. Logos that have been prepared in a page-makeup program can be copied and pasted anywhere within the same or different files or applications. Repeat jobs are no longer tedious.

● The advantages of image processing (see also "Scanning Options"). Conventionally, images such as photographs and line drawings have to be screened, scaled and cropped by means of a PMT camera and darkroom. DTP speeds this process by bringing it into one environment – the desktop. You no longer have to wait half-an-hour for another PMT – you can input images through a scanner, decide on how halftones are going to be screened, scale them to size, crop them, copy and repeat them, add borders, and so on, virtually instantly.

● The speed of line-art preparation. Graphics such as ruled borders, boxes, diagrams, bar charts, flow charts, schematics, forms, tables, etc, can be produced within the same page-makeup program as that used for typesetting, image processing and layout. Rules are always precisely the width you require, and there is no risk of artwork getting spoilt or messy however many times you make a correction. Corners can be mitred exactly, or rounded, or decorative borders can be designed, saved and edited as required.

● The problems of halftones. Current 300 dpi laser-printers cannot resolve better than 60 dpi halftones. Although various screening patterns are possible which may improve on a normal halftone for in-house or limited circulation work, it is best to output halftone material to an imagesetter (where the required dpi screening is available at up to 240 lpi halftones), or to treat contone (continuous tone) images as separate components to be screened and processed through PMT, and pasted into laserproof or bromide prints before camera work.

● The problems of full-colour output. At present full-colour separations done with an imagesetter are no cheaper than conventional film separations. This will undoubtedly change in favour of separation by imagesetter, as colour DTP is still in its infancy.

● The advantages of full-colour proofing. Using inkjet or thermal-wax printers, or colour Postscript printers, full- colour proofs can be taken at any stage in the design process.

47

Presentation graphics

Out of the convergence of DTP print graphics and video graphics has emerged the new desktop discipline of "presentation" graphics – full-colour text and image design and production for audiovisual presentation through slides or video projectors. Previously the confine of specialist audiovisual production facilities houses using expensive dedicated paintboxes, these graphics can now be produced on desktop systems that have an appropriate colour board and monitor. Presentation graphics is the design of graphics that are used to support live or pre-recorded audio commentaries, lectures, business presentations, product launches, exhibition displays and so forth.

Desktop presentation graphics systems

The principal desktop production/delivery systems include the following (listed in ascending order of cost):

Frames can be prepared in any available page-makeup or paint program and output to paper (for epidiascope projection) or film (for overhead projection) via a laserprinter or imagesetter, or for colour images via an inkjet or thermal-wax printer. Alternatively, high-resolution hard copy can be photographed onto slide film on a copy stand or rostrum.

Dedicated presentation programs can be used to prepare frames of graphics, text and images, to sequence them, and to control the method (manual or automatic) and timing of their delivery. These can be displayed directly on a suitably sized computer monitor or output:

● As slide transparencies: by photographing the screen directly. This is the cheapest method of outputting full-colour frames onto slide.

● As slide transparencies by means of an electronic RGB (red, green, blue) camera. The advantages over off-screen photography are the very high resolutions possible (typically 3,000 lpi), and the fact that it is fully automatic.

● By means of an LCD screen display system. This uses OHP technology to enlarge a duplicate screen image via a liquid crystal diode screen.

● As a composite video image: by recording the presentation sequence directly onto video tape in real time, for later replay through a large TV monitor or videobeam projector.

● As a composite video or RGB image directly through a large monitor or videobeam projector.

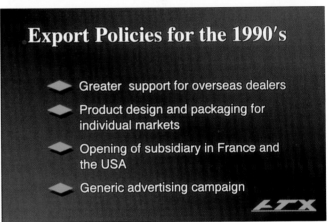

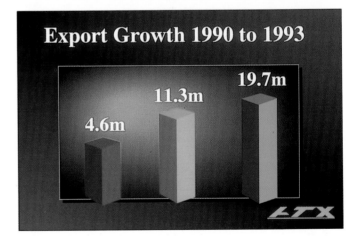

▲ **Presentations**
Presentation software (such as Powerpoint) provides the designer with a set of image-making and typographical tools for the design of individual frames, which can then be sequenced correctly and displayed in their correct order on the monitor. Frames can also be photographed (using a high resolution RGB camera) onto transparency film, and projected as slides.

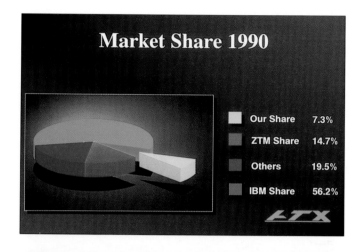

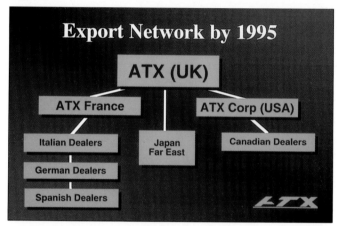

Design and production for presentation graphics

The nature of a presentation depends on several factors, including the budget, the type of data to be presented, the amount of time available, the environment or location to be used, the audience size and composition (the type of people), whether the audience is captive or mobile, and the presentation technology available. The design and production process for a typical presentation is:

● Script analysis: work with the author, copywriter or presenter to decide how the script will best be illustrated as a set of frames, and what text, information graphics and animations will be necessary. List these requirements, and obtain copy for each of the text frames and legends for illustration and diagram frames.

● Produce thumbnail ideas for a typical range of frames, and develop these up through working roughs (or interactively on screen) to produce the basic text, image and information graphic frame formats. Check these with the client before commencing production.

● From these initial designs, develop a basic background or "grid" frame or frames that ensure a visual coherence and will serve to identify all or parts of the presentation programme. For example, a basic grid frame might include guidelines for the disposition of text, images and bullet points, as well as a running title and a logotype.

● Digitize (photos, logos, line drawings, etc). This is done by means of a scanner or video digitizer, with the images stored in a suitable format for editing within a paint program or within the presentation graphics program itself.

● Produce any necessary bar charts and graphs. These can be imported from a spreadsheet program, or originated as graphics, or by means of a dedicated charting program.

● Prepare all text, image and graphic frames. The procedure here is to call the basic grid frame from memory, paste onto this frame any necessary graphics, charts, images, etc, and add the typographical components (by pasting or by setting directly).

● Prepare animated frames. This can be done in hypermedia applications such as Hypercard or Supercard by means of scripts, and in most other presentation graphics packages either by means of built-in facilities, or by custom programming. The simplest animations (such as flashing bullet points and sequentially revealed text) are produced by manipulating the colour look-up table (CLUT) palette to rotate through a series of defined colours, only some of which will be visible on screen. Animated frames will work only with "live" or video computer presentations, although it is possible to animate slide presentations by cross-fading between sequential still frames.

● Sequence all frames and add suitable transition effects, timings or manual control points. This can generally be done interactively, the designer viewing the results immediately on screen. This stage depends on whether the presentation is to be synchronized with a recorded voice-over or triggered manually to accompany a live commentary or lecture.

49

NOPQRSTUVW
mnopqrstuvwxyz

abcdefghijklmnopqrstuvwxyz
1234567890

FGHIJKLMNOPQRSTUVWXYZ
hijklmnopqrstuvwxyz
7890

XYZab
1234567
36pt
ABCD
UVWX
48pt
vwxyz12

EFG...KLMNOPQRSTUVWXYZ
rstuvwxyz

ABC
PQ
al
ITA
STI

FRUTIGER LIGHT

6pt
ABCDEFGHIJKLMNOPQRSTUVWXYZ
abcdefghijklmnopqrstuvwxyz

7pt
BCDEFGHIJKLMNOPQRSTUVWXYZ1234567890
defghijklmnopqrstuvwxyz

HIJKLMNOPQRSTUVWXYZ
mnopqrstuvwxyz1234567890

NOPQRSTUVWXYZ
tuvwxyz

TUVWXYZ

12pt
ABCDEFGHIJKLMNOPQRST
abcdefghijklmnopqrstuvwxy

13pt
ABCDEFGHIJKLMNOPQRST
abcdefghijklmnopqrstuvwxy
1234567890

14pt
ABCDEFGHIJKLMNOP
abcdefghijklmnopqrst
1234567890

18pt
ABCDEFGHIJKL
XYZabcdefghii
1234567890

ORST
NY

6pt
ABCDEFGHIJKLMNOPQRS
abcdefghijklmnopqrstuvwxyz
7pt
ABCDEFGHIJKLMNOPQRST
abcdefghijklmnopqrstuvwxyz
8pt
ABCDEFGHIJKLMNOPQRSTU
abcdefghijklmnopqrstuvwxyz12
9pt
ABCDEFGHIJKLMNOPQRSTUV
abcdefghijklmnopqrstuvwxyz
1234567890
10pt
ABCDEFGHIJKLMNOPQRSTUVWX
abcdefghijklmnopqrstuvwxyz
1234567890
11pt
ABCDEFGHIJKLMNOPQRSTUVWXYZ
abcdefghijklmnopqrstuvwxyz
1234567890
24pt
ABCDEFGHIJK
abcdefghijklmn
1234567890
AB
abc
1234

T
rs

NO
bcde
VW

ØøßÅå ' " ' " , '
NO
OPC
GHI

ABCDEFGHIJKLMNOPQR
abcdefghijklmnopqrstuvwxy
ABCDEFGHIJKLMNOP
1234567890
36pt
ABCDEFGHI
WXYZ12
48pt
Yz1234
ABC

DESIGN SKILLS

The design process is shaped by two groups of factors: the unique experience, preferences and abilities of the designer, and the type of tools and technologies used to produce the graphic images, text and final artwork. In this chapter we will analyze the typical steps that most designers work through (after the job briefing), if they are using the sort of tools and technologies widely available in the early 1990s. Many of the "conventional" tools are being rapidly superseded by their digital equivalents, and although the design procedure for both approaches is broadly similar, naturally the latest digital technologies offer new possibilities.

Basic design skills

The graphic designer's work divides into three main areas: creative design; the production of artwork that embodies this design, and the coordination of all the various processes necessary to the production of the final printed work. The designer's creative freedom will naturally be constrained by the budget, the time available for the job, the physical limitations of the various media used to produce the original artwork, the technologies of reprographics used to prepare artwork for print, the print medium itself, the inks and paper used, and by the post-print processes such as varnishing, binding, stamping, etc. It is only by acquiring an intimate knowledge of all these processes that the designer can produce creative work that optimizes their potential.

The graphic design process

In its broadest form, the graphic design process involves the following stages:

● Generating ideas in response to the brief as thumbnail designs and developing the design solution through the production of a series of roughs.

● Preparing a finished "presentation visual" for client approval.

● Specifying typesetting, and buying in, commissioning or producing any necessary illustrations, photographs, handlettering, etc.

● Producing finished camera-ready artwork for reproduction.

▲ **Page layout thumbnails**
Top down designing: the whole structure of a book outlined as a set of thumbnail sketches. These can be produced quickly, and working on a small scale enables one to consider the whole layout of the page at a glance.

▶ **Logo design thumbnails**
The design of a new corporate identity will usually focus first on the logotype. These pages of thumbnail roughs illustrate the wide variety of solutions that are considered. The designer is literally "thinking with a pencil".

1. Ideas generation
Ideas can be lists, spider diagrams – or any notation that helps to record them!

2. Thumbnail designs
These are the first small-scale initial roughs.

3. Working roughs
Thumbnails are developed to actual size.

4. Presentation visual
The all but finished job, ready for client presentation.

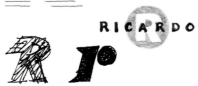

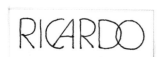

● Supervising the pre-press reproduction of artwork (colour separation, pre-press proofing, colour correction, platemaking, etc).

● Specifying paper and printing processes, checking and correcting printed proofs, and liaising with the printer during production.

● Supervising any post-print processes (binding, packaging, etc).

Scamps and thumbnails

Also described as "scamps" or "visuals", roughs are the means by which the designer first makes visual the various ideas he or she is proposing in response to the client's brief. At the earliest stages these will be very sketchy thumbnail drawings of possible design solutions, and these "thumbnails" are used as a tool to refine a suitable starting point for the production of a finished visual. Thumbnails allow the immediate expression, through the drawing skills at the designer's disposal, of the interaction between his ideas and his knowledge of the visual possibilities of type, images, colour and composition.

In the search for suitable interpretations of the client's brief, the designer will draw upon a wide range of resources, including "background" research into all pertinent aspects of the client's requirements, knowledge of how other designers have tackled similar problems, drawing skills, professional training in colour, typography, illustration, photography and print, awareness of fashion and style – and common sense. As a "processor" of graphic information, the designer must thoroughly understand the nature of the information to be communicated and the type of audience or reader who will be the final recipient. He or she must propose a design solution that most effectively communicates the client's message to the target audience.

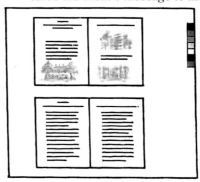

5. Typesetting and illustration
Specify and order typesetting, produce line graphics and commission illustrators.

6. Preparing artwork
Prepare artwork and specify processing that will result in the required finished job.

7. Correcting proofs
Check for registration, colour reproduction and blemishes.

8. Supervising print
Build up a good relationship with both the repro house and the printer.

Various solutions can be explored at thumbnail level. The designer "thinks with a pencil" at this stage, and should be able to quickly materialize several options. These can then be explored in greater depth by producing a series of "working" roughs, variations on the themes that emerged from the thumbnail stage. Experienced designers often intuitively identify the correct solution at an early stage, perhaps producing just one or two working roughs to refine the idea, while students and young professionals may need to produce several visuals before they adopt a suitable design for development.

Working roughs

Beyond the thumbnail stage, the designer will need to consider the choice of typefaces, rendering these in a suitable shorthand, and will need to sketch in any necessary illustrations or photographic images. Decisions on colours and layout will be refined through gradually reworking roughs, until the designer is happy that he has created a

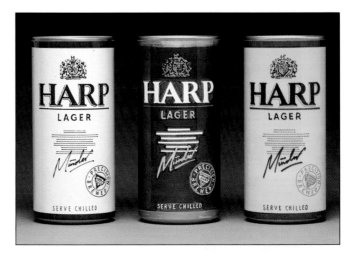

▲ Presentation dummies
For 3-dimensional products, such as packaging, the graphic label is presented to the client in situ – as a dummy of the finished product. This technique is also used to "dummy up" bookjackets and magazine covers.

suitable graphic response to the client's brief, and that he has considered the various formal and technical aspects of the design in sufficient detail to go on to produce a presentation visual for the client.

A variety of media can be used to develop the design through working roughs, but felt and fibre markers are convenient, and those (like the Pantone system) which are colour matched to the final printing ink colours, have obvious advantages. From the working roughs, the designer will derive any necessary layout grids for the production of thematically related work (such as a range of stationery, or the pages of a brochure). These will be produced in dropout (non-printing) blue, and used later to provide guidelines for the pasteup of artwork components.

Grids

A grid is a non-printing arrangement of guidelines prepared by the designer to indicate positions for the layout of text and images on the page. A grid acts as a guide for the layout of

▼ Grids
Grids are the foundation upon which page layouts depend. They should include indications of the position of all page components that are repeated throughout the book. They must also include trim marks, running heads, folio (page number) positions and fold marks. The grids illustrated are those used for this book.

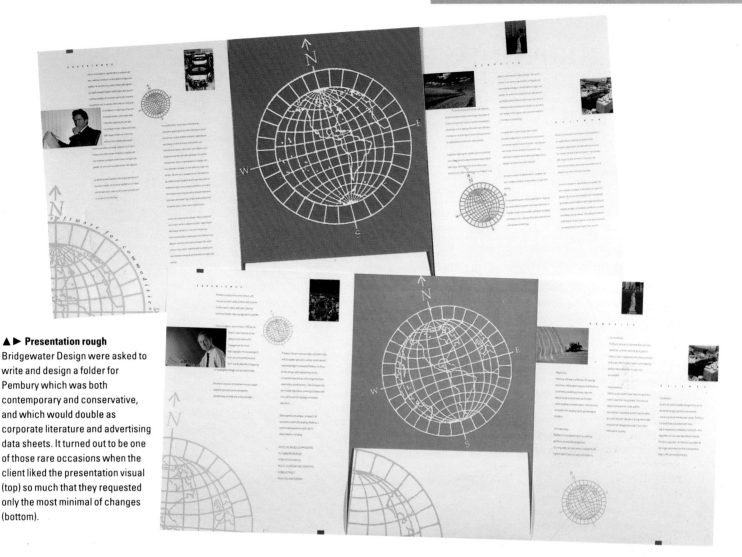

▲ ▶ Presentation rough
Bridgewater Design were asked to write and design a folder for Pembury which was both contemporary and conservative, and which would double as corporate literature and advertising data sheets. It turned out to be one of those rare occasions when the client liked the presentation visual (top) so much that they requested only the most minimal of changes (bottom).

individual items – e.g. a page – that will be seen together as part of a whole – e.g. a book, and ensures visual continuity throughout the document. Grids are always designed for magazines, newspapers and other publications such as books, that have some consistency of visual appearance. Copies of the grid may be printed (using "drop-out" blue – a colour that will not register on line film), or available as a soft image in DTP or electronic page-composition systems.

The grid should identify positions for all repeat components of the pages, including column guides for the main text, and guides for any running heads or feet, for page numbers, for back (spine), fore edge, header and footer margins, etc. For some publications, such as magazines, which combine several different page layouts, the grid may comprise two or more columns. For example, a features section may have two columns, an editorial section three, and a listings section four. In this case all column grids are printed on one grid sheet, to be used as required. The paste-up of all line components – such as text, diagrams, line illustrations and rules – can be done directly onto the grid.

Visuals
By this time all the major aspects of the design will be resolved, and the designer can commence an accurate "finished" or presentation visual. This should be as close in appearance to the final printed job as possible. To the client at least, it should be virtually indistinguishable from the printed item. Also, the presentation visual should accurately reflect, to the client's satisfaction, the type of media to be used in the preparation of the finished artwork. Monochrome type can be simulated by means of rub-down lettering, actual typesetting or photocopied dummy copy, and coloured using a dye transfer or electrostatic (photocopy) colouring process, or even hand-painted. The visual should be mounted with wide borders in such a way that it is suitably framed off from any extraneous visual "noise". The edges of type or colour overlays should be concealed with window mounts, and the whole protected by a clear acetate sheet. If relevant, dummies (mock-ups of the printed product) should be prepared to show the client how the graphics will appear on the finished product.

55

Type mark-ups and typesetting

There have been many different technologies for setting text, including handsetting, strike-on systems and typewriters, hot metal setting and photosetting. Of these the last is now the most dominant, and three generations of machines are in use: photomechanical, digital CRT, and the most widespread, the digital laser-typesetter or imagesetter. Conveniently, the raw copy is in the form of typescript, and it is the designer's job to prepare this typescript for the compositor or typesetter operator by preparing a type "mark-up", which is broadly similar for all processes. The mark-up will specify the required column width or measure, the typeface(s) required, the point size(s), the leading, and a variety of other factors such as indentation, paragraph spacing, the use of emphasis, the treatment of titles, subtitles, footnotes, page headers and footers, page numbers, as well as the way in which the type will be arranged within its measure – either ranged left, ranged right, centred or justified.

The designer makes these decisions on the grounds of aesthetics (the required style and visual appearance), logic (establishing a logical hierarchy of information), legibility (the clarity of the individual letters), readability (how easy the text is to read, bearing in mind whether it is a dictionary, poetry, a novel, etc) and the closely related ergonomic factors (of how, when, where, why and by whom the text will be read), and the physical page space available.

Display typesetting

Display setting can be done on most lasertypesetters, with their ability to output to large and very large type sizes (up to 999 pts on some systems). Alternatives include: display "headliners", which are photomechanical machines that set the type one character at a time onto a strip of photographic film, which is then processed as a positive bromide; pressure-sensitive lettering systems such as Letraset and Mecanorma; digital typeface design programs; and hand-lettering.

Digital font design software

Several computer programs are available for the design of logos, display settings and the production of complete fonts. Display settings can also be produced in the more sophisticated drawing programs. These offer the designer a wide range of options for generating display faces or processing available text faces. These include setting in very large sizes; setting on a curvilinear baseline; wrapping the setting onto two and even three-dimensional shapes and objects; viewing the setting in a variety of perspectives; mixing together illustration, type and graphic components, and using flat and graded tones of colour. In fact most of the expressive effects attainable by traditional hand-lettering techniques have been combined with effects previously available only through custom photosetting, or by means of expensive computer graphics, to provide the designer with a complete digital toolkit for display lettering.

CASTING OFF AND TYPESETTING: The edited and checked copy comes to the designer in one of two forms: as typewritten manuscript; or as a word-processed document on floppy disk (often with a hard copy for reference). The next stage in the design process is to convert the original manuscript or copy into repro quality typesetting.

The process known as casting-off involves establishing the number of characters in an average line of the manuscript (including word spaces, which count as a single character) and multiplying this figure by the number of lines in the text to arrive at a total character count. Copyfitting involves calculating the amount of space (i.e. the length of text, and therefore the number of pages) this number of characters will fill if set in a certain face and point size and to a certain measure.

The methods used to establish the number of characters in the copy are approximate. The final estimate of space required is subject to factors such as the complexity of the manuscript and the number of short lines and paragraph spaces, as well as to problems caused by justification over short line lengths, which requires extra word spacing. These factors can be accommodated by allowing a margin of error of 5–10 per cent in the character count. Although character counts are automatically available from some word-processing programs, remember that this figure will not include word spaces. Most word processors will return a word count that must be multiplied by the average number of characters per word (allowing for word spaces, six is a reliable average) to achieve a total character count.

▼ **Headline setting**
The unaltered original headline setting which is shown modified on the right.

Alphabet

Alphabet

Alphabet

Alphabet

Alphabet

Alphabet

Setting modifications
Examples of the extensive range of modifications available in certain headline setting systems. These include expanding, contracting, adding shadows and infills and setting into curved shapes.

Alphabet

Alphabet

Alphabet

Alphabet

Alphabet

Alphabet

Alphabet

Alphabet

Artwork components

This involves some or all of the following components being brought together as a paste-up on suitable art or line board: a layout grid, typesetting (both for display and text matter), hand-lettering, repro of logotypes, trademarks, etc, printed, self-adhesive or hand-drawn rules, boxes or other line artwork and illustrations, and continuous-tone illustrations, such as airbrush drawings or photographs. Artwork may also include separate overlays for any additional colours, trim and registration marks, and the whole finally "marked up" with instructions for the platemaker and printer.

Repro

This includes all the components of a paste-up which already exist as line or halftone copy, and can include logotypes, trademarks, illustrations and text already scaled to size and in reproducible form. Repro is ready to be pasted into position on the artwork.

Rules, borders and boxes

These can be hand-drawn using technical or ruling pens, or applied to the artwork as self-adhesive strips or as pressure-sensitive transfers.

Hand-lettering

This technique is generally the province of the specialist typographer, calligrapher or hand-lettering artist, who will work from a brief or from rough designs to produce a unique title, headline, logotype, etc in a variety of calligraphic, hand-drawn lettering styles using a mixture of media from pen and ink to airbrush.

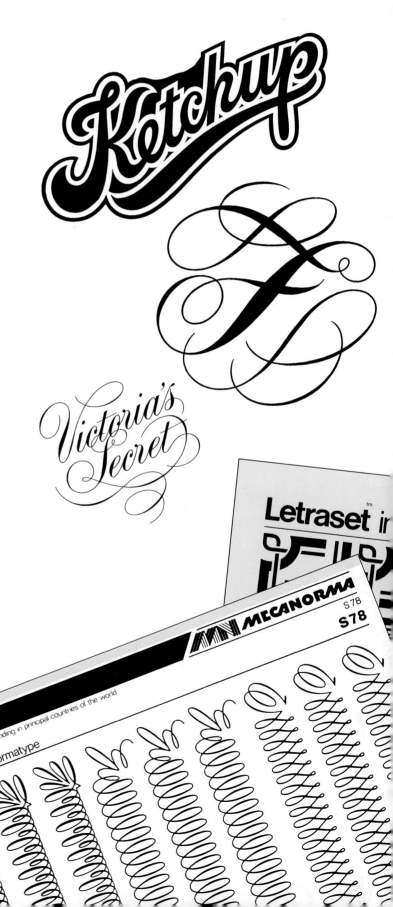

▼ Rubdown borders and lines

These are a quick and convenient, but not necessarily cheap, alternative to setting.

► Self-adhesive tapes

Border and special symbol tapes are available in a wide variety of colours, patterns and widths for creating rules, charts, diagrams and decorative devices.

Preparing for printing

When all the artwork components are to hand, they are pasted into position on a piece of line board, with components to be printed in non-black colours mounted on overlays carefully registered to the basic artwork. Artwork must contain any necessary crop marks and registration marks as well as an exact specification of the finished size. Text is usually pasted onto grids.

Illustrations

Line illustrations will need to be photographed (using a PMT camera) to scale ready for paste-up.

Contone (continuous tone) illustrations, such as photographs and water colour or airbrush paintings, need to be converted to halftones before they can be pasted up as artwork for the process camera or scanner.

Full-colour illustrations include colour photographic transparencies and flat full-colour art and are not included directly in the paste-up. Their position in the artwork is shown by an overlay, which is used to indicate the extent of the images and any special instructions about vignetting, tints and reversed-out text. In some cases keylines are drawn on the artwork to provide guidelines for the separated colour film to be stripped into position before platemaking.

Mark-up

The final stage in the preparation of camera-ready artwork is to add all the necessary instructions for the platemaker or printer. These will include details of any tints, drop-outs, vignettes and colours, and must identify the positions of all full-colour images that will be supplied as transparencies or flat art together with the artwork. Finally, the artwork must be clearly labelled with the designer's name and contact number and the job number or name.

Marking up

An example of a line illustration marked up for separation by the printer. An overlay has been supplied for each colourway and the finished printed picture is shown below.

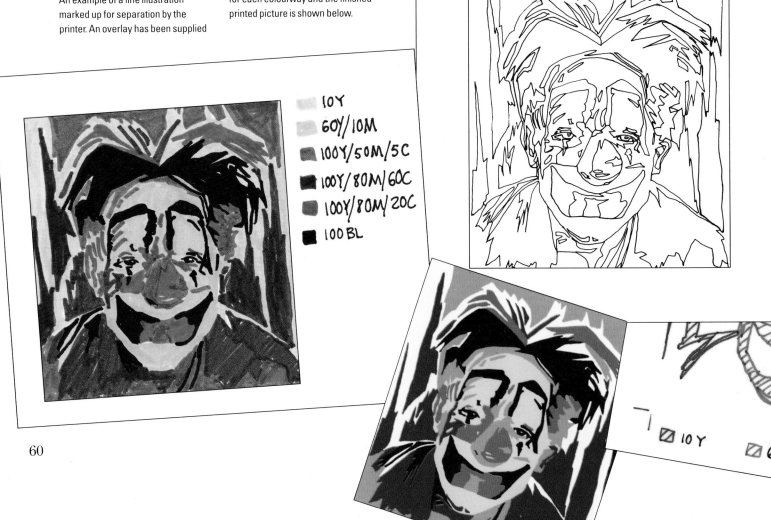

10Y
60Y/10M
100Y/50M/5C
100Y/80M/60C
100Y/80M/20C
100 BL

10Y
60

100Y/80M/20C

100Y/80M/60C

☑ 100 BLK

MPOSITION is the arrangement of pages so that when they are printed on both sides of a large sheet of paper and then trimmed and folded, they will run in the correct numerical order. Most printing machines will print in units of 8, 16, or 32 pages (or multiples of these) at a time. A large sheet, printed both sides, cut into double-pages and folded together, is known as a "signature". Correct imposition ensures that the pages within each signature run in the required order.

Imposition is planned by the printer and binder to make the most efficient use of presses and binding machinery, and will not concern the designer directly – unless the book, magazine, or document is to be made up of some parts in black or two colours, and some in full colour. In this case, the designer will need to see the imposition scheme in order to plan the "colour fall" which determines where full-colour illustrations can be used, and where single or two-colour printing is to be used.

Traditionally, imposition required the manual assembly of page art (generally as clear acetates or "foils" mounted together with tape). Nowadays, it can be carried out by means of electronic imposition devices controlled by a dedicated microcomputer that stores data on all the commonly used impositions, and prepares film or plates with allowances for trim and folding etc.

5	4
8	1

4	1
2	3

4-page signature

3	6
2	7

8-page signature

5	12	9	8
4	13	16	1

7	10	11	6
2	15	14	3

16-page signature

DESIGN, REPRO AND PRINT

An understanding of reproduction and print techniques is essential for any designer. An informed selection of paper, for example, is dependent upon the designer's knowledge of paper sizes, weights and finishes, as well as its suitability for the printing process to be used. Being in possession of at least a basic understanding of printing and reproduction technology will enable the designer to make full creative use of the technology available and to liase more effectively with production departments, printers and repro houses.

Repro

"Repro" is short for "reprographics", and describes the various processes by which the marked-up artwork is reproduced in a suitable form for platemaking and printing. Repro can be divided into three main areas, depending on whether the original art is line, continuous tone, or full colour.

Line

"Line art" describes originals that are monochrome (generally black and white), with no intermediate or graduated (continuous) tones. This is the simplest form of original art. Examples include pen and ink drawings, linocut and woodcut prints, engravings, rubber stamp prints, and typed or typeset text. Line art can be prepared for printing by:

● Photomechanical transfer (PMT) camera direct to film or paper bromide. This process involves the use of high-contrast film that reduces everything to either black or white. The film is developed to produce a line negative from which the printing plate is made. The original line art should be mounted with an overlay clearly marked with the required dimension of the final print.

● Process camera direct to film negative.

● Electronic scanning, using a monochrome "logo scanner". These systems scan the black and white original, digitize the image and display it on a monitor for sizing,

cropping, pixel editing (retouching) etc. (for a more complete description of electronic scanners, see "Electronic halftone" and "Colour scanning" p. 68).

Continuous tone (Contone)

This term refers to an original that has a full range of tones from black to white, such as a photograph, shaded pencil drawing, pen and ink wash, or airbrush drawing. Contone originals can only be reproduced exactly by photographic prints. A printing press cannot print a range of greys or indeed any intermediate tones, only a solid colour, such as black. Contone originals must be converted into line art before they can be printed, and this is done by reducing the continuous tones to "halftones". This can be done by photographic or electronic means.

Photographic halftones

These can be produced by two methods, each of which involves the use of a screen:

Glass screens contain a fine engraved grid of opaque lines, and are graded according to the number of lines they contain per inch (or centimetre). The more lines, the higher the resolution of the halftone. For example, 55 lpi (lines per inch) screens are used to prepare halftones for printing on coarse, absorbent paper such as newsprint; 150 lpi screens are used for printing on fine coated papers. The glass screen is positioned between the original and the unexposed film in a process or PMT camera, generally 2-3mm away from the surface of the original in order that light reflected from it has space to spread slightly before passing through the screen and exposing the film. The spread of light passing through

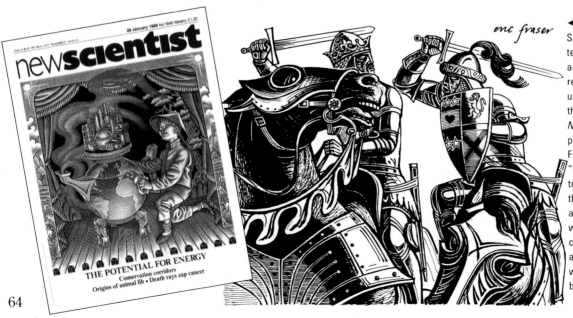

◀ **Line art**
Scraperboard (far left) is a technique that produces crisp line art. Here, Bill Sanderson (who rediscovered this old technique) uses watercolour washes to add the extra dimension of colour to this *New Scientist* cover. In the classic pen and ink drawing (left) Eric Fraser makes use of a variety of "hatchings" to add the illusion of tone. The advantage of line art is that it reproduces exactly as the artist intended. Line art reproduces well on a wide range of papers, and can be used on uncoated, absorbent papers (like newsprint) where halftone dots would tend to bleed together.

the screen varies according to the intensity of light reflected from the original, so that areas of highlight reflect strongly, flooding the screen and causing an image of very small white dots to be formed on the negative (the white dots are caused by the intersecting opaque lines of the screen). Mid-tone areas reflect less light, resulting in an even distribution of exposed black areas and white unexposed areas, and so on.

Contact (or "vignette") screens consist of a pattern of opaque dots. These dots are "vignetted" – i.e. they have solid centres, but fade gradually to clear glass. Vignetted screens are placed in direct contact with the film emulsion, the size of dot exposed corresponding to the intensity of light reflected from the original.

55 lines

85 lines

100 lines

120 lines

150 lines

175 lines

▲ Halftone screens
The choice of screen resolution for halftones (measured in lines per inch) depends upon the chosen printing stock (type of paper) and the printing process.

90° angle

45° angle

▲ Screen angles
The eye can detect patterns that are organized along horizontal and vertical axes much more easily than patterns that are at 45°.

▶ Halftone vignettes
These used to be produced by airbrushing on the original art. Now vignettes are produced using electronically generated masks.

Both types of screen have the same effect: to reduce a continuous-tone image to a halftone (the term derives from the idea that the screen removed about half of the full tone original) – an image comprised of many hundreds of solid black and white dots of different sizes. For monochrome halftones, screens are positioned so that the lines of dots are formed at 45 degrees to the vertical (the eye is very conscious of horizontal and vertical grid patterns).

Electronic halftones

The flatbed monochrome scanner is the digital equivalent of the process camera. The scanner creates a halftone by shining a fine light beam at the image and measuring whether the reflection is strong or weak – i.e. whether it should be black or white. Highlights and shadows are determined automatically by an imaging sensor. Electronic dot-generation techniques allow the operator to specify the dot shape (round, square or elliptical).

Flatbed scanners use an array of up to 4,096 charge-coupled devices (CCDs), which are basically microchips with a light-sensitive window. These are designed to detect light from a focussed image as a series of points (roughly equivalent to pixels), and turn them into a digital description of the page. The first all-digital scanners were introduced in 1988, and these can scan contone copy at up to 750 dpi. Line copy can be scanned at about twice this resolution.

Colour repro

Full-colour continuous-tone images must be separated into their constituent primary colours before they can be printed by any of the major printing processes. From the theories of light and colour vision developed by Young, Helmholtz and Maxwell in the nineteenth century, the "trichromatic" theory of colour separation was adapted as the standard method for both colour photography and colour printing. This theory is based on optical colour mixing – i.e. if a full-colour image is printed using only its primary constituent colours, and these colours are printed in very small dots, it is perceived as having virtually a full range of colours and tones. The mixing of primaries to make secondary and tertiary colours takes place in the eye. The Impressionist and, more especially, the Pointillist painters,

◀ **Additive colour mixing**
Optical colour mixes (additions) of the three primaries red, blue and green, produce white light. Where two of the primaries mix, a secondary colour is produced. Yellow, cyan and magenta, the secondaries produced by additive mixing are the three process colours used for printing.

▶ **Subtractive colour mixing**
Pigments of yellow, magenta and cyan can be overprinted to produce a wide range of secondary and tertiary colours. Mixing all three process colours produces a "theoretical" black. In practice black is overprinted to deepen and enrich the contrast.

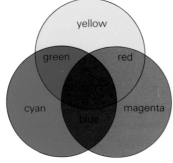

such as Seurat and Signac, made use of this theory of optical colour mixing to produce their paintings, as did early experimenters with colour photography, such as du Hauron and Lumière. In printing, four colour separations – one each for the subtractive primaries of cyan, magenta and yellow, and one for black – are used. The extra "black" separation is made using a yellow or combined CMY filter to improve tonal contrast and to deepen shadow areas of the image. The four-colour method is called "process colour".

Nowadays, full-colour images (such as photographic transparencies and prints) can be processed either photomechanically, using a process camera and photographic colour filters; or electronically, using a scanner.

Photographic colour separations
By photographing a piece of original colour art through four filters, four different "separations" are made. This results in four negatives, each carrying the colour information for the cyan, yellow, magenta and black portions of the original image. Because these are continuous-tone negatives (reflecting the tones of the original art), they must then be screened to convert them to halftones. Separation and screening may be carried out together ("direct" method) or individually ("indirect" method).

Screen angles
Great care must be taken with halftone screening to ensure that unacceptable moiré patterns do not emerge when the four patterns of colour dots are overprinted. Because the

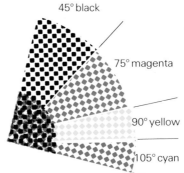

◀ **Screen angles**
The four colour separations must be carefully screened to produce halftone dot patterns that do not clash and form moiré interference.

▼ **Halftone dots**
The enlarged section of the transparency clearly shows the overlapping pattern of halftone dots.

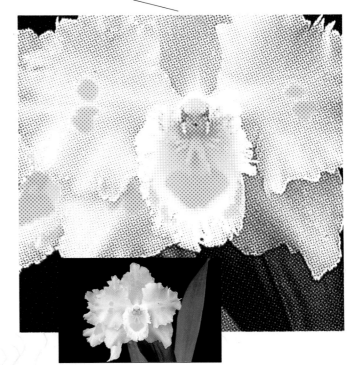

correction, and the main intention is to achieve a range of correct densities to accurately reproduce the original image. This can be done by careful hand retouching, using an airbrush and coloured dyes of different strengths to increase density, or by using special reducers to achieve the opposite effect. Photographic masks are also used to increase or decrease the density of parts of the separated films. Once the separations have been screened, colour correction can be achieved only by using a dot-etching process to alter the size of the halftone dots.

In high-speed colour printing, where the four colours are printed sequentially on the same press, it is sometimes desirable to reduce the amount of overprinting by removing unwanted colour from beneath the black printing areas. This process is called undercolour removal (UCR), and is also achieved by photographic masking.

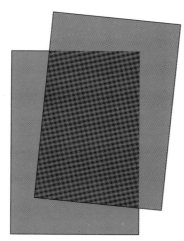

▲ Moiré
Poor screening of colour separations can result in unacceptable interference patterns called moiré patterns or screen clash.

least dominant colour is yellow, this is screened at the most visible angle, 90 degrees. The most dominant colour, black, is screened at 45 degrees, magenta at 75 degrees and cyan at 105 degrees. These angles result in the least obtrusive pattern when the four colours are finally printed. (Note that screen angles will vary slightly.

"Direct" and "indirect" methods

In the "direct" method, the original art is screened at the negative stage in a single operation. In the "indirect" method, the negative is made first, then screened to produce the halftone. The direct method has advantages of speed, and therefore lower cost, while in the indirect method, because the separated negative is held in continuous tone, it is more easily enlarged or reduced. The indirect method allows the negatives to be retouched to achieve a more accurate balance of colour densities.

Colour correction

In theory, each of the three colour filters should absorb completely one of the (additive or RGB) primary colours being reflected from the artwork, while perfectly transmitting the other two primaries. However, because filtration, and more especially printing inks, are not perfect, it is virtually impossible to produce a satisfactory reproduction with colour-separation photography alone. And so it is necessary to modify the negatives by using photographic masks or by hand retouching. This process is called colour

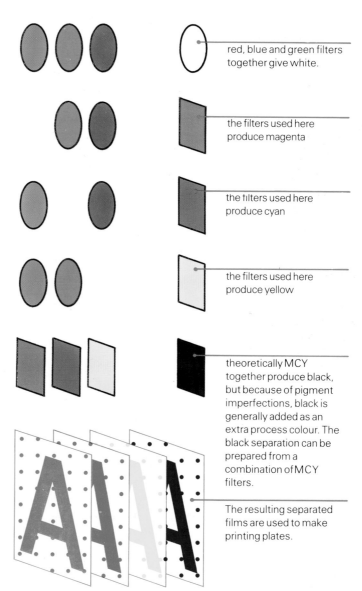

red, blue and green filters together give white.

the filters used here produce magenta

the filters used here produce cyan

the filters used here produce yellow

theoretically MCY together produce black, but because of pigment imperfections, black is generally added as an extra process colour. The black separation can be prepared from a combination of MCY filters.

The resulting separated films are used to make printing plates.

Colour separation by electronic scanning

This is rapidly becoming the dominant method of creating colour separations. Because it is largely a digital process, methods for colour correction can be integrated with the colour separation and screening operation, eliminating the need for expensive manual colour correction. Electronic scanners are of two main types: drum and flatbed, and use two sources of illumination, either lasers or charge-coupled devices (CCDs).

Drum scanners

The first drum scanners were introduced in 1963 and used analogue scanning techniques to capture the continuous tones of the original art. Modern drum scanners convert the analogue signals into digital code, giving the scanner operator all the image-processing advantages of digital computing. These include re-scaling, cropping, positioning, rotating, reorientation, pixel editing, electronic masking

and electric dot generation, as well as the use of pre-programmed colour look-up tables (CLUTS) to allow adjustments of the separations for different print processes, paper stocks, paper colours and inks. Digital data from drum scanners is stored on large-capacity hard disks and used either directly to drive the drum output (a larger-diameter drum on which light-sensitive film is exposed to produce the final separations), or indirectly through an electronic page-composition system. This latter system comprises a powerful computer with digit-pad input and a high-resolution

◄ Drum scanner
A laserbeam scans the art and produces a set of digital colour separations which are stored on large capacity hard disks. These can be processed before they are output to film.

▲ Preview system
The scanned image can be previewed on a high resolution monitor to check image quality.

monitor, and is used to plot page layouts – allowing complex juxtapositions, vignettes and image montage to be produced accurately, with great savings of time over traditional hand-stripping methods.

Flatbed CCD scanners

These scanners have a flat glass bed (or platen) on which the image is placed, and which moves over a light source, exposing every part of the original. Both transmission and reflection illumination are catered for. Introduced in 1988, flatbed CCD scanners may replace drum/photomultiplier technology – they do not require the heavyweight precision

engineering of drum scanners and are therefore cheaper; and because they are entirely digital they lend themselves more easily to the ongoing integration of the whole pre-press process. They are also amenable to the use of artificial intelligence techniques, making them easier to operate.

Colour correction is semi-automatic – the scanner is told the film material of the original and the printing process to be used. It can then select the correct colour look-up table, assess what is wrong with the original image in terms of colour casts, underexposure, etc, and compensate accordingly. Different programs are available for each printing process, and compensations can be made for tinted papers.

THE PLATEMAKING PROCESS varies according to the method of printing, but normally, corrected, separated and screened negatives are exposed against a plate with a photosensitive coating, which is then prepared in one of the following ways for letterpress or litho:

● Letterpress plates of zinc, copper, plastic or magnesium are treated so that the photographic image is rendered acid-resistant. The photosensitive coating of the plate hardens under exposure to light, and acid is used to etch away the unwanted, non-printing parts of the image. This results in a relief image which can then be either mounted on a wood, metal or plastic block so that it is the same height as type (0.918 inches), or duplicated to make a flexible or curved plate for rotary-letterpress printing. (See p.80).

● Litho plates may be metal, plastic or paper. After exposure, the image is processed chemically so that the image area is greasy and will accept ink, and the non-printing area will accept water but not ink. (See p.76).

● Gravure plates are usually of steel coated with copper and are produced either by photo-engraving or electro- mechanical engraving. (See p.78).

Halftone screens are created by using electronic dot generation (EDG), where the operator has control of screen rulings (the number of dots per inch), and dot size and shape (round, elliptical, square).

Advantages of electronic scanning

By substantially de-skilling aspects of the colour repro process, and by offering virtually automatic colour correction, electronic scanners produce cheaper separations. Scanning technology is developing very rapidly. Different manufacturers use different techniques, and produce equipment with different features. The following list summarizes these features: scaling (enlarge or reduce by around -15 per cent to +2,500 per cent, depending on size and quality of original), cropping, sharpening of grainy originals, selection of screen ruling (around 65 to 150 lpi), dot size and dot shape by electronic dot generation, correction of colour cast, density, gradation (both locally and globally), rotation, and the addition of colour tints, rules, borders, registration marks, and job reference numbers and dates. Many scanners have video screens for monitoring colour separation, and digit pads for easier input of image size and position.

The trend in pre-press is towards the integration of scanning and page composition within "image assembly systems", with output to film or direct to plate. Such systems will allow the designer/operator online interactive control over the entire range of image input, typesetting page layout, colour separation and platemaking.

▲ Progressive proofs
Progressives show the printed sequence of process colours. A complete set of progressives includes proofs of the individual colours, and the colours as they are progressively overprinted. They are used in conjunction with the colour bar (see next page) to check colour balance and registration.

Proofing

Proofs are the initial trial prints made by the printer to check for registration, correct size, orientation, colour balance, blemishes and other possible inaccuracies. They can be obtained either as scatter proofs – colour images printed in random order, unrelated to the specified final layout, or position proofs, in which images are printed in their correct layout positions. These proofs are generally prepared on a proofing press.

Pre-press proofs

Proofs can also be made from the screened separations using photographic overlay or transfer systems. This is a normal procedure for full-colour continuous tone copy, and provides an accurate guide for colour correction. The cost of a transfer proof is small in relation to the plate-making costs, and pre-press proofs made with the photographic transfer process can be prepared in around 30 minutes. There are two methods: the older overlay system, now falling into disuse, consists of four sheets of acetate, one for each of the CMYK colours, which are overlaid to produce the final proof. The superior transfer system produces high-quality proofs on a single sheet of paper, and is the most usual method of pre-press proofing. Both pre-press and press proofs are checked against a standard colour bar for accuracy of reproduction.

Photographic transfer proofs

Several systems are available that use either negative or positive separations – including Agfa Gevaproof, Agfaproof, 3M Matchprint and Du Pont Cromalin. The latter process involves selecting a suitable paper from a range of different finishes (to approximate to the final printing stock) and coating the paper with ultraviolet-sensitive film. The cyan film separation is then mounted over the sensitized film and

exposed to UV light in a vacuum bed. The UV light causes the image areas to adhere to the paper, and the remaining unexposed areas are stripped away. The paper is then coated with cyan dye which adheres only to the image areas, and its application can be controlled to simulate the different print processes. The paper is then recoated with sensitive film, the magenta separated film mounted in register, and the process repeated. Colours are exposed and coated one at a

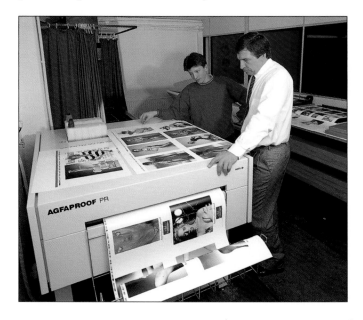

▲ **Pre-press proofs**
The Agfaproof system is one of several transfer proof systems. Pre-press proofs are made directly from the scanned colour separations.

They are very accurate, quick and relatively cheap, and because they are produced before the plate-making process, alterations are less expensive.

time, an A3 sheet for a single proof taking around 30 minutes to complete with all four colours. The result is a full-colour photographic facsimile of the reproduced image. Photographic transfer proofing systems allow the skilled repro technician to accurately predict the effects of printing the image using different processes and paper stocks. One of the most important considerations is "dot gain" – the phenomenon in which the size of each halftone dot alters according to the printing process and paper stock used (often by as much as 20 percent in web-fed litho printing on to newsprint).

▶ **Colour bar**
Colour bars are the standard means by which the designer, repro house and printer can assess the quality of the proofed colour image. The bar includes devices for checking the relative strengths of colours, their consistency across the plate, their register, screens, tints and dot gain.

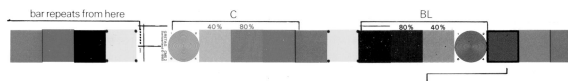

bar repeats from here C BL
40% 80% 80% 40%

3 col grey made up to check any bias toward one colour

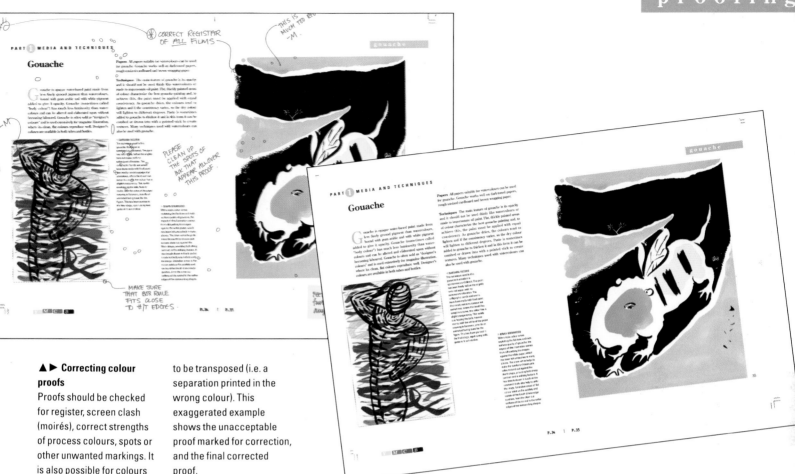

▲ ► Correcting colour proofs
Proofs should be checked for register, screen clash (moirés), correct strengths of process colours, spots or other unwanted markings. It is also possible for colours to be transposed (i.e. a separation printed in the wrong colour). This exaggerated example shows the unacceptable proof marked for correction, and the final corrected proof.

Allowances for dot gain are made during the scanning process and can be checked by means of a pre-press proof.

Electrostatic colour proofing

Although photographic transfer proofs are accurate for colour correction purposes, and although some photographic systems allow colour proofs to be made on the actual printing stock, the new electrostatic methods offer considerable advantages in accuracy, ease of use, and, importantly, in speed of production. Electrostatic systems can accurately meet both sheet and web configurations on any material used for printing, from cheap newsprint to heavy, coated art board. The toner colours can be adjusted to give densities to match all the printing processes.

The process is as follows: the negative charging of a special plate makes it sensitive to light. Exposure of the plate through the screened separations removes the electrical charge from exposed areas so that the charged image areas attract coloured toner (which has an opposite charge). The toner has a charge that can be controlled by the operator to allow thicker densities of toner to be applied to the image to simulate the different types of printing process. The toner image is then transferred first to a transfer sheet, then to the final printing stock, by means of electrostatic voltage changes (a form of pressureless printing). Each colour is applied in sequence, and the toner finally fixed. A gloss finish can be applied to the final proof, which can be ready in five minutes. Such savings in time over the photographic proofing systems, although currently offset by the high cost, will probably ensure its ascendancy in the future.

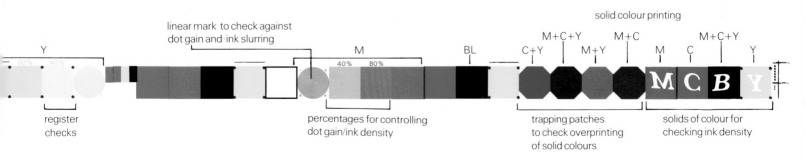

solid colour printing

linear mark to check against
dot gain and ink slurring

register
checks

percentages for controlling
dot gain/ink density

trapping patches
to check overprinting
of solid colours

solids of colour for
checking ink density

Paper

A knowledge of paper is important to the designer for two main reasons: firstly, it is available in a wide range of weights, sizes and finishes, and an intelligent selection of a particular paper must take into consideration which of these variables is both aesthetically and practically suitable for the job in hand and the printing process to be used; and secondly, it is a major component of the final print cost (for example, about 20 per cent of the production cost of a book is for paper).

Specifying paper

There are two main factors to consider when specifying paper: Size – specified in millimetres, inches, or for smaller sizes, in DIN (Deutsche Industrie Normen) and A sizes. Substance (weight) – in the UK and most of Europe, this is described in terms of grammes per square metre (i.e. a square metre of paper weighed in grammes). In the USA and some other parts of the world substance is described as the weight (in pounds) of a ream (500 sheets) of a given standard paper size.

Choosing paper

This depends on the following factors: budget; application (mode of use); intended readership; type of artwork; required aesthetic effect; and method of printing.

Budget

The total production budget (i.e. for origination, typesetting, design, repro and print) may not be controlled by the designer, but the choice of paper will obviously influence it, and must be made within its constraints.

Application

Both the function of the printed artifact, and how it will be used, must be considered. For example, the choice of paper for a mass-produced novel will be based on opacity, weight, a suitable surface for the printed text, etc., as well as on cost. More expensive full-colour books will need paper with a sufficiently smooth surface and reflectivity (whiteness and shine) to reproduce fine colour images. Book jackets may be high gloss, and of increased weight and resilience to cope with both cover illustrations and handling. Cookbooks and other technical documentation – nautical pilot books or car maintenance manuals, for example – should ideally have a coated, wipeable finish. Packaging needs to be optimally robust, as well as suitable for the required print process. Posters need to be weather-resistant, leaflets light and cheap to produce, and so on.

Intended readership

This factor has practical as well as aesthetic implications. For example, children's books may need to be of tough, wipeable, heavy paper, while a limited-circulation art journal may call for the luxury of a variety of papers with different tactile qualities, such as rough cartridge finishes for the reproduction of line illustrations and coated paper for the reproduction of full-colour paintings.

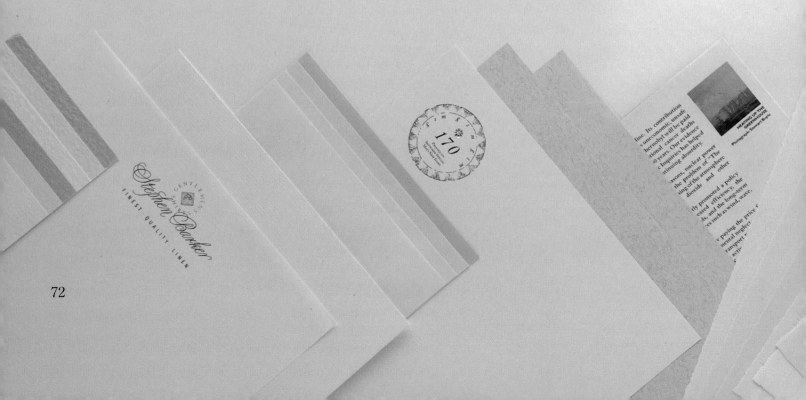

Type of artwork

In some cases the type of original images to be reproduced will determine the type of paper. Newsprint, for example, will provide nothing like the same image quality for full-colour work as a bright, white, coated paper. Conversely, a reproduction of a line original, such as an etching, may be more successful on an appropriately textured, matt paper. When artwork is used in newspapers, the absorbency of newsprint is compensated for by the use of coarser screenings of halftones and tints.

Aesthetic effect

This consideration is closely related to those of application and intended readership. However, apart from providing a suitable material for the text and images to be printed on, the paper surface has visual and tactile qualities that will have an impact on the reader, and can be used by the designer to reinforce or counterpoint the communicated content. For example, a book of Burne Hogarth's "Tarzan" illustrations was reproduced on top-quality coated art paper. These full-colour illustrations were originally designed to be printed on, and read from, cheap newsprint. The glossy paper, although superbly reproducing the illustrations, had nothing like the attraction, or feel, of the original comic books.

Method of printing

Finally, the choice of paper must be suitable for the printing method used. There is great latitude here, as modern offset presses are capable of reproducing work on a wide variety of textures and weights of paper. It is always best to discuss with the printer the choice of paper.

PAPER IS CATEGORIZED according to factors such as weight, size, grain and mode of use.

- Newsprint. Machine-finished paper made largely with ground wood pulp, and produced in a range of qualities and weights. Used for newspapers, cheaper magazines, paper-back books, etc.
- Mechanical Papers. These contain a large proportion of mechanically produced wood pulp, plus chemical pulp for strength. Different finishes are available, including super calendering (SC), machine finish (on-machine calendering, MF), machine glazing (MG), or sized. Used for cheaper magazines, leaflets, etc.
- Wood-free (or chemical) papers. These *do* contain wood pulp, but it is chemically processed, resulting in a strong white paper which is processed as writing papers, bond, ledger or bank, business paper and airmail paper.
- Cover papers. Stiff, heavyweight paper produced in a variety of finishes for magazine, book and catalogue covers.
- Cartridge. Strong, sized papers with rough surfaces used for a variety of purposes (originally used in gun cartridges).
- Book papers. Produced not only for books, but for a wide range of reading material (excluding newspapers and cheaper magazines) in a variety of weights and finishes.
- Antique Rough. Uncoated paper, with a finish similar to that of handmade papers. Not suitable for fine halftones, but excellent for type and line illustrations.
- Eggshell. Smooth, matt-finish, uncoated paper.
- Machine Finish (MF). Calendered to produce a low-bulk, smooth-surfaced paper suitable for lengthy text books.
- Blade-coated. Smooth, dull finish with thin coating, used for quality magazine and book work as it is suitable for both halftones and colour.
- Cast-coated. Very high gloss, medium to heavy-weight paper used for prestige packaging, covers for company reports or presentations.

Printing inks and bindings

There are two main ways in which the graphic designer is intimately involved in the selection of printing inks. These are: in the specification of colours (precise tints for spot colour, process colours etc); and in the specification of the material qualities that the inks should have for a particular print application (finish, durability, weatherproofing etc).

Specifying colour

Colour can be specified in several ways. Spot colour is specified by means of colour swatches, colour-matching systems or percentages of process colours. Colour-matching systems such as Pantone provide the designer with a set of matched colour materials for use in rough designs (markers); in finished/presentation roughs (colour-tinted papers and films); and in printing inks. Using such a system ensures that the original colours used for roughs and visuals will appear in the final printed work. The Pantone system covers the full range of colours that it is possible to create using the four-colour process, and colour charts and swatches show how the various combinations of percentage tints of cyan, magenta and yellow will appear when printed. Note that repro separations, dot gain, and other pressroom factors may cause slight deviations from the system colours. Printing on colour papers, and the choice of coated or uncoated papers, will also affect the final printed appearance of the specified colour. For special effects, such as metallic and fluorescent colours, which cannot be created by means of process colours, consult with the printer.

Ink types

A wide range of inks are available for applications that demand specific ink qualities. The range includes inks specially prepared for printing newspapers, which are made of low-cost pigment and mineral oils, and generally dried by absorption into the uncoated newsprint; quick-setting inks designed for multicolour litho or letterpress, where each colour must dry almost immediately to avoid any image "set-off" onto the following colour plate; and moisture-set inks that work by precipitation when subjected to a fine water spray. The latter are relatively odour-free, and are used in the printing of food packaging. Other types of ink include those that are especially durable and scuff-resistant (for labels, cartons or other types of packaging); watercolour inks (for wallpapers and cheap greeting cards); wax-set inks (for printing waxed wrapping paper); magnetic (for machine-readable cheques and credit cards); metallic, in which metallic powders are suspended in the vehicle and binder; heat-set – another fast-drying ink designed for heated printing presses to allow very high-speed, long-run printing; high gloss – used for letterpress and litho printing on glossy, coated papers and boards; and fluorescent inks, which are available in a limited range of colours and mostly used for screenprinting signs and posters.

Finishing processes

Various services can be provided by the printer in addition to printing. Some can be performed on-press during a print run,

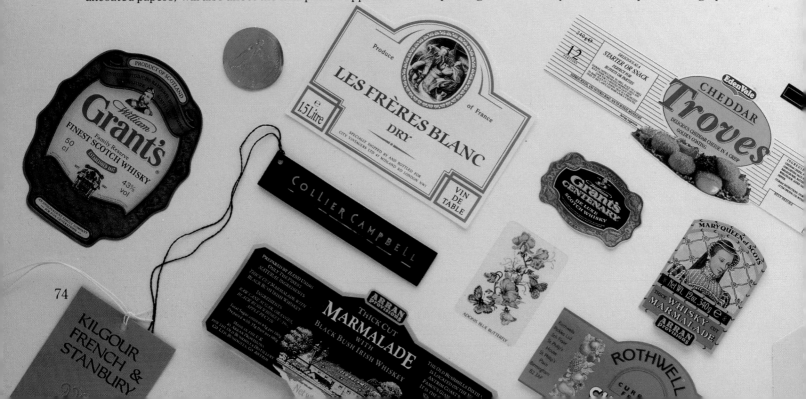

others use special presses or other equipment. Collectively these processes are known as "finishing". They include: cutting and collating; scoring, perforation and folding; embossing; thermography (embossing without using engraved matrices, often used for business cards and stationery); die-cutting, cartons and rounded corners (processing regular and irregular shapes); blocking (used to stamp an impression onto card, spines and covers of cloth-bound books); varnishing and lamination (gloss finishes are produced by applying varnish or lacquer after printing); wrapping and labelling (the finished product can be bag-wrapped in plastic and recipient's address automatically printed onto prepared panel).

Binding

The designer's choice of a binding method and materials is conditioned by a number of aesthetic, practical and ergonomic factors. These include the consideration of what the book is for and how it is to be used; the length of the print run; whether the book or document has to open flat; whether a permanent or temporary binding is required; the unit costs of different binding methods; and what sort of binding has a suitable "look and feel" for the publication. The main binding methods have been listed below, covering the range from short-run/temporary to long-run/permanent options.

Short-run/temporary methods

These involve mechanically fixing the pages of a document together with plastic or metal fasteners, and include: slide-on plastic spines (temporary binding of small documents, does not open flat); ring binders (documents that need to be updated or to open flat); spiral and comb binding (documents that need to open flat, often used for presentation documents and short-run reports); stapling or saddle wire stitching (cheep and efficient for small number of pages, document does not open flat); side stitching (small number of pages, document does not open flat).

Long-run/permanent binding

Perfect binding is the method used to bind most paperback books and glossy magazines, and involves gluing the spine edges of the document pages together as a "butt" joint. If an extra-strong binding is required, a strip of fabric gauze is added to the glued spine. Finally a paper jacket is glued to the spine, and the whole unit trimmed to its final size. Covers of board or cloth can also be used, but these are applied after trimming.

Edition or case binding is the conventional method for hard-cover books, and provides a permanent (relatively expensive) binding. The printed pages are folded and gathered into sections in the order of their signatures (indicated by reference numbers printed in the foot margin of the first page of each section) and then stitched together either through the centre folds of each signature, or side-sewn (the thread passes through the entire book from front to back, about 4 mm in from the centre fold). End-papers are then glued to the gutter edge of the first and last signatures. These end-papers must be made of heavier stock than the text paper, as they bond the book and its cover. The book is trimmed on three sides and glue added to the spine to reinforce the stitching. Finally the prefabricated cover (made of cloth-covered board) is glued to the end-papers – "casing in" – and dried in an hydraulic press.

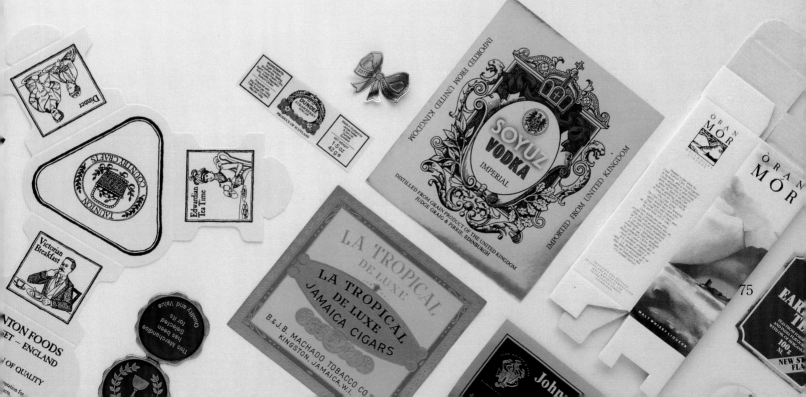

75

Lithography and gravure

Lithography is now the predominant printing process. Invented in 1796 by Alois Senefelder in Bavaria, it became a favourite medium of book illustrators and poster designers during the nineteenth century, but it was not until the 1920s that any considerable commercial litho printing was practised, and not until after the Second World War that it became a major printing industry. The main advantages of litho are that it is a relatively cheap and very efficient method of printing both high quality text and images in black and white and colour.

The lithographic process

Lithography means "stone-writing", and it is a planographic (flat-plate) process based on the principle that grease and water do not mix. Prints are obtained by dividing the flat surface of a plate into grease-receptive (printing) areas, and water-receptive (non-printing) areas. The plate is then made wet with water so that the non-printing areas repel ink. Ink is applied, which adheres only to the printing areas, and paper is pressed onto the plate, transferring the image and forming the printed reproduction.

Offset litho

Modern litho presses use the rotary offset method, whereby the inked image is transferred (offset) to the rubber surface (blanket) of a rotating metal cylinder and only then brought into contact with the paper. Offset methods prolong plate life, and bring less water into contact with the paper. The resilient rubber cylinder enables finer copy to be printed onto rough paper surfaces, and the printing process is much faster than traditional lithography.

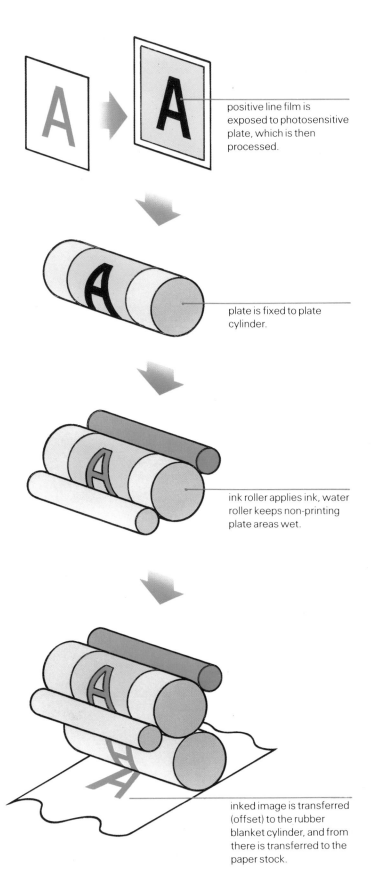

positive line film is exposed to photosensitive plate, which is then processed.

plate is fixed to plate cylinder.

ink roller applies ink, water roller keeps non-printing plate areas wet.

inked image is transferred (offset) to the rubber blanket cylinder, and from there is transferred to the paper stock.

▲ **Flat plates**
Litho plates are planographic, which means that the image and the non-printing area share the same flat surface. The fact that grease and water do not mix is used to make the (greasy) image attractive to the printing ink, while the wet non-printing area repels the ink.

Sheet-fed offset
Sheet-fed litho is used for short to medium print runs.

Web-fed offset
Web-fed offset is employed for medium to long print runs.

Offset presses are of two main types, depending on whether they print on sheets or continuous reels of paper. These machines may print on one side of the paper only or on both sides (the latter is known as "perfector" press): The most sophisticated offset machines will print four process colours on both sides of the paper in one pass through the press, and some also fold and gloss-finish the paper.

Sheet-fed offset

Sheet-fed presses are available in a range of sizes, accommodating paper sizes from A4 to larger than twice A0. "Small offset" machines are used by "instant printing" bureaux, in-house printing facilities and small jobbing printers for a variety of black and white and two-colour tasks, including general office duplication, letterheads, business cards and leaflets, in relatively short runs of up to about 5,000. These machines often use disposable paper printing plates. Larger machines (taking paper sizes up to A0) will generally print in two or more colours, and are used for medium-run (5,000 to 20,000 copies) general colour printing. The largest sheet-fed presses will take paper sizes of twice A0 (or larger), and are used for long runs of up to 100,000. Process colour ("multi-colour") machines will print all four process colours sequentially by means of four printing heads.

Throughput for sheet-fed presses is between 4,000 to 12,000 sheets per hour, and they are capable of a very wide range of printing applications. However, for very long-run multi-colour work, such as holiday brochures and magazines, presses that are fed from a large reel of paper are faster and more economical. These are known as web-fed presses.

Web-fed offset

Web-fed offset machines print onto a continuous band (web) of paper fed into the press from a large reel. The web passes through several printing heads, a drying chamber and a folding machine on its way through the press. In one such "pass", the web may be printed in full colour on both sides (each impression comprising 16 A4 pages), and be delivered dried and folded – at up to 50,000 impressions per hour.

The very high print speeds possible with web-fed presses are a result of dispensing with the time consuming process of manipulating single sheets of paper between each printing operation. Other advantages of web-fed printing include the fact that paper is cheaper in reel form, and that folding and various other finishing operations, such as gluing, perforation and gloss coating, may be included in the print process. Due to the large scale of production, press "make ready" times can be lengthy, and the larger web-fed presses are only economical for long or very long runs. Another disadvantage is the paper wastage, caused either in preliminary print runs or in trimming. Smaller web-fed ("mini-web") presses that print only eight full-colour A4 pages at a time are more economical for shorter runs. The term "mini-web" also describes specialist bookwork presses designed to print 32 or 64 pages in black only, and this is the process used to print most text-based books (such as novels).

Origination for litho

One of the reasons why litho has become the dominant print medium is that litho plates are both cheap and simple to prepare. As with all printing media, original copy must be in line form (i.e. black and white with no intermediate or graduated tones), so typesetting in the form of bromide galleys, complete page makeup in the form of imageset bromides, and any separate repro components – such as halftones, display type, logos, etc., are all pasted down into position and marked up ready for the process camera. Often, line components and halftones will be produced separately

and "stripped in" to make a film line positive (foil) of the complete artwork. Before platemaking, the film images of separate pages must be placed in the positions they will occupy on the printing plate. After the imposition stage (see p.61), Ozalid (or "blueprint") proofs are made so that the client can see exactly how the job will appear when printed.

Platemaking

When the Ozalid proofs have been approved, and any necessary corrections made, plates can be produced from the imposed foils. Litho plates have a uniform granular surface, designed both to help the image adhere to the plate, and to increase its surface area, thereby increasing its water-carrying properties. The photographic plate image is formed by exposure of a photosensitive diazo or photopolymer resin which is oleophilic (grease-sensitive), and is capable of producing 200,000 copies or more on press. The pre-sensitized litho plate is placed in a vacuum frame, the imposed foil positioned over it, and the plate exposed. Exposure to artificial light has the effect of hardening the image areas, leaving the non-printing areas soft. These unwanted parts are removed during the (generally automatic) developing and washing process, after which the image areas will be grease-sensitive (accepting ink but repelling water), while the non-printing areas will accept water but not the greasy ink. Plates can be heat-treated to give a longer life. Non-image areas are treated with gum arabic to make them receptive to water.

Printing

After processing, the plate is fitted to the cylinder of the offset press, where it is first dampened then inked. The inked plate image is transferred by contact pressure to the cylinder, and thence to paper ("offsetting" the image from the plate). Most modern presses incorporate a computer-controlled monitoring process, to check register, ink and damper settings.

Gravure

Gravure is an intaglio process, similar in principle to etching. The gravure plate is made photographically. First, a continuous-tone (unscreened) positive film (or set of separated films for colour work) is made from the original art. If type is to be combined with images, the typematter is photographed onto line negative, and a contone negative of the image produced. Both type and image are then printed onto a combined positive film. This film image is then transferred to a gelatin transfer medium ("carbon tissue") which has been previously screened with a 150 line glass screen. The screen is composed of small, opaque squares separated by transparent lines. During exposure of the gelatin through the film positive, the light passing through the non-printing and pale areas of the image causes the gelatin to harden. The gelatin transfer is then laid around the electroplated steel cylinder (the plate), and developed to wash away any soft areas of gelatin. This results in gelatin of a thickness corresponding to the tonal values of the image

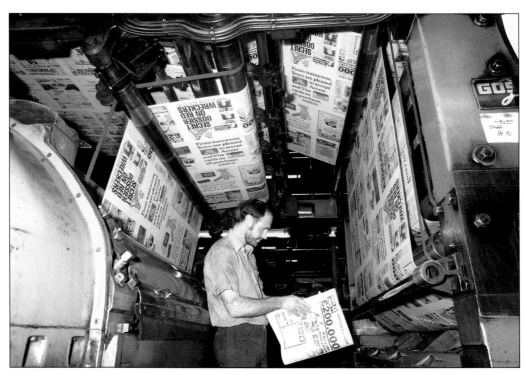

▶ **Rotary presses**
Huge web-fed rotary presses are used in newspaper and magazine production, where high speed and large volume runs, often in full colour, have to be produced literally overnight. Such presses are monitored continuously, both by skilled printers, and increasingly by computer-controlled sensors situated at strategic points in the press, to check ink flow and density, register and image quality.

(i.e. of varying thickness) being deposited on the cylinder. Subsequent etching with ferric chloride penetrates the metal to a depth determined by the resistance of the gelatin coating. The result is the production of cells of differing depths. Deep cells are produced where the gelatin is thinnest (i.e. in the darkest portions of the image), and shallow cells where the image is of a light tone.

More recent gravure techniques use the halftone principle whereby the size and depth of the cells vary. The latest technologies involve electromagnetic engraving with a diamond or laser cutting tool controlled by a computer attached to a scanning head, which "reads" the image and adjusts the engraving accordingly. Electronic engraving is

◄ **Gravure plates**
There are three types: (top) conventional plates that have the same size cells with variable depth; (centre) variable surface/variable depth plates with cells of variable size and depth and (bottom) variable area direct transfer plates that have cells of the same depth but of variable size.

cheaper and more accurate than the earlier chemical methods, and enables the gravure process to operate competitively at shorter print runs.

Gravure printing

When the plate is ready, liquid ink is applied, filling the cellular impressions. Excess ink is removed by means of a "doctor" blade, and paper is fed through the press on rubber-covered cylinders. These press the paper into the cell recesses, picking up the ink to form a printed image. Because there is more ink in the deeper cells, a blacker image is formed on the paper in those areas. Gravure is superior in this respect to litho or letterpress, and is used for the high-quality reproduction of photographs and paintings, as well as glossy full-colour magazines and books.

Gravure presses are usually very large web-fed machines, printing up to 128 A4 pages at speeds of 50,000

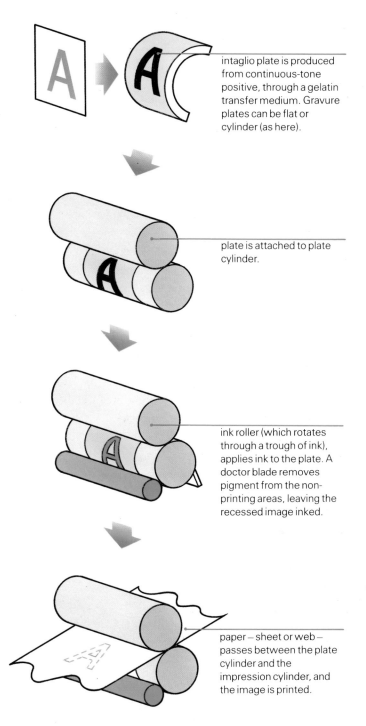

intaglio plate is produced from continuous-tone positive, through a gelatin transfer medium. Gravure plates can be flat or cylinder (as here).

plate is attached to plate cylinder.

ink roller (which rotates through a trough of ink), applies ink to the plate. A doctor blade removes pigment from the non-printing areas, leaving the recessed image inked.

paper – sheet or web – passes between the plate cylinder and the impression cylinder, and the image is printed.

impressions per hour. The process is expensive, and is only economical for very long runs (300,000-plus copies), though automated electronic engraving is making shorter runs more economically viable. The disadvantages of gravure include the expensive plate/cylinder-making process, difficulties in colour correction, and the high cost of press proofs. The advantages are: very high-quality reproduction of images, high-speed printing, easier maintenance of colour consistency throughout a long run, and decreased paper costs (as gravure can use lower-grade, lighter papers than litho).

Letterpress and flexography

R elief printing is the oldest form of reproduction, perhaps dating back to 1800 BC and the earliest examples of Mesopotamian cylinder seals. It reached its modern form in the fifteenth century with the invention of the letterpress, a platen press taking impressions from movable types carved in relief. The invention is ascribed to Gutenberg, though Faust, Schoffer and especially Coster, also have strong claims, dating from as early as 1420.

Letterpress traditionally involves printing from two kinds

▲ Relief plates
In letterpress, both the metal type and image blocks are arranged so that the printing surface is at a uniform height above the platen. These areas receive ink, while non-printing areas, which are lower, do not.

of relief image: type (made up of individual pieces of type held together in a metal frame or "chase"), and relief blocks – wood cuts, wood engravings and, from the 1880s, photo-engraved metal plates. Nowadays, plates are of zinc, magnesium, copper or plastic. The relief image is formed by coating the plate surface with a photosensitive material, then exposing the plate through a negative of the required image. Exposure causes the image areas to harden and become acid-resistant. The soft non-printing areas are removed by etching with acid. Plates can be duplicated from the original by mould-making, and this process is also used to produce flexible plastic plates for the cylinders of rotary letterpress.

Although much of the work previously produced on letterpress is now done by the cheaper and faster offset litho process, letterpress techniques are still used in book and newspaper production, and, using flexographic techniques, in the printing of packaging and other general printing. The major disadvantage of letterpress is the cost of setting metal type, and of producing relief plates. It also requires a higher quality paper to produce work comparable with that produced by litho, which can print well on cheaper papers.

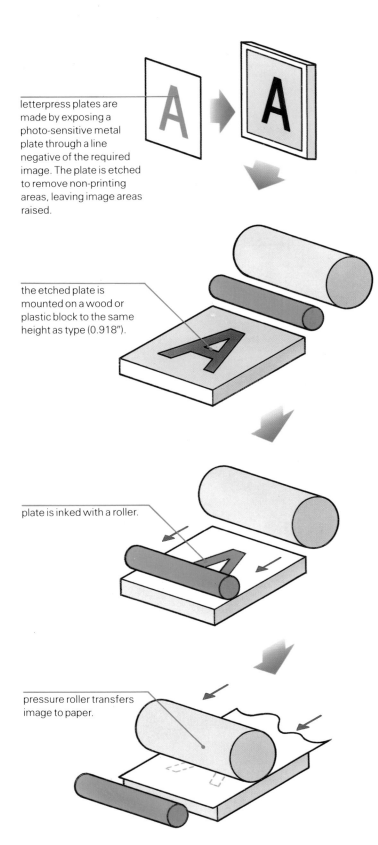

letterpress plates are made by exposing a photo-sensitive metal plate through a line negative of the required image. The plate is etched to remove non-printing areas, leaving image areas raised.

the etched plate is mounted on a wood or plastic block to the same height as type (0.918").

plate is inked with a roller.

pressure roller transfers image to paper.

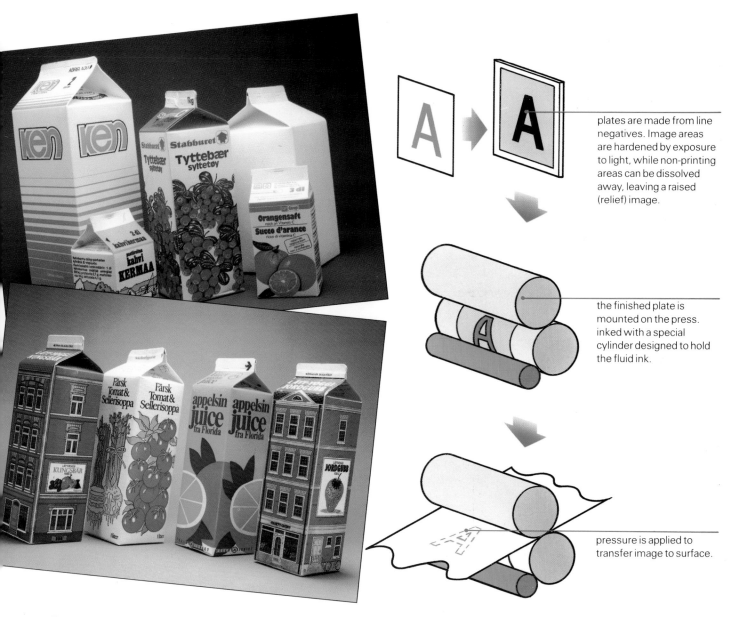

plates are made from line negatives. Image areas are hardened by exposure to light, while non-printing areas can be dissolved away, leaving a raised (relief) image.

the finished plate is mounted on the press. inked with a special cylinder designed to hold the fluid ink.

pressure is applied to transfer image to surface.

▲ **Flexography**
Flexography is a relief process akin to letterpress, but uses flexible rubber or plastic plates. This process is often used for long runs of low-cost printing – for packaging, point-of-sale material, cartons and the like.

Flexography

Previously used for the relatively low-cost mass printing of comic strips, paperback books and packaging, flexography is currently undergoing developments that are making it a viable alternative to the major printing processes of litho, gravure and letterpress. It is currently one of the fastest-growing sections of the graphic arts industry, with uses in colour newspaper printing, disposable paper products, point-of-sale advertising and packaging. It can now produce full-colour halftones with resolutions of up to around 120 lines per inch, printing sharp-contrast, vivid colour images even on uncoated paper stock. The advantages include its ability to use cheap, uncoated paper (water-based inks have less "show-through"); less paper waste than web offset; and quality comparable to that of offset litho.

The printing method is relatively simple: liquid (mostly water-based) inks are transferred from a special "Anilox" cylinder (which comprises a hard surface pitted with millions of tiny cells to hold and evenly distribute the ink) to the flexible relief-printing plate, and thence to the paper or printing material. The relief plate can be made of rubber (for lower-quality flexographic printing) or photo polymer. The latter consists of a base of polyester or metal coated with photosensitive plastic. The image is exposed onto the plate and the non-printing areas are washed out to form the relief image. Photo-polymer plates have the advantage of producing no size distortion, better register, and longer life.

Screenprinting and xerography

Screen printing is based on the use of a gauze-like material (originally silk, but now either nylon or fine metal mesh) stretched on a wood or metal frame, on which are fixed stencils of the image to be reproduced. Ink is squeezed through the stencil by means of a rubber-bladed "squeegee", forming a planographic print of the image on any flat surface. The process was first used as a method of producing coloured point-of-sale advertisements and promotional material in the early part of this century, and has gradually become more and more refined. In the sixties, it became a favourite medium with fine artists of the Hard Edge, Cool School and Pop Art movements.

Screen process units consist of a vacuum bed (for holding paper stock in place), and a hinged frame that allows the screen to be raised (for paper feeding) and lowered (for

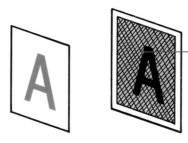

screen stencils are made from line positives, exposed onto a water-soluble stencil and dried onto the screen mesh.

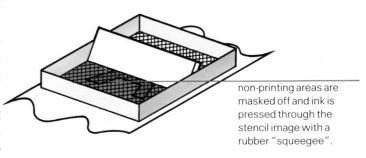

non-printing areas are masked off and ink is pressed through the stencil image with a rubber "squeegee".

the printed image is produced.

printing). Such equipment can be entirely manual (and therefore very cheap). Manual presses can be used economically for runs as short as a few dozen copies. Professional presses are semi- or fully automatic, and sheet-fed mechanisms deliver up to around 6,000 copies per hour.

Stencils

Stencils can be produced by hand or photomechanically. Hand stencils can be made by using cut-out paper, by blocking the screen with a water-based medium (this can reproduce very gestural, painterly effects) or, more commonly, by means of stencil films. These consist of a soft coating on a dimensionally stable plastic base. Image areas

◀ **Screen printed materials**
Screen process printing (serigraphy) is a planographic process based on the idea of stencils. The process is used for a wide variety of printing, from electronic printed circuits, to posters and packaging.

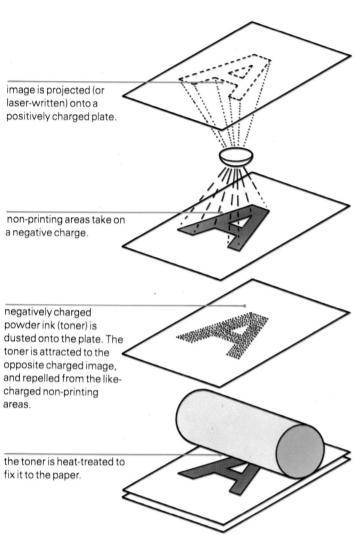

image is projected (or laser-written) onto a positively charged plate.

non-printing areas take on a negative charge.

negatively charged powder ink (toner) is dusted onto the plate. The toner is attracted to the opposite charged image, and repelled from the like-charged non-printing areas.

the toner is heat-treated to fix it to the paper.

▲ Xerography
Now a staple of in-house print departments, the photocopier has replaced other print methods for low- to medium-run monochrome work. The relatively high cost per copy has to be balanced against the convenience of instant reproduction.

are removed with a scalpel and the coating is dampened, applied to the screen mesh and air-dried. When the coating is dry, the plastic backing film is removed, leaving the stencil in place. Photomechanical stencils can be prepared from any line or halftone art produced as a film positive. The positive is laid over a photosensitive film (like the hand stencils, this has a clear plastic base) and exposed to a source of artificial light, which causes the non-image areas to harden. The soft image areas are removed with a water spray, and when the stencil has been applied to the screen and dried, the plastic base film is removed.

Screen printing deposits a fairly thick layer of ink on virtually any flat material, including metal or plastic, which makes it suitable for posters, signs, packaging, fabric printing, and also for printed electronic circuits. Inks can be metallic, fluorescent, gloss or matt varnish, custom colours or four-colour process. Screen printing is not suitable for very fine detail, or for very small type sizes.

Xerography

The principle on which many modern photocopiers, laser-printers and "plain-paper" typesetters are based, xerography is a pressureless and "dry" process. Its quality is now approaching that of offset litho, and larger machines can collate, print both sides, and insert staples.

A photo-conductive plate is used, consisting of an electrically conductive backing material faced with a coating of selenium, which becomes conductive when exposed to light. The plate is positively charged to make it light-sensitive, and exposed to an image which is photomechanically projected from the original. Where light falls on the plate (i.e. is reflected from the non-printing parts of the image), the electrical charge is reversed. The plate is then dusted with toner powder which is negatively charged. As like charges repel, the toner sticks only to the printing areas of the image. The paper is charged positively as it enters the machine, and as it comes into contact with the plate attracts the toner image, which is fixed onto the paper by heat. Modern machines can produce around 7,000 copies per hour, and successfully compete with offset printing for shorter runs.

In laserprinting, the image is created on the sensitized plate by means of a computer-controlled laserbeam, instead of photomechanically, but the process is basically the same as xerography. The xerographic process is also used to create both paper and metal plates for offset litho.

83

2 THE DESIGNER AT WORK

This section of the book provides a set of overviews of the principal applications of graphic design. These overviews have been organized with the practising designer in mind, who, despite all the new technologies, has still to solve graphics problems by manipulating type, illustration, photography, motion and volume. The applications span the entire process of symbol and image-making, from the intimate specifics of typeface design, through logotype and symbol design, to the broad creative canvas of corporate identities, sign systems, publishing and broadcasting. Reference to the variety of those applications is not intended to imply that they are necessarily separate specialisms; all the current applications of graphic design are continuously cross-fertilizing each other as they increasingly rely on the same

DESIGN APPLICATIONS

The basic visual components of graphics are the individual letterforms, symbols and signs that can be configured to express everything that it is possible to write about. Typeface design is an ongoing process. In the sixties, we had for the first time to design faces that communicated not only to fellow humans, but to machines also. Now we have trained the machines to recognize a wide variety of faces, but changing fashions and technologies create a constant demand for new faces that work more successfully in particular processes, and reflect more precisely the nuances of our age.

The applications of graphic design

Typeface design, manufacture and marketing are under-going profound changes in this period of the rapid development of digitally coded fonts, screen fonts and imagesetting. Whereas just a few years ago type founders such as Monotype had perhaps 5,000 customers worldwide, now they have millions of users of electronic publishing and DTP systems who require their own range of fonts. A particularly good example of contemporary typeface design is the award-winning work by the design group Banks and Miles for British Telecom. By a careful analysis of the ergonomics of phone directories, the design of an appropriate digital face, and a logical restructuring of the typography, Banks and Miles have saved the client paper and money, and provided a more accessible tool for the customer.

Logotypes and corporate identity

The design of more complex symbols, such as trademarks and logotypes, is linked to the specific requirements of the client. These range from the needs of a small business to those of a large multinational, but the problem of crystallizing the typographic, pictorial and abstract components of a logotype are essentially the same. The problems presented by large corporate-identity programs are not limited to the design of a logotype, or to its graphic application throughout the company's sphere of operation. The designer needs an intimate understanding of the company, its aims and objectives, and of the relationship between the executive, the shareholders, the work force, the company's clients, and the general public. The resulting graphic treatments use the logotype as a central symbol for these relationships and the aspirations of the company. In a volatile market such relationships can change and there is an acknowledged need for a constant re-examination of the role played by a company's symbol. So, whereas logotypes have traditionally been designed for longevity, albeit with periodic restyling,

there is now in some areas of commerce (notably the high street, where fashion is a major consideration) a trend towards more ephemeral graphic identities.

Signs and sign systems

Symbols can be used for purely informational ends – for example, as components of signing systems for exhibitions, airports, urban transport systems, and large events such as the Olympic Games. Such systems may include the use of pictograms, and even extend to the application of a total house-style throughout a wide variety of printed media, including tickets, posters, advertising, maps, flags, placards, brochures, programmes, etc. Like corporate-identity programs, these graphic applications of a central logotype or theme are presented in the form of a manual of specifications, setting guidelines for every conceivable use, with strict grids and systematic layouts to ensure consistency.

Display: type and letterforms

Another application that has developed as a specialism for many designers is the design and execution of display

▶ **M Magazine**
Sophisticated type and state-of-the-art photography and design provide a suitable combination for the Rotterdam Art Council's magazine.

lettering. This may be used to express the name of a particular product, such as a brand of car or type of breakfast cereal, or used to illustrate or emphasize the main strapline in an advertisement, or as the central component of a shopfront or other commercial architecture. This area involves the use of type and letterforms as a primary part of what is in fact a means of illustrating the projected style, market niche, mode of business, or other attribute regarded as desirable by the client.

Type as text

In terms of bulk, the publishing industry produces more text-based books than any other kind. It is in this area of working with type as text that designers can benefit from over 500 years of accumulated experience in how best to present material both for continuous reading and for reference. The basic design principles for books in these two categories have changed little since the adoption of Roman typefaces in the fifteenth century. Serif faces are still superior for continuous reading matter, and layout is still mainly as justified text, with margins conforming more to a regard for economy of paper than to the true ergonomics of book usage. In reference works, such as dictionaries, timetables,

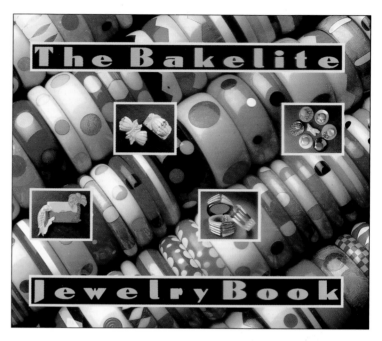

▼ **Type and image**
Thirties-style type and a modern design combine brilliantly to create an eye-catching, colourful bookjacket for Abbeville Press' *Bakelite Jewelry Book*.

directories, manuals, parts lists and catalogues, there has been a consistent improvement not only in the adoption of highly legible faces, but in the consideration of structure and layout to reflect the use to which the work will be put. This is a continuing process, and can involve the development of custom-designed typefaces as well as research into efficient ways of structuring information. The use of non-print media for reference works (such as an aircraft construction manual embodied as computer database) is also helping to develop new forms of information structuring and styles of graphic interface for this type of publication.

Type and image

Most graphics applications use both type and image to communicate their content. This practice is part of a continuing tradition that stretches back to the earliest graphic communications – the beautiful combinations of image and pictogram of Egypt and the Middle East. This powerful linking of media has been transformed in the last 100 or so years from monochrome type and illustrations to full-colour photographic imagery that works in fusion with letterforms now unrestricted by the conformal requirements of the letterpress process. Advertising has been the main area in which this fusion of type and image has been

KONRAD BOEHMER
'DE OPERA GAAT AAN PERVERSITEIT TEN ONDER'

89

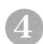
developed, though increasingly these techniques feed back into editorial design – especially in magazines, where the influence of advertising graphics can be directly contrasted with editorial styles. Advertising graphics are themselves moulded by changes of taste and fashion, and the ephemeral magazine must reflect these changes too.

In terms of catalogues, graphic designers seem only recently to have discovered the range of integrated display options that shop-window designers have developed over the last 20 years. Catalogues are no longer seen as pictorial lists of products, but rather as composite images that feature products in their "natural" settings. These presentation techniques blur the distinctions between advertising and editorial styles.

The emergence of new national newpapers over the last decade has highlighted an area of publishing that is going through a period of radical technological change. The demands of economy and speed of newspaper production and distribution have been met with a technology that (almost incidentally) offers the graphic designer greater creative freedom in text and layout, and especially in the creation of news graphics. The improved treatment of newspaper graphics to explain news items, science features and weather forecasts has been inspired directly by broadcast television, where the technology we now associate with desktop publishing was first made available to creative graphic designers.

The third dimension

The spectacular rise of the integrated design group has been a major feature of the last decade. These design groups offer an integrated range of design services that may include architectural styling, fascia design, interior design, shop fitting, corporate identity, packaging and product design and development, as well as graphic design. The recent renaissance in the style of high-street retailing is largely due to the collaboration of designers working within such groups. The result is a totally designed retail environment where everything from customer traffic flow and window displays to interior fittings and label design plays a part in the coordinated design approach.

As the general level of design awareness has risen throughout the field of marketing, so the talents and skills of the graphic designer are increasingly employed in restyling existing products and in developing new ones. This activity may amount to a new range of graphics for the surface treatment of product packaging. Or it may involve the specification for a completely original product, its packaging

▼ **Time-based graphics**
TV designers are able to use an exciting array of animation, digital paintbox, rostrum camerawork and special-effect technologies to produce commercials such as this one for Toshiba by Hibbert Ralph.

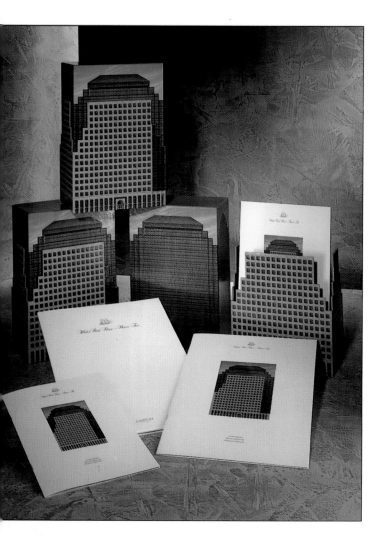

computer requires a thorough understanding of a variety of non-print technologies and techniques. These include story-boarding, traditional animation, film making, video production and editing, rostrum camerawork, and nowadays often special-effects technologies such as motion control. But the central technology will be the paintbox, allied to high-resolution computer-graphic solid modelling – i.e. hardware and software used to create virtual three-dimensional objects (such as letterforms) and animate them through time and space. However, not all the production technology of TV graphics is expensive, for designers have recently used cheap personal computers with good colour-handling facilities to produce graphic sequences for use as economical "animatics" or pilots for idents or titles that will eventually be produced with highly sophisticated broadcast-quality equipment.

▼ Corporate branding
A relatively new branch of design, corporate identity and branding is now an essential part of a company's image. Duffy Design developed this brand image for Ralph Lauren's clothing, stationery and labels.

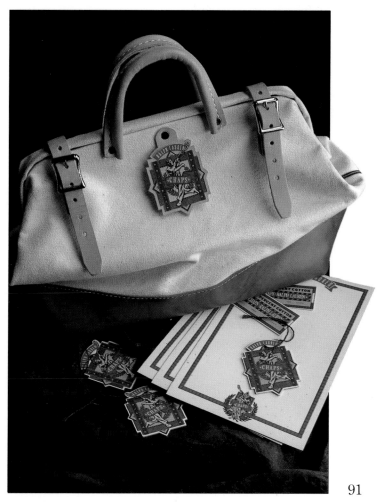

▲ Packaging
Packaging design is an increasingly important aspect of selling a product. This promotional package for an office block in Toronto consists of an elaborate cardboard box holding brochures.

and "positioning" within the market place, as well as the design and production of advertising and promotional material, including videos, film and TV advertising, press or magazine campaigns and even coordinated ranges of supportive merchandizing.

Time-based graphics

The relatively recent introduction into television production of digital video workstations has resulted in the rapid expansion of graphic design in that field. Not only have the quality and quantity of broadcast television graphics been transformed, but the production methods themselves have fundamentally changed. The digital paintbox is now a central component in video post-production and editing for both tape and live productions. The design of graphics that transform both through time and through the virtual space of the

91

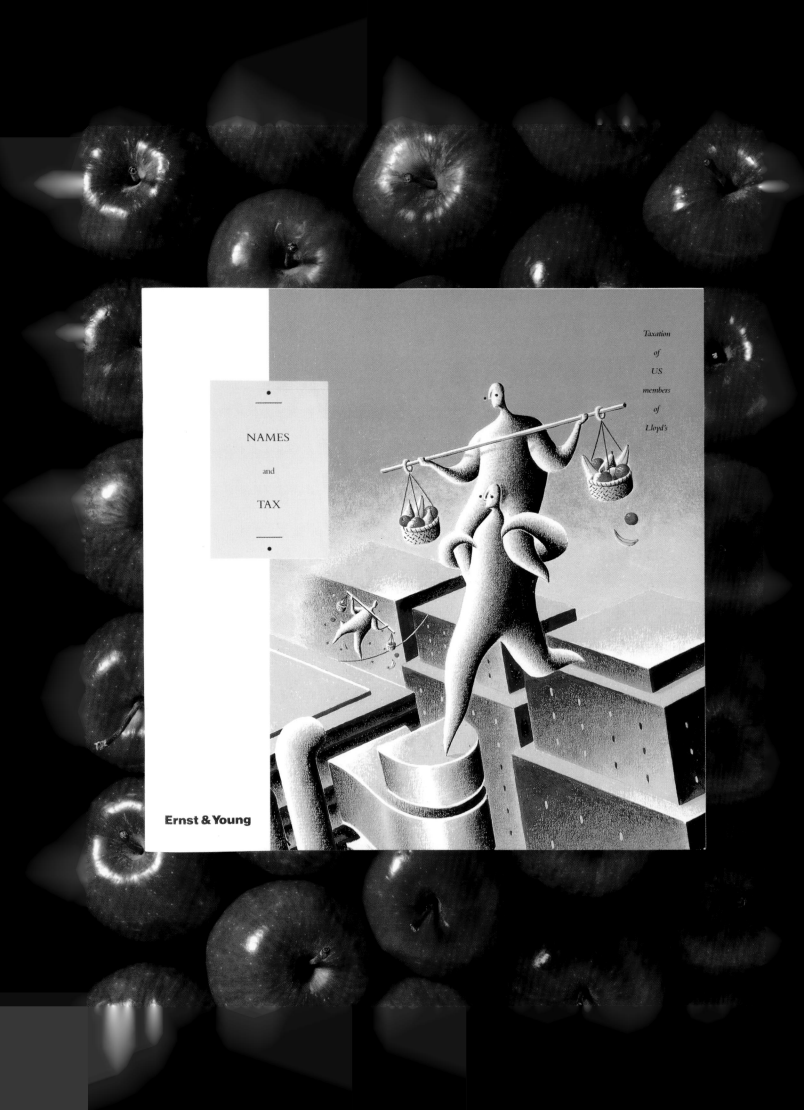

5

PROFESSIONAL PRACTICE

W hat does "professional practice" mean? Some would say, "whatever you need it to mean at the time". But, as **David Hughes** of The Fine White Line explains, most codes of practice are voluntary and possess strength only if a sufficient number of individuals adopt them.

A common basis on which your industry conducts its business provides a degree of protection, principally from being constantly swayed by the varying business practices of your clients. "Oh, we never expect to pay for creative pitches" should really be, "Well, obviously, as we will be paying for the creative pitches we will need to be more selective in our shortlist and more accurate in our briefing". This sort of change will only happen when sufficient numbers adopt and adhere to a common policy of not working speculatively.

A code of practice

Professional practice does not begin and end with paid pitches. It also provides a degree of protection for your clients. Common methods of conducting business enable clients to reach judgments and be confident in their selection. This chapter cannot be an exhaustive guide to the subject. In the UK, becoming a member of the Design Business Association (or its equivalent elsewhere) is probably the first and most important step you can take to find out more about commonly valued codes of practice for this industry. Below is the association's recommended code of conduct for designers and design consultancies:

● The first responsibility of a member is to its client. In discharging that responsibility members are expected to act in a competent, honourable and efficient manner.

● While members may act as clients or as traders, and may receive payment for services or goods in a variety of ways, providing there is no conflict with their client's interests, they should disclose all sources of payment before commencing work and should ensure that they are included in any offer or proposal. Similarly, members must disclose to a client any financial involvement with suppliers or sub-contractors or similar third parties involved in the contract.

● A member should not work simultaneously for two clients, known to be in competition, without their knowledge.

● Members should not divulge to any third party information about a client which is confidential or which may be detrimental to the client's business. This confidentiality may by agreement be limited as to time. Similarly, members should not allow their staff to show work of a confidential nature to others, including potential employers, without prior agreement.

● Members should not give or receive substantial financial benefits which might cause an obligation to any party in a contract and therefore not best serve their client's interests.

● Members should not take part in pitches which require unpaid work. The level of payment for pitches should relate to the time and effort involved.

● The Design Business Group recommends the use of its standard Conditions of Engagement. They have been drawn up for the mutual benefit of both client and member company.

● While members may promote their services by all normal commercial means such as advertising, PR, etc, it is expected that no promotional activity will be undertaken which either seeks to harm a fellow member or which could bring discredit to the industry.

▲ ◄ Plagiarism or pastiche
This tourism campaign for the Isle of Man borrows elements from an old railway poster found in a book. Although this is perfectly acceptable, you must be careful not to plagiarize directly.

● Members shall not seek to obtain work by any means harmful to another member company.

● Members shall not knowingly copy the work of another company or practice.

The following pages cover a range of topics that could loosely be described as "professional practice": pitching for work and selling your skills, terms of business, managing the business, and quality control. Throughout, it is assumed that the reader is either a newly qualified designer about to start up their own business, having been a practising designer for a short time; or a newcomer to the industry responsible for setting up a design resource for another organization. Before concerning yourself with professional practice, you will need business to practise on. The first step is to get the client through your doors.

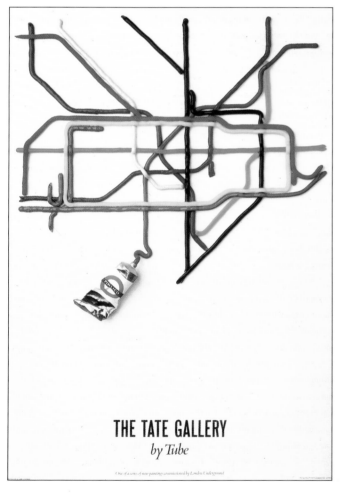

THE TATE GALLERY
by Tube

One of a series of new painting commissioned by London Underground.

▲ **Breaking into new markets**
"The Tate by Tube" is an example of a piece of work that opened the door to many unrelated new business opportunities for The Fine White Line because of the universal appeal of its simple graphics.

Pitching for work

Does the world need another design company? The answer is probably not. Certainly there is little, if any, room for "me-too" organizations. It is therefore important to be clear about your product or service and what differentiates it from that of your competitors. Only then will you have a clearer idea of your target audience and how to approach it. With over 3,000 design practices and over 50,000 qualified designers in the UK alone, you need to think carefully about what will set your organization apart. Certainly creativity is a prerequisite, but it is no longer enough on its own.

Start with a plan and then test it. Decide what you want to do and why you will be good at it, where you want the company to end up, and who you want to work for. Divide your plan into short-term tactics and a long-term strategy to attract and build your client base. Then talk to people: prospective clients, contacts, friends and colleagues. Gauge their reactions and be prepared to alter your initial ideas in the light of their comments. They may not have the answers, but by a process of refinement and experimentation this research will help you ensure that you have a proposition that is sufficiently valuable to a large enough audience. Without such a realistic appraisal of the consultancy's strengths, the chances of losing any sense of direction are great. Short-term opportunity or misfortune will easily deflect you from the best long-term course.

Your choice of sectors to pursue may well be determined by your previous experience in those areas. This is a good enough way to start but inevitably you will need to break into new markets and these new areas of opportunity should form part of your target list. That does not mean that a consultancy known for its skills in packaging should necessarily put as much effort into promoting itself to an audience interested in corporate communications simply because some day it may view that as a business opportunity. It does mean that you should look at the transferable skills that will allow you to offer a service in new areas. As designers we tend to think of ourselves as packaging designers or designers for print, or exhibition designers, when in fact our clients view us as designers who specialize in their particular area: drinks packaging or print for financial services or exhibition design for the information technology industry. Thinking about the long-term development of your client base in this way will help you target all your promotional activity and prevent excessive wastage of scarce marketing resources. Beware of going in too many new directions at once. It can dilute your message and your share of the audience awareness.

Organizing the portfolio

Think carefully about who you are to see. That may mean leaving out some of your favourite pieces in favour of those that are going to win over your prospective client. Why show a beautiful piece of packaging to someone who is commissioning an exhibition stand? There are times when you have to show work from seemingly unrelated areas. Make sure that its relevance is understood, otherwise you will seem to totally lack an understanding of the requirements of the brief. It is easy to fall into the trap of believing that a credentials presentation should consist of simply the best of your work. But if your best work is not relevant then it is not likely to get you the project. One or two relevant pieces matched by a real understanding of the client's market will be more persuasive than a larger catalogue of brilliant but irrelevant case studies.

The size of your audience will help determine how you present your work. The folder you left art college with is serviceable, but probably more appropriate for illustrators and visualizers. A more transportable and flexible vehicle is 35mm slides, which can be used for large audiences in a darkened room or for smaller meetings using a daylight projector. Slides have the added advantage of remaining as good as the day they were made. Distinctive features of a design can be focused on to help build your argument. Multiple copies can be made and filed as separate, prepared presentations under headings such as: Financial services experience; Packaging experience; General presentation. These can then be "topped and tailed" as appropriate.

Do not rely on the images to provide you or your audience with all the clues. Produce text slides to help you explain the case history. This will also help new staff to understand the work. These slides should be short and succinct. They are there for you to expand on, not read.

Increasingly, computer-generated presentations are taking the place of traditional slide shows. The economy and speed with which information can be put together and tailored to the needs of a particular audience makes this an ideal adjunct to 35mm slides. Speakers' notes, audience handouts, and hard copies of the slides can all be automatically generated. Video will grow as a popular and convincing presentation medium. Moving text and graphics from a computer-generated presentation package, inter-spersed with moving footage or a compilation of 35mm stills, can already be produced quickly and economically.

Apart from a very high level of creativity, your future clients will be looking for reassurance: that you know and understand their market or at least have an empathy with it; that you will deliver on time and on budget; that they can work with you easily; and that they are making the right choice. Building that sense of security starts well before the first meeting.

A survey conducted in the UK by *Design Week* indicated that as many as 54 per cent of clients chose their design consultancies by word-of-mouth recommendation. Forty-six per cent made their decision by comparing the work of different consultancies. Clearly, getting a good name for yourself is high on the list of priorities. Your starting point should be all the past contacts, ex-clients, intermediaries, friends, suppliers, manufacturers and former employers – in fact almost anyone who knows you. Getting in touch with this group of people is not a once-only exercise. You need to maintain a flow of information on a regular basis. Given that word of mouth is the most likely method of shortlisting, this free database could well be your most powerful source of new business.

▼ **Presentation material**
The range of possible presentation material is growing all the time – a standard range includes information packs, 35mm slides and videos. Increasingly, computer based packages offer improved economy, speed and finish.

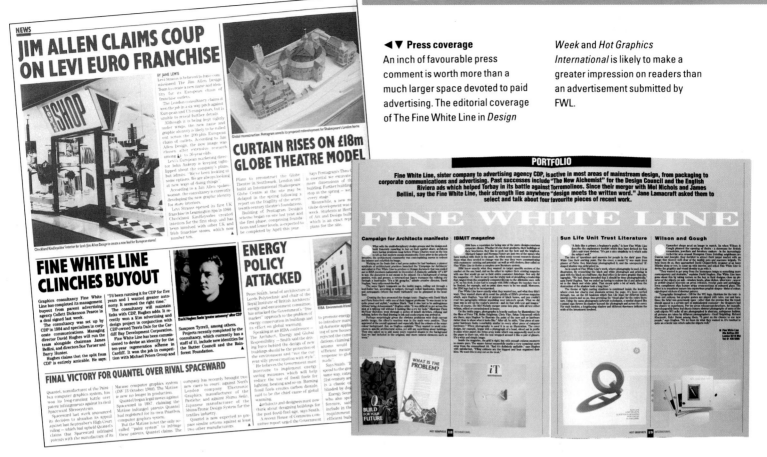

◀ ▼ **Press coverage**
An inch of favourable press comment is worth more than a much larger space devoted to paid advertising. The editorial coverage of The Fine White Line in *Design*

Week and *Hot Graphics International* is likely to make a greater impression on readers than an advertisement submitted by FWL.

The role of PR

An inch of favourable editorial comment is far more persuasive than a much larger amount of paid-for advertising. When cultivating press interest do not forget that it is the prospective client that you are hoping to convince. By all means get your story into the design press but do not overlook the special interest magazines that are read by your target audience or the local press that may be interested in your work. Each of the sectors in your master plan will be served by their own periodicals. Draw up a "hit list". You will find the names of your contacts in press directories.

Unfortunately, you will not get away with writing your press release once. You will need to tailor the message to the individual editorial slant of each magazine. A copy of each magazine's special features list will help you to time your approach and decide who would be most likely to take your story. Most magazines will want exclusivity. A features list will help you decide which of two or three competitive magazines is your best bet at any time. The editorial staff will also be able to tell you when their deadline is for each issue, an important element in planning your approach.

Keep the text short, to the point, double-spaced and use only one side of the paper. Supplementary material, such as transparencies, names of the key people involved and any time restriction on the use of the material, should be included. Most important of all, do not forget the contact name. If possible, it is a good idea to issue a joint release with the client, as this confers status on the news being offered. In any event it is important to have your client's blessing before going to the press.

A word of caution: unlike most other forms of promotion, PR is out of your control once the press release has been issued or the interview given. It is surprising how often a story quite different from the one you had in mind finds its way into print.

Cold calling

There is no guarantee that your unsolicited call will receive a warm reception. Never cold call unless the information you have is so perishable that a letter pre-empting your call would miss the moment. The first step is a short letter outlining why your consultancy is of specific interest to your prospect, possibly including a few samples of relevant work. Indicate that you will be calling in the next few days and what you will be calling about. At the very least your call will be expected and you are more likely to get past first base – assuming that all the other prerequisites of timing, relevance and point of difference are of interest.

Building a database and advertising

Building your own database is a time-consuming activity and one that never ends. It has been estimated that the annual turnover of marketing management – a key audience for many designers – is between 25 and 30 per cent. At the end of the first year at least a quarter of your database will be out of date and in three years it may be totally useless unless you constantly check it. Updating the information is the only way to have a predictable dialogue with your prospective clients. As a starting point for building your own database you can buy lists from list brokers. After that it is down to you to update them. An alternative is to rent lists of names from a variety of list brokers and magazines. These are only as good as the individual organizations that maintain them and cannot be used to build a dialogue with your potential customer. A one-shot mailing to 4,000 people gives you no guarantee that they will be the same 4,000 the next time you rent a list.

You may find it more effective to enlist the services of a database consultancy who will build and maintain a database for you. Any responses can then either be fed back to your database consultancy into a "contact" database or kept in-house to build a "warm prospect" database that you continue to manage yourself.

Consider every scrap of information you have about your prospect. Imagine each element – name, title, job title, type of business, address, postcode and telephone number – occupying separate boxes in a grid. With the aid of a computer you could juggle all these boxes and rearrange your database to show, for example:

● all marketing managers living in a particular city and working for insurance companies
● all chairmen of football clubs in a particular area
● all companies with an annual promotional spend above a certain figure.

In this way you can create more precisely targeted mailings and communicate topical or specialist news to a tightly defined segment of your total database.

Advertising your services

Advertising is the least accountable of all the methods of marketing your consultancy. This is not to say that it does not work; it just means that you cannot assess the results as

easily. The difficulty for most practices is that, apart from the design press, there are a large number of appropriate places in which to place advertisements. Unless you are very specialized, it would be possible to draw up a long and expensive list of options. Be clear about what you want to achieve. The design press may be better suited to gaining recognition among your peer group and as a recruitment vehicle. The marketing press may be appropriate for some aspects of design expertise and not others. The quality daily press may be appropriate for certain corporate audiences but prohibitively expensive. The specialist trade press may be a very cost-effective way of targeting special interest groups but often the quality of the host magazine does little for the image of the consultancy.

Wherever you decide to advertise, it is likely that your budget will be relatively small. In these circumstances it is important not to spread your media choice too wide and your coverage over the year too thinly. As with all your other activity, timing is important.

Throughout all this activity there are some basic rules to follow if you hope to maximize the number of conversions from prospect to client. Everyone is a suspect until you start defining who you are really interested in. Then they become prospects. A prime prospect must have the following;
● money
● the authority to spend
● need.

Establishing these three criteria as early as possible in your dealings with a prospect will not only save you a lot of time but also improve your new-business strike rate. Far too

▲ Boosting response
A comprehensive reply card will help you gather data that will be useful at some later date even if there is no immediate business to gain. Making the card reply paid is an essential method of increasing response.

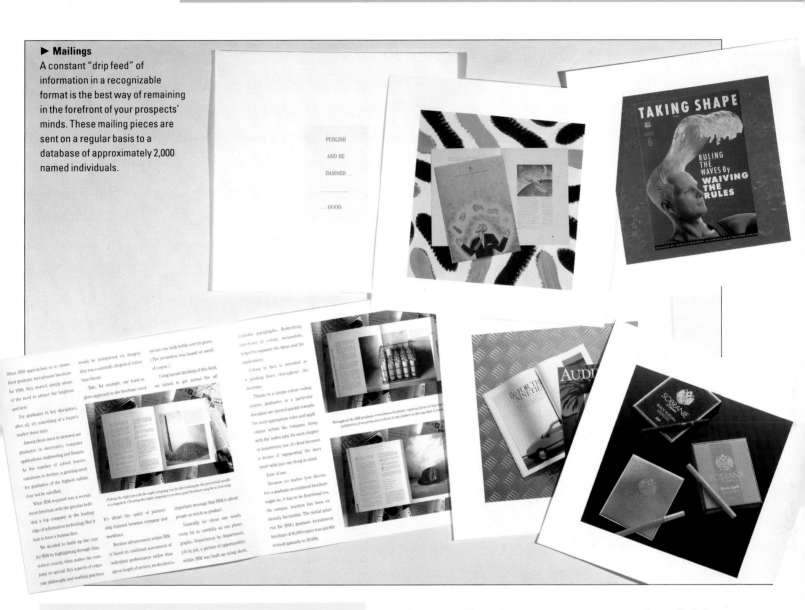

► Mailings

A constant "drip feed" of information in a recognizable format is the best way of remaining in the forefront of your prospects' minds. These mailing pieces are sent on a regular basis to a database of approximately 2,000 named individuals.

MPROVING THE RESPONSE rate. Although two per cent has been quoted as an industry average, much higher levels are achievable by following a few simple rules:

● the quality of the list is the most significant factor – its accuracy; its appropriateness; its uniqueness.

● the appropriateness of the message. Make it relevant. Many companies receive more mailings from design companies than they can possibly be bothered to read, let alone follow up.

● the timing. Your clients will be planning ahead. Your mailing should arrive when they are in that planning stage, not after they have appointed someone else for the project. Each industry has its own annual cycle of activity. Time your mailing to coincide with that cycle. Avoid holiday seasons.

● offer reply-paid cards and envelopes.

● make sure you include contact names and numbers.

● follow up with a phone call.

often you will reach some remote outpost only to find that the person you are seeing has neither the authority to commission you, nor the budget required, nor perhaps any requirement for design consultancy at that time.

Once you have identified the prospect who fulfills all three criteria you then have to convince them. Describe your offer and how they can benefit. Reinforce the primary benefits and then, most important of all, close the sale. They liked you, and your work. You know they have a brief – ask them for it. When they say how much they rate the work and that it is just the sort of thing their company needs, ask them when they think they might be sending you the brief. Otherwise you will undoubtedly fall into the common trap of walking away from the meeting with nothing more than a warm feeling. Remember it is much easier for someone to say nice things about your work than to be negative. It is important to test the depth of their positive comments.

Terms of business

Y ou have landed the project. The champagne flows. Before the bubbles of enthusiasm disappear make sure you have defined exactly what you expect from the relationship and what in turn your client can expect from you. Well before you get your first client, set out your standard terms of business in writing and have them vetted by your legal adviser. Make sure each and every client receives a copy along with each schedule of work. It is quite likely that many of the client organizations will have terms of their own. Be prepared to compromise. It is always better to discuss terms before they become an issue, but do not lose

▲ Ownership and limits of use
When BZW wanted to produce a Japanese version of their highly successful brochure on currency swaps they had to come back to The Fine White Line. Many clients wrongly assume that they can translate and reprint without referring to the design company. Draw your client's attention to the extent of your copyright and the restriction on their usage.

the business by arguing over every dot on every i. Your terms should cover: method of payment; credit terms (offered and received); advance fees if appropriate; interest charged on late payment; at what point client becomes liable for charges; what constitutes sufficient authority to act on your client's behalf; ownership of work; limits of use of any

▼ Copyright
These roughs are from a larger group presented to the London Transport Museum. While we happily granted copyright in the chosen rough (top right) to the museum, all rejected roughs remain the property of The Fine White Line.

 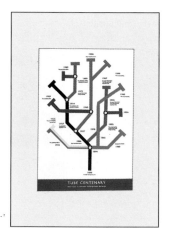

work produced; levels of commission charged on third-party production (print, typesetting, photography, etc); limits of your responsibility to your client both in terms of service offered and delivery (late or otherwise).

Do protect your copyright. It is a powerful right that is abused so regularly that many clients come to believe they are acting within their rights. State the limits of usage in your terms and conditions. Too often, work originally commissioned for the domestic market is subsequently used internationally with no further payment to the consultancy or the other specialists involved. It is increasingly likely that you will find yourself the custodian of other people's copyright. Your liability is increased, so it pays to have specific reference in your terms of business.

Client relationships

Some consultancies have people specifically responsible for account handling and others do not, but even the latter still need to manage the account properly if they want the

relationship to grow. The client has a right to expect that his account will be handled professionally in all respects – not simply creatively. He will be looking for prompt response, good administrative control, a high level of service, efficient coordination of all resources and proper reporting.

In return, the client should provide you with a written brief covering:

- the market background
- positioning
- the objectives of the brief
- the target audience
- current perceptions
- desired status
- key message
- tone of address
- product information
- any technical data
- any legal requirements
- a timetable or achievable delivery date
- budget
- any other elements such as production requirements.

▼ Terms of agreement
Make your position clear in your terms of business and make sure all your clients receive a copy.

use thereof and you agree fully and effectually to indemnify us and keep us indemnified against any liability claims, costs, losses, damages, expenses or other sums suffered, incurred or paid by us arising out of any such infringement.

e We shall be entitled to submit artwork and proofs of our work to you and if we do so we shall not be responsible for any errors therein which are not corrected by you.

10a The copyright or such other limited right as we may secure in all work prepared, designed, created, commissioned or otherwise acquired by us in relation to the Project (including without prejudice to the generality of the foregoing all designs, artwork, blueprints and copy) shall not withstanding the provisions of any statute vest in us alone absolutely throughout the world for the full term of

15

If you do not receive a brief, ask for one. Do not assume that it is correct when it does arrive. If necessary improve it by:

- site visits
- interviewing the key personnel
- researching the market
- talking to the client's other consultants, advertising agency or management consultants.

Avoid the internal brief. Whatever brief you finally arrive at, make sure both consultancy and client are in agreement. When you have all the answers you can brief your team and complete the costings and schedules.

Costings

Graphic design consultancies are generally paid in two ways: fees based on an hourly rate and commission on production. Fees are geared to salaries and overheads, with an element for profit. Production refers to all bought-in costs.

When working out your scale of charges it is important to take into account that the annual total of chargeable hours may be less than you think:

1 person working a 40-hour week	2080 hrs
Deduct: holidays	120 hrs
public holidays	− 80 hrs
sickness	48 hrs
	1,832 hrs
20 per cent administration	− 366 hrs
Available hours per year	1466 hrs

In practice you may find that the administrative down-time is greater than 20 per cent.

The individual salaries and salary-related costs of chargeable staff will then need to be divided by the available hours to arrive at the basic hourly cost. To this you will need to add an overhead recovery sum which will take into account the salaries and salary-related costs of all the non-chargeable staff as well as all the other overheads: space, heating and lighting, marketing, etc. At this point you have a figure that you *need* to charge to break even. Making a profit is extra. Remember to take into account the economic value of the project to your client when arriving at an appropriate fee. Otherwise, if a time/cost equation is the only basis on which your consultancy fees are arrived at, the brightest and the quickest may find themselves the least well rewarded.

Schedules

You will need to take account of availability of external specialists as well as that of your own team. Unforeseeable delays are a regular occurrence. Involve the client in preparing the schedule. A client consulted is a client committed.

Contact reports

Make sure each and every client meeting is contact-reported, and that includes phone conversations. Apart from being a useful check that everyone left the meeting with the same message, a contact report also acts, if undisputed, as a legal record that you will be glad of at least once during your career. The essential ingredients are: time, place, names of those present for the client, names of those present for the consultancy, circulation list and action responsibility. It should be as short and precise as possible. Nobody likes reading long reports, and important facts may be buried.

Studio management

Good recruitment is the first and most important step in managing your team. Because designers have a portfolio of work to show it is often tempting to base your judgment on that alone. Disciplines where such graphic evidence of ability is not available have had to develop ways to unearth a candidate's weaknesses and strengths. Adopting the same approach will lead to better decision making.

Making the right choice, even of junior staff, is vital. Making the wrong choice will cost you dearly. It is equally important that the candidate goes into the relationship with their eyes open, otherwise you may not keep them for long.

A legal adviser will help you draw up a standard contract that will cover most circumstances. Remember to include a clause relating to ownership of copyright of all work produced during the designer's association with the consultancy and a clause relating to protection of your client base should the designer leave your employ.

Fortunately, not everyone is an unstoppable creative dynamo. A company made up of one type of creative person will ultimately be able to service only one type of business. You need to get a balance between workhorses and visionaries – they seldom come in the same package. Having

SUCCESSFUL INTERVIEWING involves preparing beforehand. These guidelines will help you structure an interview.
- tell them who you are
- sell your consultancy – a brief potted history (size, background, expertise, affiliates)
- check what sort of job they are looking for
- who else are they seeing?
- explain the job on offer
- explain who they would report to and be responsible for. Ideally, the person they report to should be part of the interview team
- describe future prospects, but beware of making idle promises
- question them about why they made the moves they did
- what exactly were they responsible for? Client liaison, costing, team leadership, or simply membership, visualizing, typography, art direction?
- why do they want to move now?
- ask them to discuss their favourite piece of work or most admired consultancy
- be clear about money and review periods
- show them where they will work
- show them your consultancy's work – and, of course, look at theirs.

established a mix of abilities, it is important not to pigeon-hole any team member. It is very tempting to give more of the same type of work to the person who handled it so well last time. Very soon you will end up with unhappy experts; any longer and not only will enthusiasm and performance drop off but you will almost certainly be looking for new staff.

Briefing the team and the time sheet
Without a good brief neither you nor your team will produce good work. Your team should have access to all the raw data as well as the condensed brief. Ideally, they should also have access to the client. In addition, your team will need to know: the division of responsibility; the budget available and who controls it; the schedule and the critical stages. Throughout, it is important to motivate the team. People work best when they are enthusiastic.

After working hard for weeks it can be very demotivating to hear nothing from the team that presented the work. As soon as possible after a meeting with the client, take the team through the conclusions. Don't rush it, plan it as carefully as you would the initial briefing. It's an opportunity to motivate the team which could easily be missed.

The time sheet is one piece of paperwork that no designer can afford to avoid. Without an accurate time-monitoring procedure you will never know how much to charge and how long a project will take. And the larger your consultancy becomes, the greater the discrepancy. No designer I have ever worked with has been lazy, so the time sheet is seldom used as a check on a designer's commitment. However, as designers, we do sometimes fall into the trap of spending

◄▼ Reproducing an illustration Your contract with an illustrator should spell out the basics on which you commission any artwork. The illustration below was commissioned specifically for this use. The company concerned would not be able to re-use the illustrations without incurring additional costs.

more time on a job than it warrants, refining it well beyond its economic value to either client or consultancy. Keen monitoring will allow you to be profitable enough to choose the exceptions on which to lavish an inordinate amount of time.

Using freelancers and ownership of work

Many design consultancies operate with an almost exclusively freelance workforce. The benefits of related costs and a very flexible overhead are obvious. However, it is important to check with your tax department: in some countries the firm, not the employee, is liable to pay tax on freelance payments.

Your contract with your own employees should already make the consultancy the owner of any work produced by its staff. If you employ many freelance creative people you will need to be clear about ownership of copyright of work produced by any third party. There are occasions when total ownership is necessary – the logo for a corporate identity obviously must be owned by the client. There are other occasions when an agreement covering limited usage will suffice; for an illustration in a magazine, for example. The various prices associated with different levels of usage and ownership can play havoc with budget planning. It is important to make clear to your client the basis on which the commission has been costed in your proposal, so that at a very early stage the client has the opportunity to ask for a wider-ranging agreement. Include a specific reference to copyright in your terms of business with your suppliers. Finally, remember that copyright can only be transferred in writing. Do not assume it is included in the price.

Control systems

Creative quality, production quality and quality of service will not look after themselves. The key to a quality-control system is accountability. Individuals must be responsible for specific tasks, and overlap kept to a minimum.

As the consultancy grows you will need to create a more formal structure for maintaining creative control, otherwise the consultancy's product will simply be the collected outpouring of a talented bunch of individuals. However, the truth is that in most large practices people are not equally talented, or rather, not equally talented at the same things. The role of the creative director becomes increasingly important. At one level it is an expression of the underlying approach that a consultancy has to all its work. At another, it provides an informed but objective sounding board that helps a creative team to improve the end result.

Essentially professional practice is not a rigid application of a set of systems or attitudes. In such a young industry we can expect to see rapid changes and improvements in the way businesses conduct themselves. Like all good management, professional practice is dynamic and creative.

▼► Model fees
Models will require repeat fees and extra payment if the usage is extended beyond the original brief.

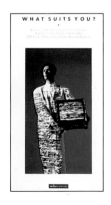

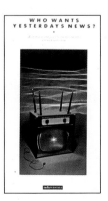

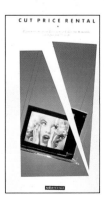

103

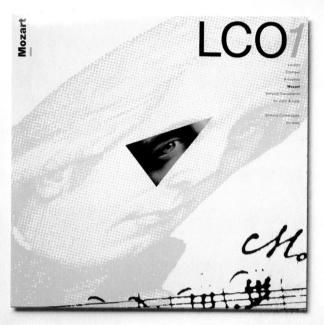

Mozart

LCO1

London
Chamber
Orchestra
Mozart
Sinfonia Concertante
for violin & viola

Sinfonia Concertante
for wind

Vaughan Williams/Elgar

LCO2

London
Chamber
Orchestra
Vaughan Williams
The Lark Ascending

Fantasia
on a theme
by Thomas Tallis

Fantasia
on Greensleeves

Elgar
Introduction
& Allegro

Serenade
for Strings

Vivaldi/Pachelbel/Albinoni

LCO3

London
Chamber
Orchestra
Vivaldi
The Four Seasons
Pachelbel
Canon
Albinoni
Adagio

Britten

LCO4

London
Chamber
Orchestra
Britten
Prelude & Fugue
Simple Symphony
Lachrymae
Chacony

DESIGN AND TYPOGRAPHY

Until the advent of cheaper full-colour reproduction, the role of the graphic designer was often limited to typography. Nowadays, despite much wider use of illustration and photography, and a broadening of the graphic designer's role, typography and its design is still a key element in all graphic work. Failure to pay attention to the impact and importance of the typographic element of graphic design can mar otherwise talented design ideas. **Nicholas Thirkell**, of Carroll, Dempsey & Thirkell, discusses the development of typographic design, and highlights some of the most interesting examples. He also examines in detail his firm's design for the launch of *The Independent*, the first quality newspaper to be launched in Britain for 100 years.

◄ **A new style for the classics**
CDT's brief for this project was to make the series of 12 classical albums appealing to the young pop fan. LCO not only looks more modern than London Chamber Orchestra, but implies that you should know what it stands for. The bar of colour under the first letter of the composer's name gives emphasis while adding to the impression of a modern approach.

The medium and its message

The Oxford English Dictionary describes typography as "printing as an art". But this terse definition belies the enormous impact of typography on the lives of all literate people.

Although it is often regarded as the Cinderella of the design world – less glamorous than photography, film-making or illustration, for example – typography's importance should not be underestimated. It is the method we use to translate the spoken word to the printed page.

The function of this visual language is to communicate ideas, stories and information through all sorts of media, from bus tickets, clothes labels and street signs to advertising posters, shopping bags, books, magazines and newspapers. The typographer's work is inescapable in all areas of everyday life.

There seem to be as many typefaces as there are styles of handwriting. Look through any collection of printed material – a rack of daily newspapers or the wrappers on a shelf full of chocolate bars, for example – and it is easy to detect just some of the enormous variety of typefaces and their uses.

In the late twentieth century we are visually sophisticated and are used to reading and interpreting images. It is the typographer's business to know that certain typefaces will trigger off predictable reactions and emotions. To take two obvious examples – a fancy, flowing copperplate type is instantly associated with romantic fiction, the Victorian era or boxes of luxury chocolates. In contrast, bold, plain typefaces are frequently found in political posters and advertising for the construction and manufacturing industries. The associations sparked off by typefaces are an integral part of our popular culture.

Image-makers

In its broadest sense typography, as a method of translating words into images, has been in existence for many thousands of years. Early cave drawings rely on symbols to tell stories, the Babylonians developed a method of printing using wedge-shaped marks called cuneiform and the ancient Egyptians developed hieroglyphics to record and recount events and tales.

As language evolved and alphabets were formed, typography was further developed, largely through the work of religious orders, to keep books of records and to illustrate manuscripts.

One of the most significant events in the history of typography came with the invention in the fifteenth century of printing with movable type. As literacy increased so did the demand for more books, pamphlets and eventually newspapers, together with a wide range of other printed material. The typographer's craft was born. His task was to develop typefaces, carved out of wood or cast in metal,

A MOVED LINE IN JAPAN

PICKING UP CARRYING PLACING
ONE THING TO ANOTHER
ALONG A 35 MILE WALK
AT THE EDGE OF THE PACIFIC OCEAN

SHELL TO CRAB
CRAB TO FEATHER
FEATHER TO FISH
FISH TO BAMBOO
BAMBOO TO CARROT
CARROT TO PINE CONE
PINE CONE TO CHARCOAL
CHARCOAL TO JELLYFISH
JELLYFISH TO STICK
STICK TO SHELL
SHELL TO SHELL
SHELL TO SEAWEED
SEAWEED TO PEBBLE
PEBBLE TO DOG SKELETON
DOG SKELETON TO STICK
STICK TO MERMAID'S PURSE
MERMAID'S PURSE TO BAMBOO
BAMBOO TO CACTUS LEAF
CACTUS LEAF TO FLOWERS
FLOWERS TO LOG
LOG TO FEATHER
FEATHER TO PEBBLE
PEBBLE TO CROW
CROW TO CRAB
CRAB TO PEBBLE
PEBBLE TO THE END OF THE WALK

◀ **Richard Long**
A Moved Line in Japan was Long's record of a walk he undertook in 1983. The arrangement of type is reminiscent of Japanese calligraphy.

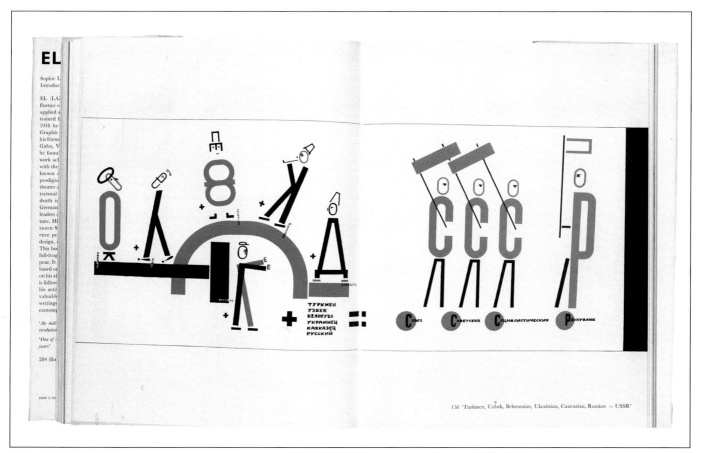

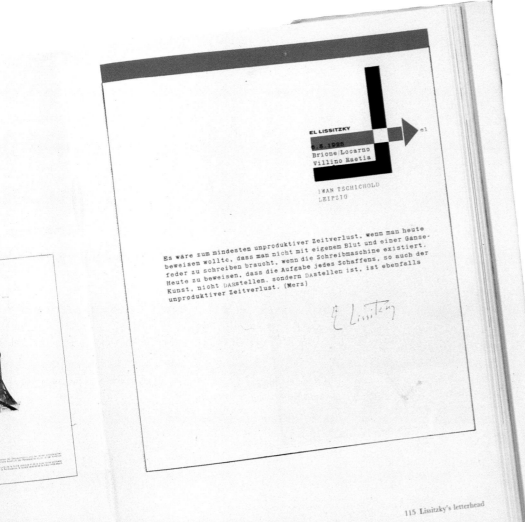

▲ El Lissitzky
Sketches for a Russian children's book, *Addition, Subtraction, Multiplication, Division* (1928), designed by El Lissitzky.

◀ Lissitzky's letterhead. Born in 1890, Lissitzky has exerted a strong influence over typographers throughout the world, which is still evident today.

► Jean De Tournes
A page set in Granjon italic type by the French printer from Froissart's *Chronique,* 1559.

► Theo Van Doesburg
This cover for *Mécano* magazine was designed by Van Doesburg in 1922. He was an influential member of the De Stijl movement in Holland (see page 17).

▼ The cover of *De Stijl* magazine designed by Van Doesburg in 1928.

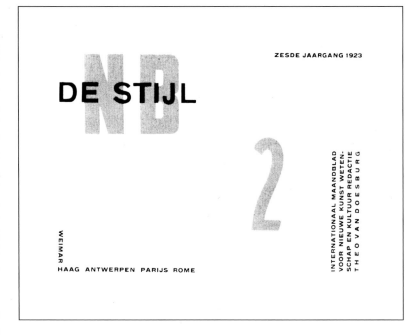

► Giovanni Battista Bodoni
A severe but nonetheless beautiful title page designed by Bodoni in 1791. The typeface designed by Bodoni, which bears his name, has retained its popularity until the present day.

mesler du mien à les restituer en leur naturel, pour la raison que i'ay autrefois dicte en
semblable cas, sur les Memoires du Signeur d'Argenton, & selon que verrez par
nostre annotation 33. & par quelques autres, qui vous pourront satisfaire : comme
i'espère que le reste vous contentera semblablement en ce, qui pourroit requerir
nostre diligence. Laquelle ie vous prie prendre en gré, pendant que ie
tasche, de mieux en mieux, à respondre à la bonne opinion, que
vous ont peu faire conceuoir de moy mes labeurs précedens,
&, en accomplissant mes promesses, donner fin à œuure
de plus-longue traitte : ainsi que i'espere faire de brief,
en faueur de nostre nation Françoise, moyenant
l'aide du Tout-puissant : qui nous vueille
tenir en sa saincte grâce. A Lion,
ce premier iour de l'an, 1559.
commenceant à la Cir-
concision de nostre
Sauueur.
*

STAATLICHES
BAUHAUS
WEIMAR
1919
1923

WEIMAR - MÜNCHEN

BAUHAUSVERLAG

◀ **L. Moholy-Nagy**
The title page for a book designed by Moholy-Nagy to accompany the first Bauhaus exhibition in 1923. The Bauhaus was formed in 1919 by Walter Gropius as an art centre for industry and trade. Its teachers included Paul Klee, Vassily Kandinsky, Herbert Bayer and El Lissitzky.

▼ **Bruce Rogers**
A double page spread from the 1909 version of *The Compleat Angler* designed by Rogers. He adhered to the view that the most important element of beauty in bookmaking was proportion – "it pervades the whole business".

TO THE
Reader of this Discourse
BUT ESPECIALLY TO
THE HONEST
ANGLER

I Think fit to tell thee these following truths; that I did not undertake to write, or to publish this Discourse of Fish and Fishing, to please my self, and that I wish it may not displease others; for I have confest there are many defects in it. And yet, I can⁄ not doubt, but that by it, some readers may receive so much profit or pleasure, as if they be not very busie men, may make it not un⁄

The Complete Angler 207

course, but it might rather perplex then satisfie you, and therefore I shall rather chuse to direct you how to catch, then spend more time in discoursing either of the nature or the breeding of this carp,

or of any more circumstances con⁄ cerning him, but yet I shall re⁄ member you of what I told you before, that he is a very subtle fish and hard to be caught.

And my first direction is, that if

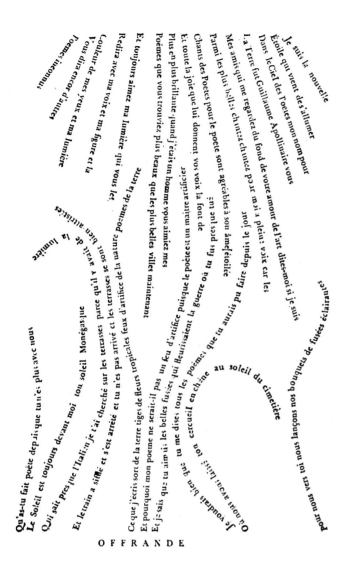

▲ Pierre Albert-Birot
The poem "Offrande" typeset by the
author, Albert-Birot, in his book,
La Lune, 1924.

which were rolled with ink and then pressed onto paper. As sophistication increased as a result of mechanization, the range of typefaces grew, until today these amount to many thousands.

Typography responds to fashions in visual culture as a whole. For example, the taste for heavy decoration in Victorian Britain spread through the entire spectrum of the visual arts from architecture to typography itself. Any opportunity for a flourish, a scroll or fancy adornment was seized upon by the nation's designers, and typography continued to reflected this style until the early part of the present century.

By contrast, the bold and simple designs produced by many of the students and lecturers at the Bauhaus School in

Germany (1919-33) sprang from its fashionable Modernist philosophy. Lecturers such as László Moholy-Nagy and Herbert Bayer preached the virtues of simple design and the stripping away of ornament. The ideas were in direct opposition to the rather overdecorated, overblown work which was then being produced by mainstream German designers.

Post-revolutionary Russia also saw a reaction against the heavy decoration of the period before the Revolution, and there emerged some of the twentieth century's most striking typographical design. Among the pioneers of Soviet typography was El Lissitzsky, who held that, "Typographical form should do by means of optics what the voice and gesture of the writer do to convey his ideas."

In the following decades, the introduction of more advanced printing methods – notably filmsetting of type and the use of Letraset in the 1960s – led to another explosion of experimentation in type design, resulting in the distinctive and fluid sixties look. In the 1980s, with the arrival of computer-aided design, pioneers such as Neville Brody, produced new approaches to type layout.

However, although there has been a constant stream of new typefaces, it is fascinating to see that many early type designs, such as those of Garamond (sixteenth century), Caslon (eighteenth century), and Bodoni (nineteenth century) have become timeless classics. Despite the vagaries of fashion the best designs survive.

The typographer at work

Typographer Nicholas Thirkell, of the design group Carroll Dempsey & Thirkell, explains the professional's role: "The job can be divided into two areas – that of the typographer and that of the type designer. They are quite distinct skills; the former uses type already in existence while the latter tends to specialize in the design of new faces.

"The typographer's job is to communicate ideas and emotions. The tools are fairly modest and include a reference library containing alphabets of typefaces, a drawing board and increasingly nowadays, a computer.

"One of the greatest attributes of a good designer is an understanding of how people think and how they respond to images portrayed by type.

"The typographer must also be able to understand the requirements of a client and his or her products and be able to respond to those demands. It is a job which requires sensitivity and the ability to pay attention to fine detail."

▶ **Royal Mail Special Stamps 1988**
In this project the typography is a
foil for the colourful illustrations.
CDT wanted the type to flow around
the images, however irregular the
shape. The text was computer-set,
but the designer and the copywriter
then rewrote and reshaped the text
until they were satisfied with the fit.
Such a design is enormously time-
consuming and not be undertaken
lightly. Chapter headings are
designed to look like book covers,
becoming image rather than text.
The slip case was inspired by the
issue of stamps bearing the
nonsense verse of Edward Lear.

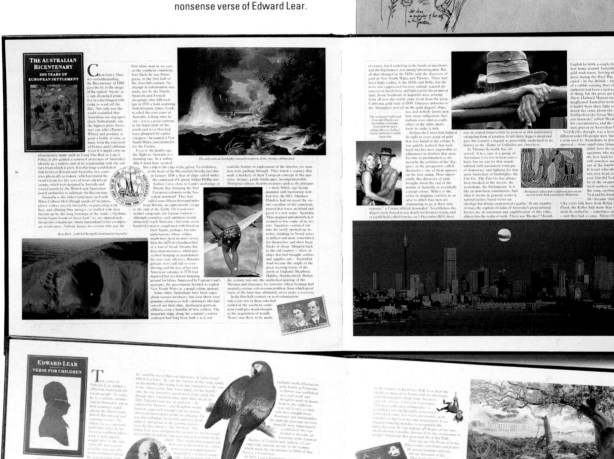

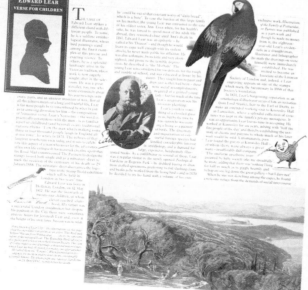

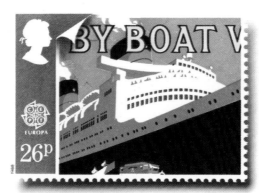

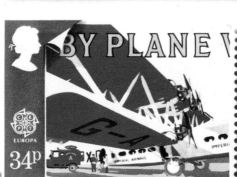

◄ Transport and communications
CDT evoke the great transport posters of the thirties, with each stamp recording a specific anniversary. The typography has been given a period feel and is designed as an integral part of the poster, rather than a caption. In order to make the pale lettering stand out from the images, it is outlined in black.

▼ V & A Picture Books
Every aspect of CDT's design evokes the Victorian era. The typography subtly reinforces this impression without detracting from the richness of the fabric. The letters in each corner of the slipcase stand for Victoria and Albert and the publishers Webb and Bower, the borders recalling Victorian postage stamps. The title of the series has been cleverly incorporated into the medallian image.

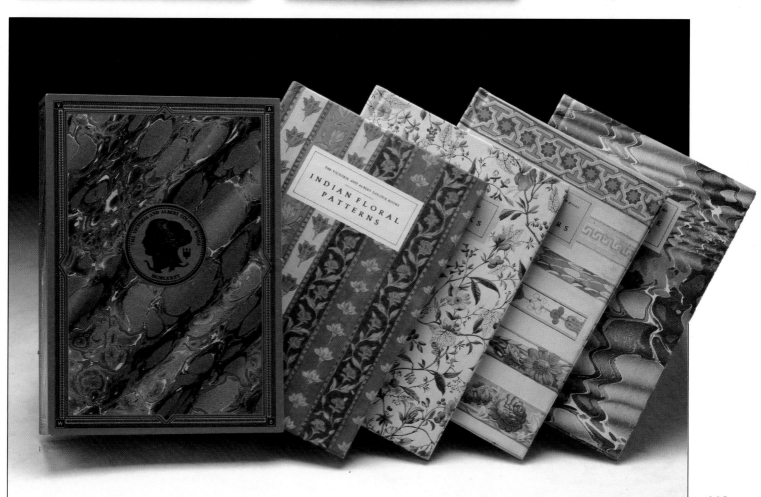

case study

NEWSPAPER DESIGN

CLIENT *The Independent*
DESIGN GROUP *Carroll, Dempsey & Thirkell*
BRIEF *To produce the design for a new quality national newspaper which not only had its own air of authority and style, but which also looked like an established newspaper from day one.*

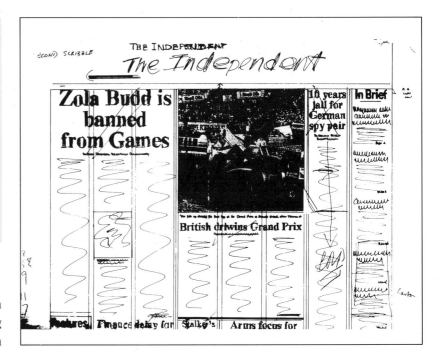

▲ **Front page**
One of Nicholas Thirkell's initial scribbled roughs for the layout of the front page.

"*The Independent* was being set up in direct competition with three existing quality papers and had to portray an image of the same pedigree as the competitors.

"The first task was to select the headline typeface. It had to convey the news clearly, it had to be authoritative and, very importantly, it had to be conservative."

With a core team of three designers, *The Independent* emerged after two months' hard work. "We took a long, hard look at the competitors and analyzed their style and eventually selected Century for headings and Times for the main text. Century was chosen for three reasons – because it was a traditional newspaper typeface, because it was not being used by the other papers and because it has a warm and friendly look. Times was chosen for the main text because it is clear and easy to read. Many purists would claim that it is wrong to mix types for headings and text, but that seems to be taking things to extremes and is a rather rigid approach."

Considerable attention was lavished on the newspaper's all-important front page. The masthead – the title – was based on Bodoni and the addition of fine white "inlines" to each letter lent a Gothic touch of tradition. The effect of the inline was echoed in the horizontal division between stories, which was accomplished by an Oxford rule (one fine rule above a thick rule) – a distinctive feature not exploited by the competition at the time.

An eagle emblem was added to the masthead to represent the idea of independence, strength and grace. The final masthead lettering and drawing was commissioned by Michael McGuinness, art director of *The Independent*.

The designers next tackled the basic page layout. Thirkell opted for a grid based on eight columns per page. Most of the quality British papers use seven or eight columns, while many elsewhere in Europe favour six broader columns. The paper has also become known for its use of generous-sized photographs.

The successful design of *The Independent* achieved professional recognition in 1987 when it was awarded the title of Newspaper of the Year.

▲ **Initial logo**
Carroll, Dempsey & Thirkell's version of the eagle symbol, drawn by Bill Sanderson.

VERSION 1 (INITIAL DEVELOPMENT)

THE INDEPENDENT

No 1

MONDAY 14 JULY 1986

25p

Brittan line gets backing in Cabinet

From our Correspondent in Johannesburg

Lord Pennock, joint chairman of the Euro Tunnel group, admitted yesterday that financial backers were raising unexpected queries about the financing of the £6 billion Channel tunnel scheme due for completion in about 1993.

There were also problems in Parliament, where objectors complained that the select committee was rushing the scheme through without giving them a proper hearing.

Lord Pennock said that the prospectus for the first £200 million had been postponed until the end of the summer after queries from financial backers about both the construction contract and detailed financing of the project. The delay would cost the founder shareholders about £1 million a week.

He admitted that they had overestimated the speed with which so complex a scheme would go through, and that banks were asking more questions abot the prospectus than they had expected.

But he insisted that it was a matter of explanation rather than disagreement. The delay arose somply because it was felt better to postpone issue of the prospectus until outstanding details on financing, construction and contracts with British and French Railways had been fully cleared up.

"Our prospectus is about ready and due. But because the project is of such major proportions, the advice of brokers and bankers is not to issue the prospectus until ...

aspects of the scheme," Lord Pennock said.

Mr Jonathan Sloggett, chairman of the opposition Flexilink consortium, said: "Lord Pennock's statement does not stand up to the most cursory examination. He has been telling us for months that it is in the bag. There is plenty of money in the City, and ample time to get the prospectus out by August.

A label in his studio card index said simply it was from a carte-de-visite of Charlotte Brontë, taken within a year of her death. Apart from that statement, and the photographed face's physical resemblance. The negative was among thousands forming the collection of Sir Emery.

There were also problems in Parliament, where objectors complained that the select committee was rushing the scheme through without giving them a proper hearing.

Lord Pennock said that the prospectus for the first £200 million had been postponed until the end of the summer after queries from financial backers about both the construction contract and detailed financing of the project. The delay would cost the founder shareholders about £1 million a week.

He admitted that they had overestimated the speed with which so complex a scheme

What is so frightening about automation? We have accepted mechanisation happily enough. We drive motor-cars with barely a nostalgic look over our shoulders to the horse and buggy; we receive white cell counts from a Coulter Counter more rapidly than from an individual technician; we reap the consumer benefits of mass-production even though we may be The difference between mechanisation and automation is that in an automated process

Mansell wins Grand Prix in Nelson Piquet's car

By Tony Allen-Mills, New York

He admitted that they had overestimated the speed with which so complex a scheme would go through, and that banks were asking more questions abot the prospectus than they had expected.

But he insisted that it was a matter of explanation rather than disagreement. The delay arose somply because it was felt better to postpone issue of the prospectus until outstanding details on financing, construction and contracts with British and French Railways had been fully cleared up.

Our prospectus is about ready and due. But because the project is of such major

brokers and bankers is not to issue the prospectus until everything is in place on all aspects of the scheme," Lord Pennock said.

Mr Jonathan Sloggett, chairman of the opposition Flexilink consortium, said: "Lord Pennock's statement does not stand up to the most cursory examination. The delay arose somply because it was felt better to postpone issue of the prospectus until outstanding details on financing, construction and contracts with British and French Railways had been fully cleared up.

"Their case is inaccurate, badly presented and full of holes, particularly in regard to capital cost, traffic forecasts,

Lord Pennock, joint chairman of the Euro Tunnel group, admitted yesterday that financial backers were raising unexpected queries about the financing of the £6 billion Channel tunnel scheme due for completion in about 1993.

There were also problems in Parliament, where objectors complained that the select committee was rushing the scheme through without giving them a proper hearing.

Lord Pennock said that the and tariff and interest rate assumptions. EuroTunnel have been rumbled. This is the beginning of the end for the Channel tunnel."

Sale delayed, page 17

News in brief

Jet crash
man of the Euro Tunnel group, admitted yesterday that financial backers were raising unexpected queries about the financing of the £6 billion Channel tunnel scheme due

Ferry aground
holes, particularly in regard to capital cost, traffic forecasts. EuroTunnel have been rumbled. This is the beginning

Fire beaten
and tariff and interest rate assumptions. EuroTunnel have been rumbled. This is the beginning of the end for the Channel tunnel.

MiGs deal

10 years jail for German spy pair

By Peter Wilby

The Brontë Society has made what experts believe is a "very exciting discovery" of the original, only known photograph of the author Charlotte Brontë.

The carte-de-visite photograph in sepia tones of a woman in profile was found among items bequeathed by Mrs Elizabeth Gordon, a former vice-president of the society, who died last December. An accompanying letter from a nineteenth-century

▲ First presentation
Carroll, Dempsey & Thirkell's first presentation for the overall feel of the paper.

▼ The finished result
The paper as it appears today.

▲ Final logo
CDT's version was rejected in favour of that by the art director of the paper, Michael McGuinness.

THE INDEPENDENT

No 971

MONDAY 20 NOVEMBER 1989

••• Published in London 35p

Thatcher widens rift with EC

PM set to face early leadership challenge

By Anthony Bevins
Political Editor

SUMMARY

CBI attacks government pay policy

Business leaders warned the Government not to interfere in private sector pay settlements and defended above-inflation wage rises. On the eve of the CBI's annual conference, its director-general, John Banham, said talk of pay restraint sounded like "a gramophone record of the 1970s". The CBI's president, Sir Trevor Holdsworth, said industry should look after its own pay settlements....Page 22
Pay disputes, page 2

Teachers' pay hope
Teachers may have their pay bargaining rights restored next year, John MacGregor, the Secretary of State for Education, hinted.................Page 2

Aids talks threat
An international Aids conference in San Francisco may be boycotted by British welfare groups who say US immigration laws infringe civil liberties of HIV-infected people. Page 3

Health in the House
Changes in the NHS are expected to provide the main battleground for the next session of Parliament, which starts tomorrow.........Page 4

Prague march
Some 20,000 protesters marched through Prague on the third day of anti-government demonstrations as the government denied that a student was beaten to death by police on Friday.........Page 10

Eat more cabbage
Peking's cabbage surplus is now so serious that the mayor has declared buying and eating it a political duty.........Page 10

Pretoria's secret

Summit on East Europe signals new row as Prime Minister rejects partners' definition of union

By David Usborne in Paris and Anthony Bevins in London

MARGARET THATCHER this weekend displayed new depths of distaste for economic and monetary union in the European Community, setting the scene for further confrontation with colleagues at the next summit, in Strasbourg, early next month.

Speaking after Saturday's dinner-summit in Paris devoted to developments in Eastern Europe, the Prime Minister confessed for the first time that she not only disagreed with EC partners on how union should be achieved, but, more significantly, that she cannot accept their definition of it.

The Elysée summit agreed urgent preparation of bolstered aid programmes for Poland and Hungary, and opened the way for talks on a full trade and co-operation agreement with East Germany. President François Mitterrand said after the dinner: "We should show solidarity with the whole of Europe — the whole of Europe should rendezvous with democracy."

But he also said: "We have noted the inseparable duality constituted on the one hand by the changes in the East, and, on the other, by integration in the West. The more Europe moves where it needs to move, the more must the Community strengthen itself and, when necessary, quicken the pace."

It is in that context that the forthcoming battle over economic and monetary union will be fought at Strasbourg. A clear majority of EC governments believe that union must mean a single monetary policy, guided by a central EC bank and leading eventually to a single Community currency.

dent Mitterrand is expected to push for a date next autumn when talks on the required EC Treaty amendments can begin.

Insisting that the proposals now being considered, based on the three-stage Delors Report, would displace monetary policy to a central bank beyond democratic control, the Prime Minister sought to contrast the process with the moves to democracy in Eastern Europe. "It would be ironic if, while we are encouraging the countries of East Europe to move to full democracy and human rights ... we should take what is at the heart of parliamentary control out of democratic accountability," she said.

As Mrs Thatcher spoke, Mr Hurd, who is known to be more favourable towards the plans for union and especially full membership of the European Monetary System, sat silently beside her, his head bowed and staring into his hands.

Although the West German cabinet is divided over whether to fix a date in Strasbourg for Treaty-changing talks, officials are confident that come the summit, Chancellor Helmut Kohl will fall in line with Paris. In those circumstances, Mrs Thatcher may be alone in voting against the move and will have no choice but to accept it.

But with the French and West German backing closer and accelerated integration of the EC, British ministers are determined to prod Community partners about unfulfilled commitments already entered into — the "fine-breaking" and "foot-dragging" referred to by Lynda Chalker, Minister for Overseas Development on Friday.

EC aid plan; James Fenton; US cuts....10
Walesa in Chicago;
E Europe protests....11
Leading article.........20
Terry Coleman.........21

THE TIMETABLE for election of a Conservative leader could be advanced, with voting to take place at the earliest possible date — 5 December — senior party sources said last night.

The Independent has been told that a challenge to Margaret Thatcher is now a virtual certainty. That high-risk assessment was considered by members of the backbench 1922 Committee executive at a recent meeting, where it was felt that the sooner a contest was held the better.

Party rules state that it is up to the leader to fix the date for a ballot, and Mrs Thatcher has until next Thursday to decide whether to go for 5 December or to hold the election over until 12 December, following the Strasbourg EC summit. Nevertheless, well-informed sources have told *The Independent* that Cranley Onslow, chairman of the 1922 Committee and the backbencher who would organise the contest, is expected to announce on Thursday that leadership nominations will close on 30 November. If Mrs Thatcher is challenged, the contest would take place the following Tuesday.

Sir Anthony Meyer, MP for Clwyd North-West, has assured friends that if all else fails, he will stand against Mrs Thatcher in order to test the level of dissatisfaction. But two other contenders, one from the left of the party, another from the right, were also being mooted by close colleagues over the weekend.

The risk for Mrs Thatcher is that if she is challenged, and a significant proportion of the 374-strong parliamentary party either vote against her, abstain, or spoil their ballot papers in the secret vote, she could go to Strasbourg on 8-9 December without a solid mandate from her own party. However, if she stalls an election until after Strasbourg, she could risk increasing hostility within the party if, as expected, she ends up in her customary isolation: standing out against further EC integration.

High-level nerves over the prospect of a contest were yester-

...irector who's climbing to the [...] in a man's world

...but careful enough to suggest
...she would be a contender. The
... of suffering which has been
...spect from actors and critics alike.
...s earned her stripes.

...e tends to watch quietly from a
...s play around with the text. They feel
...is presented with a wealth of ideas.
...hand, she moves in to prepare an
...d product. The joint hallmarks of her
...l which can be observed in even the most
...ring characters, and the towering central
...rom Brian Cox she coaxed a Titus An-
...pairing and black as anything ever seen on an
...ge. With Fiona Shaw in *Electra* she went on an
... hysterical rage in the face of injustice that
...allenged both their sanities. But what makes
...arner unique in British theatre is that she sees
...every performance. She doesn't skip off to the
...out remains part of the working unit with her

...of a theatrical one-off. By Paul Arnott

...West End

...ors. She sat through *Titus* on over 100 occasions.
...We don't yet know whether ladders will feature again in
...e Brecht at the National, but amongst the theatrical
...community there is a belief that, no matter how high
...Deborah Warner rises, she won't b... the ladder up
...behind her. Not since the early wor...
...been such widespread convictio...
...director is also good for the ...
...er Deborah Warner has to look...

Handkerchief around neck, £24.95, by Blazer. Rugs in background at ... Post ...

the 48 hr father

When Paul Spike divorced his wife, he also left a family behind. Now a stranger in his own home, he discovers the bleak reality that is every part-time father's weekend with the kids.

ON FRIDAY EVENING, I leave the office early for Paddington Station. It has been an exhausting week and tempers are short. Everyone wants to find a seat on the 5:02, but many will have to stand in the aisles. To top it off, British Rail has neglected to attach a smoking car to this train.

I am smoking more since the divorce. So, I imagine, are a lot of other divorced fathers. They all feel guilty about it. My kids are merciless in their criticism. 'Do you want to die, Dad?' they ask. 'Don't you know smoking damages your health?' What can I tell them? That it's lonely living in a London bed-sit after 15 years of conjugal habitation? They'd simply say, 'Well, why don't you move back home?'

I want to believe that my predicament is less unusual than it feels. Hence I am tempted to imagine myself as a member of a special class of gloomy, downtrodden men. I understand how the feminists feel in this regard. But imagining that this train is full of divorced fathers, all desperate for a cigarette, does not actually make the experience any more pleasurable.

As the train rattles west, I stand holding my copy of the *Evening Standard*, leaning against the lavatory door and thinking of all the details I should have finished at the office. They must wait until Monday now. Despite myself, I wish I could have gone into the office this weekend. How can I wish to spend time in the office rather than with my kids? I haven't left London yet and already I am feeling guilty.

These weekends begin tentatively; my children and I behaving like actors at the rehearsal of a play which, in our hearts, we suspect will flop. The actual hand-over of the kids goes smoothly. My ex-wife is in a rather jolly mood. As soon as I enter, my young daughter is up and clinging to me. I stroke her hair and reach out to pat my son's head as well. Predictably, my pre-adolescent son jerks his head away; never taking his eyes off the screen. Well, later I will have to sort that out. A long talk once the boy is in bed, a 're-establish our close relationship' kind of talk. If my son will permit it, which I doubt.

'Did your mother have some friends over for dinner last night?'

'No,' my son says. 'She had a dinner party on Wednesday. Last night we went to an Indian restaurant in *Reading*.'

So she has gone and left the washing-up from last Wednesday's dinner party... the French casserole pot. And dried bits of radicchio sticking to the salad plates.

The children are watching a game show in the next room. As soon as I enter, my young daughter is up and clinging to me.

'Oh, I see. Was it . . . fun?'

'I guess so. They didn't go home until one o'clock,' the boy says disapprovingly. 'One o'clock is not awfully late for a dinner party,' I say.

The boy turns and cocks an eyebrow. 'I think they got drunk,' he says.

There is nothing so puritanical as a boy on the verge of puberty. Or a divorced father. I find myself sharing his outrage.

But the washing-up must be done. And what is for supper? After a thorough investigation of the fridge, I conclude that supper was meant to be the packet of mince, four days past its 'Sell By' date, which has turned purplish-black and which, when the cellophane...

me to do? I am careful not to show my annoyance to the children.

After a further search of the cupboards, I decide that supper will have to be pasta with a sauce of tinned tomatoes and tuna. Delicious, but there is no garlic. The dish needs large quantities of garlic, lightly browned in olive oil. There is no olive oil.

As it turns out, the children had eaten tuna spaghetti on Wednesday, prior to the dinner party, so my efforts are not wholly appreciated. 'I thought we were going to have hamburgers,' my son complains.

'I thought this would be nicer.' My boy cocks his eyebrow again.

After supper, and more washing-up, I join the children in front of the television. I would like to put them to bed, but there is a programme they insist on watching. It is...

156

DESIGN AND PHOTOGRAPHY

There are two main areas in which designers work with photographers and photography: publishing and advertising. Some of the tasks and skills are the same, although the budgets differ widely. Magazine designers and advertising agency designers tend to be different breeds. **Margaret Donegan** of *GQ*, explains that a magazine art director must have a feel for a good story and allegiance to his or her readers, whereas an advertising art director is involved with sales, and answers directly to the client. A magazine and an advertisement are radically different mediums of communication, demanding different relationships between designers, writers and photographers.

The art director's role

A young art director working in a small agency may be asked to supervise a job from concept to completed product. This involves converting ideas into a rough for a layout or package design; choosing and commissioning the right photographer; taking responsibility for every stage of the budgeting; and ensuring that the photographer sticks to the original visualization and that the client is kept fully briefed. On most magazines (which have much smaller budgets than advertising agencies) an art director will be expected to choose the typefaces, oversee all the page layouts and take responsibility for the overall look of the magazine. He or she will also take charge of the day-to-day business of commissioning photographers and dealing with picture libraries.

However, the same basic qualities are required in both fields. You need to be visually literate and possess a military flair for organization. Good communication skills are crucial, as is a taste for new trends in image-making. Most importantly, you must know when to choose a photograph rather than an illustration, and have an understanding of the possibilities of photography – both before and after a picture is taken.

Agency and editorial

The major differences between agency and editorial work are that photographers in each area have different expectations of assignments. A magazine photographer willingly sacrifices financial gain to enjoy greater creative freedom than advertising can offer. By contrast, the highly paid advertising photographer will not expect much creative input. While the magazine art director has to please his editor, his agency counterpart has a client to satisfy who is in

A creative approach

A brief to provide the photographs for Mobil's publication on careers for graduates could easily have resulted in conventional, rather boring, portraits. Instead, photographer Phil Starling made clever use of multiple exposures to produce exciting images which bring the pages to life. Although none of his subjects are professional models, he has succeeded in making them appear "unposed", which is a major ingredient of their success.

118

most cases not visually trained. So the agency art director needs to be an exemplary communicator of complex ideas about photography and design.

Photography vs illustration

There are many reasons why you might choose photography in preference to illustration. Apart from the fact that your client or editor may have specifically asked for a photograph to illustrate the job, sometimes only photography will do. Imagine a centre-spread portrait of the latest screen star illustrated by a felt-tip pen drawing; or a holiday brochure filled with line drawings. Nothing can evoke as well as photography the presence of a place, person or product. A photograph has authority, even if the reality it depicts is idealized. Photography's vital role in commerce is to reaffirm our dreams of luxury and success. But a photograph must do more than make the viewers dream. It should surprise, and stimulate experimentation, whether it be trying out a different recipe or wearing a new fashion.

119

Art directing for an agency

As an agency art director your aim is to use visual imagery to communicate a message as succinctly and as directly as possible. Once you have polished your written and visual brief, and you start to consider the budget, you will need to decide whether a commissioned photograph or a stock library picture is best for the job. Stock photographs are perfectly suited for jobs with fairly simple requirements, such as travel brochures. But given the option, most art directors prefer to accompany a photographer on a location shoot rather than buy in a stock shot, simply because this way every detail can be overseen. The problem with commissioning any type of photography is that it is costly and often requires a large team. And the more links there are in any creative chain, the more can go wrong.

A stock shot may be chosen purely for budgetary reasons. If you work for an agency that can afford to employ a picture researcher or art buyer, and if you brief them well enough, they should be able to find stock shots that meet your requirements. If you need to use picture libraries, the best way to learn how they operate is to contact an as-

▲ **Picture libraries**
Most picture libraries send out promotional material giving an indication of the type of material they have in stock. This is a standard way of obtaining bought-in material.

sociation such as the British Association of Picture Libraries (BAPLA) or the Picture Agency Council of America. Libraries file images by subject matter and description, not photographer or style, so it is essential to give the broadest possible brief. Cultivate a regular contact, who will get to know your special needs, likes and dislikes. Most importantly, insist on exclusive use of the picture for between two and four weeks either side of your printing date. If you fail to do so, the image you have chosen may well appear simultaneously in a rival magazine or advertising campaign.

It is a fallacy that it is always cheaper to use stock photography than commissioned work. All picture agencies charge search fees for selecting a shortlist of pictures, and there is normally a holding fee, which can be expensive when transparencies are needed for the months that may elapse between picture editing and printing. In cases where an image is going to be used in a wide variety of locations – from

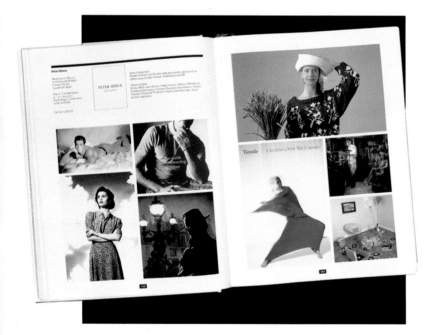

▲ **Showcase work**
Contact is one of the largest of the publications displaying showpiece photography and illustration.

Produced annually, it is an excellent means of discovering talented photographers, illustrators and design groups.

BOBBE WOLF PHOTOGRAPHY
1101 ARMITAGE AVENUE
CHICAGO, ILLINOIS 60614
312.472.9503

◀▼ **Self-promotion**
Many photographers include a
sample of their best work on
business cards and promotional
material as a way of advertising
their work.

magazine advertisements to billboards, to brochures – it
may work out cheaper to hire a photographer. It is important
to read the small print of any agreement you sign with a
picture library.

Choosing a photographer

If you decide to commission a photograph the first step is to
choose the right photographer. Young art directors tend to
play safe, picking a photographer from one of the many
directories used as shop windows by established and award-
winning photographers. But a good art director knows that it
is unwise to judge a photographer's capabilities by a single
picture in a directory. Also, photographers resent being
asked to repeat a successful formula. Always ask to see the
photographer's "book" (portfolio) because a good still-life
specialist may be a surprising portraitist or an undervalued
location photographer.

A vital part of your job involves looking, so develop an
appetite for images. Start by building up a reference file from
tearsheets and photocopies. Collect international magazines
and look at the work of both advertising and editorial

121

▲ Portfolio
Still-life photographers generally mount their best shots before showing their portfolio to an art director. Martin Norris' photograph of his portfolio doubles as a publicity shot.

photographers. If you ask yourself why you like a particular approach you will be better able to brief photographers. Get yourself on the mailing list of different sorts of photographic galleries and go to sales of photographs, where you will get the invaluable chance to handle a catholic range of images spanning the whole history of photography. Keep catalogues from sales and exhibitions. Give the galleries your card and tell them you are interested in commissioning some of the exhibitors.

As you become known, agents will invite you to view portfolios by the photographers they represent. Viewing "books" is time-consuming for all art directors, but the experience of comparing the work of different photographers in a short space of time can be educational and will save effort for future jobs. You should allocate a specific time just for looking at portfolios – say, two hours a week or two afternoons a month, depending on your needs, and make sure you are left to do it in peace. Younger photographers

with "test shots" (self-initiated, unpublished pictures) will approach you for work. Using existing tests can be an inexpensive way of illustrating a brief and giving youngsters their first crucial break. If none of their existing work is suitable, you might still see future potential. If so, ask the photographer to do tests on a subject that is more suitable to your needs, inviting him or her to come back in a few months. It is always worthwhile cultivating new talent. Final-year college shows, which are listed in design magazines, are another very good place to meet young talent and sample the latest visual trends.

When an experienced agency or editorial art director

meets a photographer, he asks: Do you specialize? Do you make a distinction between commercial and "personal" work? Do you own a studio? What formats do you use? Do you "package" a day's work (estimate for all the back-up services such as models and make-up artists)? Or would the art director need to do it? As you gain experience of dealing with photographers you will develop your own comprehensive list of such questions.

Location vs studio

Choosing between shooting in a studio or on location is rarely easy. Studios are ideally suited to fashion, portraiture, food and drink, and car photography, but so is a location, especially if atmosphere is desired. Surreal or special-effects photography can be done in the studio, but pictures can also be manipulated later by computer. Studios are chosen because everything from lighting to backdrops can be carefully controlled in a manageable and friendly environment. Locations have the advantage of providing natural ambience and actual backgrounds that can lend credibility to a copyline. Some art directors compile a file of pictures of locations with interesting skylines or unusual scenery.

The biggest drawback of location photography is the unpredictability of the weather. Valuable days can be lost because of bad light, or, in extreme conditions, the effect of sunburn or mosquito bites on a model's face or body. More days of shooting time can be wasted while a model's skin returns to normal. Cameras and flash equipment can be adversely affected by extreme heat or cold, likewise delaying the shoot.

Ask the photographer what contingency plans he has made in case of equipment failure. Transport can be a problem when roads or timetables are unreliable. Finding adequate accommodation may also prove difficult. Given such problems, many art directors cultivate local contacts who will, for a small fee, smooth the path for the crew.

Now you have selected the right photographer, it is important to explain exactly what you require, supplying both a written and a visual interpretation of what you want to achieve. The next stage is to book a date that suits your copy deadline and ask for a written estimate of the final cost. While building and lighting a tropical set is less hazardous than

◄ **Studio shoot**
This studio shot for a cookery book was masked to a square format which meant that the photographer did not have to worry about excluding the ragged edges and extraneous background.

▼ **Location shoot**
Shooting food in an outside setting means that the photographer may have to cope with a variety of problems, ranging from the weather to insects.

traveling to the real place, it is often more expensive. Weigh up the pros and cons when you ask the photographer to quote a price. It helps to draw up a budget checklist with categories of expenditure under headings such as the photographer's fee, studio hire, model fees, lighting hire, location-finders, fees and expenses, transport, catering, props hire, and any other services. Send a typed sheet with these headings to the photographer who should provide you with all the relevant information.

The most expensive part of any shoot, whether location or studio, is not the photographer but the back-up team. An average studio fashion or beauty shot needs one photographic assistant, a make-up artist, a hair stylist and a fashion stylist, and, of course, the models. Some shoots also require specially constructed sets or props. Most photographers like working with people they know and trust, so it may be best to let the photographer assemble the team. In such cases the photographer may charge you for the whole package, cutting your administration costs. You should still ask to see the invoices from all the participants for accounting and tax purposes.

If the photographer does not "package", you may be responsible for the time-consuming business of booking the team. So keep a file of studios and talent agents and find out what you can expect to pay. The hire of special lighting equipment or extra backdrops is chargeable to you. Do the same shoot on location and you must add expenses for travel, accommodation, food, a location finder and sometimes a fee for using a location. Ways to cut down the cost of travel include contacting airlines and hotels to ask for free accommodation in return for a credit. But this approach is only suitable in editorial, calendar or catalog work.

124

Sporting action
When Adam Scott covered this game for *The Independent* he knew that his pictures would be accompanied by a caption rather than a report, which meant that the paper was relying on him to convey the atmosphere of Britain's first indoor football match. A sports' photographer aims for action and feature shots. This commission was unusual in that the feature was based on the event rather than on an individual.

Copyright and budget

The copyright situation is complex and may vary from country to country. The points made in this section should be used for guidance only. If you intend to negotiate for copyright of the image, you should ask the photographer at an early stage in the negotiations how this affects his fee. A freelance photographer may own the copyright of any commissioned image – and the restriction on use may remain in force until 50 years after his death. A prudent agency or editorial art director will explore questions such as whether the person who buys the copyright has the right to use the pictures in one country only or worldwide, or how long the copyright is to be assigned. In some countries, the law gives the photographer a number of other rights, such as the right to forbid his work to be doctored without his permission. Another important fact to remember, when negotiating a

contractual arrangement involving copyright, is that whoever commissions the work may have to respect what is called a right to privacy. This means the picture cannot be displayed without the consent of those depicted in it. It is sensible, therefore, when compiling a model release form for a commercial picture to state what uses it will be put to.

When the estimates come in, it is advisable to add 10 per cent as a contingency sum, the total being your working budget. At this stage you may need to be more realistic and perhaps cut down the number of models, or find a less remote location. So far, all your approaches will have been provisional, but if the quotes you receive are within your working budget you should go ahead and book the team. Working back from your copy deadlines, draft a detailed schedule that includes dates by which you need every contributor's work completed.

The shoot

On any shoot your role is to ensure that the photographer works within budget and to the brief. Photographers often complain of dictatorial art directors who will not listen to their ideas, but the photographer's role is to meet your requirements. Work with the photographer to make sure that the format of the finished picture suits your layout and the intended use. Your first visual reference will be in the form of Polaroids made as test shots. Use these to judge how the composition is working. At the end of a day's shooting (or if on location, when you return) you will be able to scrutinize the appearance and sharpness of transparencies by examining them through a magnifying loupe, or – if the job is black and white – by inspecting contact sheets (proofs made by contact-printing the negatives on photographic paper). The next job is to edit the choice down to a usable selection. This can be more time-consuming than it sounds.

Cropping and retouching

When the photography is complete and the pictures have been selected, they may need to be manipulated, either by simple cropping – to give emphasis to the main subject or to lend compositional balance – or by sophisticated techniques. Knowing how to crop a picture comes with experience. If the layout requires a black and white photograph to be manipulated – by high-key printing or hand tinting, for example – finishing houses provide these and a variety of other darkroom skills. Transparencies, including large-format ones, can also be retouched. Many adverts are montaged by carefully printing sections from two or more transparencies onto the same sheet of paper. The most common request

◄ Art director's layout
A final choice of image is made from Polaroids showing variations of arrangement and colour and test films with different exposures.

▲ Tinting
A tinted black and white photograph will provide a very different effect from a full-colour picture. Increasingly such tinting is

received by retouchers is to montage a perfect sky with another photograph – depicting a car against a plain background, for example. Such montaging is one way to get around the inconsistencies of location photography.

Increasingly, computers such as the Quantel Graphic Paintbox are replacing the old retouching houses, and today's art director needs to be familiar with the possibilities of computer manipulation. All computers scan the visual material that is to be incorporated into the final image. Any colour anywhere in the image may be electronically matched and reproduced anywhere else in the image. The colour of skies and sand can be enhanced and montages can be produced that fool even the experienced eye. The art director should consult the operator before briefing the photographer, since it may be possible to shoot a transparency in a way that will speed up manipulation, saving money. With the photography completed, the next stage is to prepare the artwork and layouts for reproduction.

Editorial art direction

▲ **Close-up**
Jaap Stahlie's photograph has a very narrow depth of field and the background is slightly out of focus, which gives the subject added interest. The quality of the transparency was extremely fine, enabling GQ to use it as a close-up, making the watches larger than life-size.

As a magazine art director your brief is to illustrate a particular feature, which can be anything from an interview with a movie star to a story about the extinction of a rare animal. You share many of the same tasks with an agency art director, such as looking through portfolios, booking models and back-up personnel, and dealing with picture libraries. But the photographers you commission will expect to be given considerably more creative freedom than advertising photographers.

Through discussion with the writer or commissioning editor, the art director begins to visualize the kind of photographs needed, and how they will key into the text; and the "pagination" – how many pages the story might require. In large magazines the picture editor deals with commissions and presents an edited selection of pictures to the art director. But if you have to do the picture editing, your first task is to choose between a stock shot and a commissioned photograph. In some cases the feature dictates your choice. For example, if it is a story about a dead celebrity the art director will contact a picture agency that specializes in the field. Some magazines have their own picture library, made up of past commissioned photographs, including portraits. By contrast with special-interest consumer magazines dedicated to, say, hi-fi or motoring, most magazines cover a wide range of topics in each issue. It is therefore important to keep a file containing the contact numbers of a wide variety of picture agencies and specialist photographers. It is a good idea to acquire, and keep updated, a directory of international picture agencies such as The Picture Researcher's Handbook or Picture Sources (USA) which list libraries by their area of specialization. As with agency work, the stock shot is not always cheaper to use than a commissioned photograph. When budgeting for a library picture, consider what size the picture will be and whether it is to be a cover shot. The size of your print run and whether the magazine is to be distributed in one or more countries will affect the library fee.

Other sources

Make sure you get your name on the mailing list of publishers, film distributors and art and photography galleries. Their press officers will keep you notified in advance of forthcoming launches that might interest your readers. Sometimes you will be asked to buy in certain topical or hotly contested publicity pictures. The press or PR offices will be happy to provide information, to let you attend shoots and to give an art director exclusivity in return for mentioning the event in the editorial and an agreed syndication fee. It is important to secure exclusivity, because the worst fate for

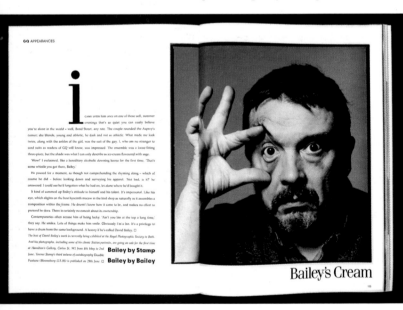

▲ **Portraits**
Text portrait by Stamp and photographic self-portrait by Bailey complement each other to perfection. The picture has been placed across the gutter deliberately to give a "spread feeling". It is important in magazine design to avoid a monotonous individual page feel.

an art director is when your rival hits the streets with the same pictures before you. The second worst thing is that both magazines appear on the same day with the same pictures.

Some agencies specialize in syndicating stories as a package. Sometimes, but by no means always, buying a package can be cheaper than commissioning a photograph; especially if the story is sensational and was shot in a distant country where it would be expensive to send a photographer. Examine carefully the small print of any such agreements and secure exclusivity in writing. In a competitive world your job may depend on it.

If the job calls for commission, the art director will consult

his file of names and images culled from magazines, and photocopies or duplicates of images from the many portfolios that go through his hands. The next step is to contact your chosen photographer. Follow a phone call with an official commissioning letter stating the type of job, how many pictures are likely to be required, and the deadline. If a story demands the skills of an experienced photojournalist you might find yourself having to organize flights and hotels and provide documentation for visas in the same way that agency photographers arrange location shoots. But with one photojournalist working alone, or maybe with a writer, the risks of hitches are minimal compared with the risks involved in, for example, a fashion shoot.

After you have commissioned the photographer and agreed on the timing of the shot to suit your deadline, ask him what he needs in terms of a back-up team, studio hire, special lights, etc. Each magazine has its own method of working with photographers and its own terms of employ-

▼ **Innovative design**
Photographs of downtown Pasadena, California were specially commissioned from Steven A. Heller to accompany an article on the Art Center. Creative use of cutouts and squared-up images form a striking decorative border, as well as making maximum use of the allotted space.

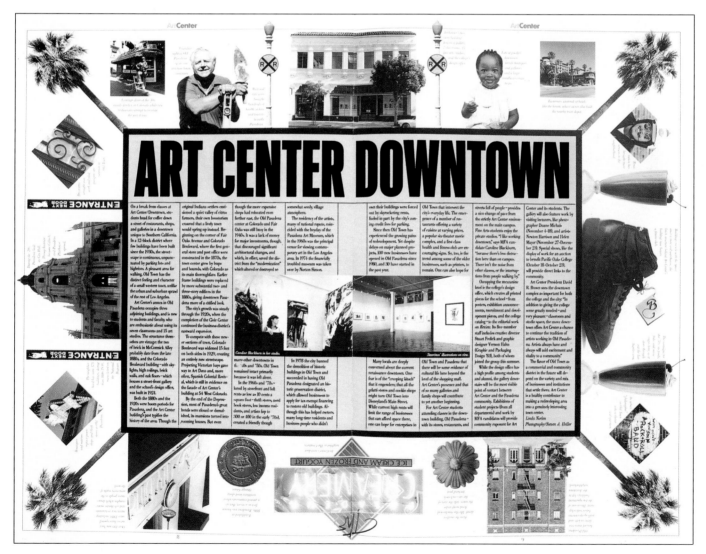

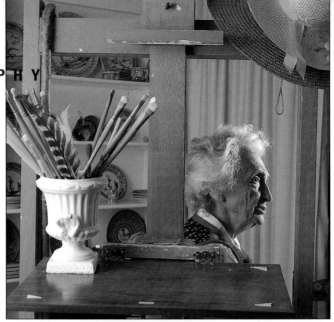

▼ Fish stories

The envelope, embossed cover and spreads from a brochure for a paper manufacturer are designed to show off the quality of Warren Lustro Dull paper. Top quality production and printing ensure that both the typesetting and the Herb Ritts/Myron photographs are shown to the best possible advantage.

ment. Some, for example, pay photographers a modest page rate, but collect the bill for film, processing, studio hire, the back-up team and any other expenses. Always ask if a photographer "packages" his team – that is, assembles it and charges you accordingly. If not, you may have to book the models and the back-up personnel. Be sure to obtain all the invoices of the participators and the processing house, for accounting and tax purposes.

Pictures may be used from as small as a single column right up to several pages. Normally photographers accept that editorial is comparatively poorly paid, and so many advertising photographers are prepared to work for at least a day for much less than their normal rates, just for the kudos of being published in a glossy magazine. Traditionally, editorial has been a place where established photographers experiment, as well as a proving ground for young photographers prepared to work hard for a credit that will get them noticed by an advertising art director.

Copyright

As mentioned earlier, copyright law varies from country to country and you should be versed in the relevant laws. Depending on the publisher, a magazine will probably prefer to keep copyright of an image, but careful negotiations with

Portraits

Portrait photography is often mundane, but a creative approach can bring striking results. Phil Starling's brief from *The Observer* was simply to take portraits. For the street guides spread (left) he decided to photograph his subjects behind part of their surroundings, turning each shot into an artistic composition. He had originally intended to take close-ups of the homeless (right) but decided that the backgrounds would add interest.

Cut out in Cardboard City

TRACY and Guinness **PADDY** **LESLEY and BLODWEN** **TONY**

SARAH **ALAN**

freelancers may be necessary. Some magazines draw up a licencing agreement with the photographers they commission that gives the magazine the right to stop the picture being reused for up to six months after publication. Bigger magazines reach an agreement with photographers to keep commissioned images to be syndicated, the royalties being split 50/50 between them and the photographer. It is important to familiarize yourself with such "house agreements". If in doubt, consult the magazine's lawyer.

Once the pictures have been edited to fit the proposed layout, they might need to be cropped and/or retouched. Some glossy magazines still order images to be retouched to enhance the appearance of a cover girl, for example. If the image is a colour transparency the art director lays a sheet of tracing paper over it and indicates, to the origination house, where retouching is required. Retouching is done at the stage when the transparency is being scanned by computer, leaving the original untouched. The final layout will be produced by a layout artist who will be under the supervision of the art director.

One of the most satisfying aspects of being an editorial art director is to know that magazines and their creative departments have long acted as patrons to many photographers who have achieved international prominence.

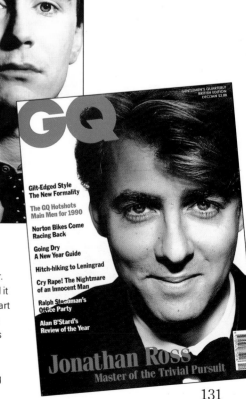

Covers

Shooting close-ups for covers is more difficult than it might appear. A cover shot has to be strking and it may take both photographer and art director some time to achieve the required results. In addition, Chris Ridley (top) and John Stoddard (bottom) had to take the *GQ* logo into account, which meant posing their subject to one side.

131

POSTER

CLIENT *Perrier Ltd*
AGENCY *Leo Burnett*
ART DIRECTOR *David Owen*
PHOTOGRAPHER *Martin Thompson*
BRIEF *To produce a poster campaign to sell Perrier mineral water*

The campaign to persuade people to drink French mineral water was won by combining clever copy-writing with simple yet arresting photography. An ingenious marriage of a literal and visual pun is at the heart of the "rainbeau" picture. Together with his copywriter Richard Cook, David Owen came up with eight ideas, based on the "eau" theme, and emphasizing the distinctive bottle, that he translated into roughs. The best six were presented to the client, who eventually decided on this one and three others.

David then approached Martin Thompson and asked him to devise a way of shooting the rainbow effect in one shot. He says: "The easy option would have been to retouch the rainbow into the transparency. But I didn't want that. It would have looked retouched and I hate the effect. So I left the idea with Martin for two weeks to find a solution."

Martin was experienced in macro photography, which involves using a close-up lens to reproduce small objects in larger-than-life detail. Part of any good still-life photogra-pher's repertoire is the ability to solve complex visual problems. His first idea, based on a tried and tested technique, worked without a hitch (see right). Martin explained: "We tried pouring water through the bottle using a pipe. But that never works because the gas escapes and you get turbulence. So we did it by hand. The fizz was created by pouring water from an ordinary watering can. A sheet of diffused Perspex formed the background and the whole thing was lit by ordinary strobe flash equipment. It worked so well we finished early."

▼ **Working roughs**
The art director's initial rough (bottom) had to be translated into the shot opposite, which presented the photographer with some complex technical problems, since it was decided not to retouch the rainbow into the transparency. The diagram (below) shows how he worked out the angles to get the shot he wanted.

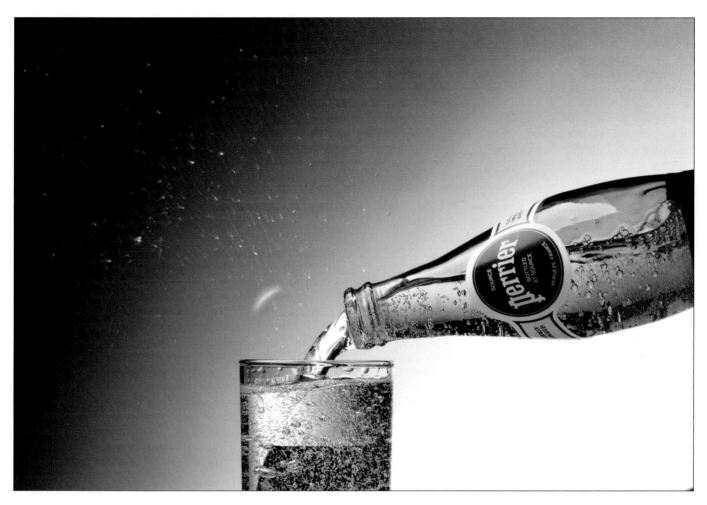

▲ The chosen shot
The tiny handpainted rainbow motif on gel was masked like a transparency, then mounted on an opaque Perspex "soft box" (flash diffuser). A semi-silvered mirror, which reflects (although apparently transparent) was angled between the camera lens and the still life until it caught the reflection of the projected rainbow, creating the illusion that it appeared above the glass. Black card arranged around the still life and the mirror prevented stray light causing unwanted reflections.

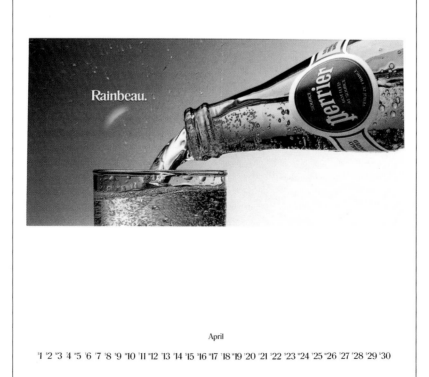

April

¹1 ²²2 ³³3 4 ⁰⁵5 ⁰⁶6 ⁰⁷7 ⁰⁸8 ⁰⁹9 ¹⁰10 ¹¹11 ¹²12 ¹³13 ¹⁴14 ¹⁵15 ¹⁶16 ¹⁷17 ¹⁸18 ¹⁹19 ²⁰20 ²¹21 ²²22 ²³23 ²⁴24 ²⁵25 ²⁶26 ²⁷27 ²⁸28 ²⁹29 ³⁰30

◄ Rainbeau in spring
The shot from the poster campaign was chosen to represent the month of April in a Perrier calendar based on the advertisements.

133

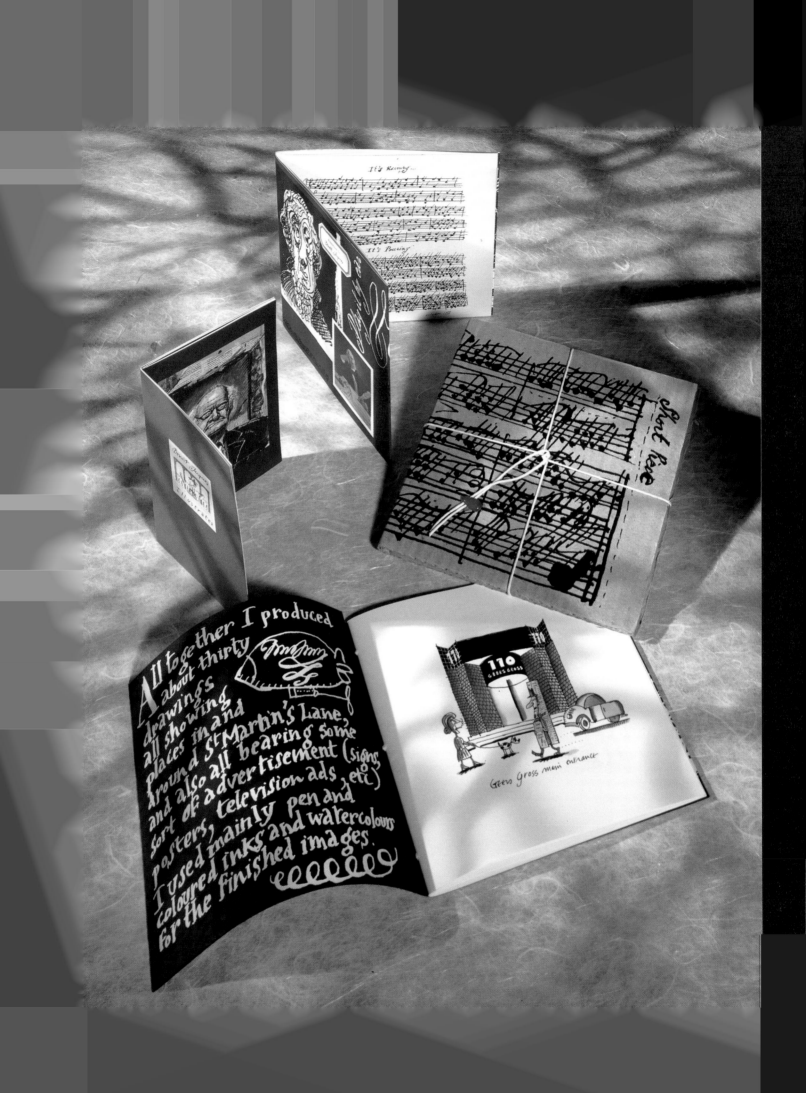

DESIGN AND ILLUSTRATION

The designer's role in commissioning illustration for publication can vary enormously depending on both the nature of the publication and the style and content of the illustration required. Changes in technology have made possible much wider variation in the kind of work that can successfully be reproduced in books, magazines and posters, for example from woodcuts to collage. Cheaper reproduction methods have also seen a resurgence in the use of illustration, which is enjoying a new-found popularity. In this chapter, **Martin Colyer**, an experienced magazine art director and **Amelia Edwards,** art director of the children's book publishers, Walker Books, explain the graphic designer's role in commissioning illustration in these two very different areas.

◄ **Promotion**
These three little books have been illustrated and produced by Benoit Jacques for promotional reasons. "Benoit Jacques illustrates" (centre) was a miniature version of his portfolio; "Played by Ear" (above), a collection of visual puns on music, is both promotional and sold in shops; Geers Gross Advertising initially commissioned a series of drawings of places in and around St Martin's Lane, London for their annual report, and then combined them in a little gift book (bottom) to celebrate their 25th anniversary.

Magazine design

The illustration in British early 1960s magazines such as *Town* tended to be very much of a kind, the sort of work that now looks like Letraset illustration. Even if you look back at early copies of the *Sunday Times Magazine,* which everyone agreed broke new ground, while the photography still stands up, the illustration simply seems to be a space-filler – rather dated and weak. By the late 1960s and early 1970s illustration started to free itself and move in a new direction, particularly in the USA, where artists such as Milton Glaser were being commissioned.

In the mid-1970s the initiative shifted back to England, notably with illustrators from the Royal College, following the lead of Peter Brookes, Mick Brownfield, Peter Till and Bill Sanderson, whose work of the early 1970s became very

▼ **Cover art**

Bill Sanderson's cover drawing illustrates *The Listener's* lead article about the pressure on today's sportsmen to win at all costs.

► **Theatre poster**

Andrzej Kranze has been working with The Old Vic for several years and has almost complete freedom to produce a poster just from reading the script and sometimes meeting the director.

influential. Peter Brookes was at the *Radio Times* with Nigel Holmes; Nigel produced the charts and Peter did the illustrations. Then, when Nigel Holmes went to the USA along with a couple of other designers, they began using English illustrators there, and so their influence shifted across the Atlantic.

By the late 1970s illustration had become fashionable. People recognized at last that illustration could be an exceptionally creative medium, and not only in its own terms. Its flexibility meant that it could deal with certain subjects that photography could never touch. From 1976 to 1980 the covers Bush Hollyhead did for *New Scientist,* for example, dealt with abstract ideas in a way that photography could never have handled.

One of the reasons for this change of course was that in the early 1970s illustration at certain art schools in Britain had become a part of the graphics course. Previously it had been seen purely as a craft in its own right, something set aside with its own niche, such as children's book illustration. Several art schools had good reputations for producing

graphic designers with a strong background in illustration. Out of the 18 students on the graphics course I took, six are now successful illustrators.

Design and illustration today

Commissioning illustration for a magazine depends greatly on the kind of magazine it is. On the *Observer Magazine*, where we might not know in advance whether we had four or five pages to fill, we might commission three illustrations, with a loose brief that the images could be used big or very small, depending on the space. The illustrator was then left to come up with something original and appropriate.

How you pick an illustrator determines the result you will get. You might choose an illustrator to match the subject. For example, on a story we carried once about the Virgin Mary, we chose an illustrator whom we knew would find it interesting and liked to do a lot of her own research. Her final illustration included a variety of symbols with which the Virgin Mary had been associated throughout history.

You can usually gauge whether a particular approach will suit a particular story, but some subjects are especially sensitive and difficult to translate into illustration. A story about child abuse, for example, needed a striking image, but one that was a hopeful rather than a depressing message.

Although it is often extremely difficult to get this kind of illustration right, when you do, it carries considerable impact. Paradoxically, the unreality of the illustration somehow makes the image more telling than a photograph would have been, rather in the same way that a black and white film

137

examples of illustration, or, just as bad, good illustration marred by unsympathetic typography.

One of the most important roles of the art editor is to marry the illustration and typography successfully. In the old days, in cases where the illustration and typography were done by the same person, this tended to happen naturally. Today there are very few graphic artists capable of doing the whole job in the way that, say Herbert Bayer did. His work was really integrated. The only equivalent modern example who springs to mind is Neville Brody, of *The Face* fame.

◄ Open brief
Gary Baseman was told to produce anything he liked for February's cover illustration as long as it had Valentine's day connotations.

▼ Poster illustration
Paul Cox was given a very open brief; it had to be bright and breezy, contain Scottish elements and promote the idea that driving a Morgan sports car is fun.

often seems more realistic than full colour. Presumably, in both cases, your attention is more concentrated.

Apart from having different tastes and opinions about illustration, every art editor and director works in a different way. Some have a very clear idea of the kind of illustration they want, and will provide carefully worked out roughs, so that ultimately the illustrator has very little creative freedom. I prefer to give the illustrator as much licence as possible. Although this carries more risk in terms of not getting precisely the kind of image you had hoped for, you can also get illustration of a much more creative nature than if you had simply laid down the framework yourself.

Illustration and typography

One of the problems with the use of illustration today is that there is now a wide division between illustrators and designers. In the 1940s and 1950s many designers and art directors did their own illustration and were highly regarded illustrators in their own right; people such as Tom Eckersley, Mervyn Kurlansky and Milton Glaser. Today, I do not feel that designers are in as much sympathy with illustrators as they were, say, 15 years ago. You often see very bad

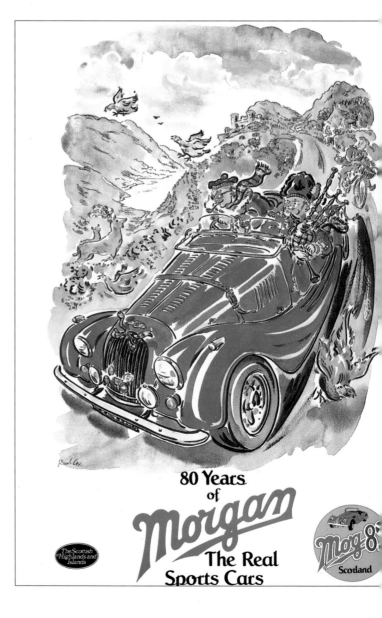

Uses of illustration

When I became art editor of *The Listener* (a job I held from 1982 to 1985) a tradition of illustrated covers had already been established. My predecessor, David Driver had commissioned Peter Brookes to do a black and white illustration each week, with a spot colour, usually red. Although it gave a unity of identity to the magazine, it also meant that no matter how good or clever Peter's drawing, it looked similar every week, and the overall effect on a bookstand was rather like wallpaper.

When we went over to full colour for the cover, we decided that we would stay with the tradition of illustration, and that the illustration would always be contained within roughly the same area, but that the subjects each week would be very varied. Even if we had wanted to go over to photography, it would have been difficult, given the nature of the magazine, the weekly deadlines, and the varied nature of the article. With illustration, if the subject is not particularly striking, the illustrator can create a twist to it in a way that a photographer cannot. For example, one of the subjects was "the New Man". The image we produced was a heroic poster pastiche in a twenties or thirties style of a strong, muscular man with a tear rolling down his cheek. Although we could have set that up as a photograph, it would have lost the element of parody.

Another example of a difficult subject was an article on "Biotechnology – the new industrial revolution". Bill Sanderson produced an image for this of Mercury, the winged messenger, bringing a DNA spiral to the old industrial revolution imagery. It was a good way to visualize the subject, and fortunately Bill is so good at organizing the elements of his illustrations dynamically within the frame that even if you do not immediately grasp the significance, you can still find them extremely interesting to look at.

▲ Multi-purpose design
Andre Klimowski created 40 related images combining photography, collage and painting for record sleeves, posters, t-shirts and a video promoting the band, Thrashing Doves, in an exciting collaboration between himself, the band and A & M's art director.

▼ Editorial illustration
Andrzej Kranze regularly illustrates articles for *The New Statesman*. He is sent the article and given the freedom to produce appropriate illustrations, such as this pen and ink cartoon.

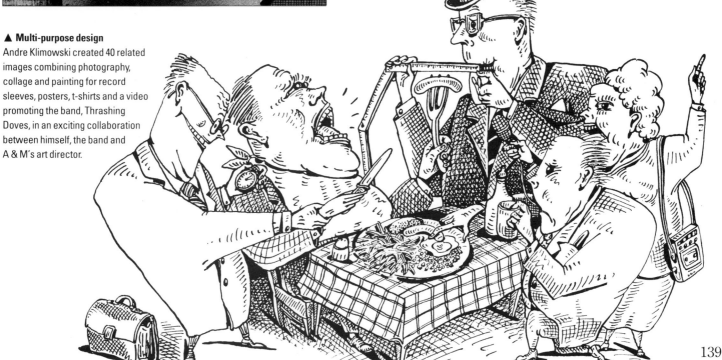

BOOK COVER

CLIENT *Bloomsbury Publishing*
ILLUSTRATOR *Jeff Fisher*
AGENT *None. Commissioned direct by Liz Calder.*
BRIEF *To produce a cover illustration for* Sexing the Cherry *by Jeanette Winterson.*

◀▼ First roughs
My first roughs in which the elements of the illustrations were more or less decided upon but in which I was still playing around with the style and size of the typography, although I had already made up my mind that it would be hand-lettered.

This cover was commissioned by Liz Calder at the book publisher Bloomsbury in 1989. I do quite a few covers, and normally I am sent the manuscript to read and left to come up with a couple of initial roughs. I sometimes do pencil roughs, but in this case I needed to work the idea out for myself, and so I did them in colour. My main concern was what to do with the type.

Although it can be hard to hit on an idea for a boring manuscript – is a boring cover the answer? – in this case the manuscript presented another problem – it was terrific. It was packed with images, particularly of fruit, hence the choice of the banana on the cover, which was irresistible and needed to be as large as possible. Coming up with a cover for a great book can be terrifying, though it's always enjoyable.

Once I have worked out the basic idea, and the rough has been approved, it usually takes only a couple of days to complete the final artwork. In this case the final artwork was in acrylic and ink, with the type hand-lettered.

The more open the brief, the more I enjoy the work and the better the result usually is. A lot of companies have a set format for their covers – Faber and Faber, for example, puts all the type in a box (which would solve a few of my problems) – but I quite like doing the type myself.

I have agents, though I usually work directly with the designer or with the client as in this case.

140

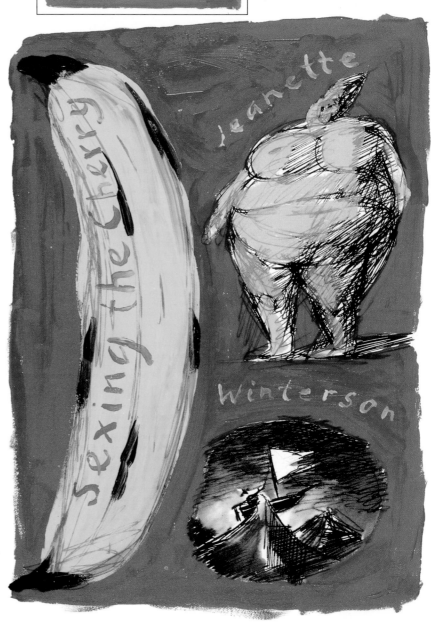

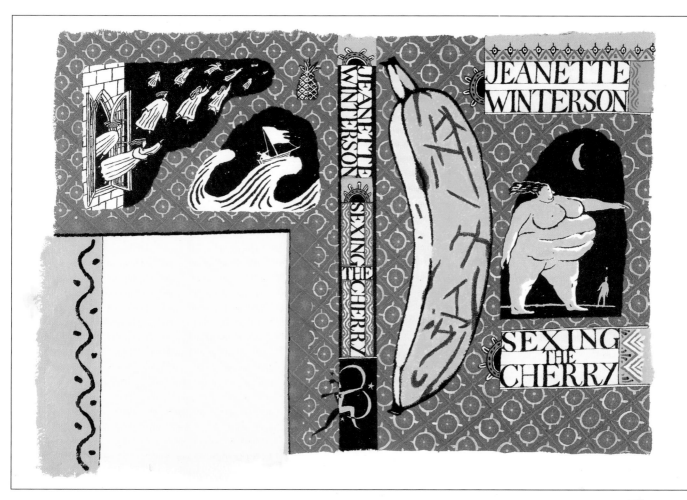

▲ The final artwork
The artwork was in acrylic and ink. The red background was chosen, but with a pattern added, and some of the images previously on one of the roughs were moved over to the back cover.

▶ The printed cover

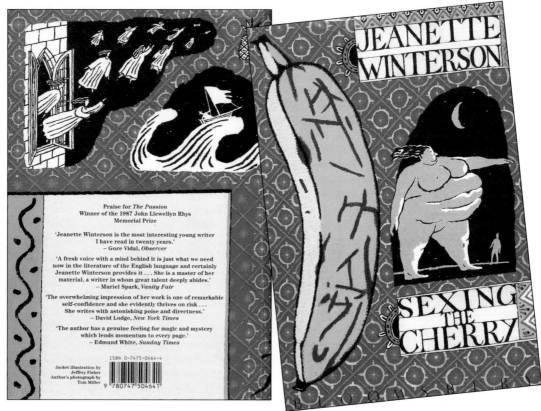

141

ADVERTISEMENT

CLIENT *Scottish Amicable*
ILLUSTRATOR *Dolores Fairman*
DESIGN GROUP *Ogilvy & Mather*
AGENT *Sharp Practice*
BRIEF *To produce an illustration for a nationwide colour press advertisement campaign.*

To be given this job was particularly flattering to me as a virtual beginner in illustration. Derrick Haas, then at Ogilvy & Mather, called me in, having produced a series of roughs in my style. The agency was producing a nationwide colour press campaign, and the brief was very tight, but as the roughs had been produced originally by reproducing the style of my then business agency card, it was not hard to follow.

The only problem I encountered on this job was that it repeated an illustration style of mine that was rapidly becoming out of date – the original artwork for the business card had been produced two years earlier. It is easy to get into a rut with an illustration style that you have become unhappy with, and yet find it difficult to break away, because you are continually receiving commissions based on that style.

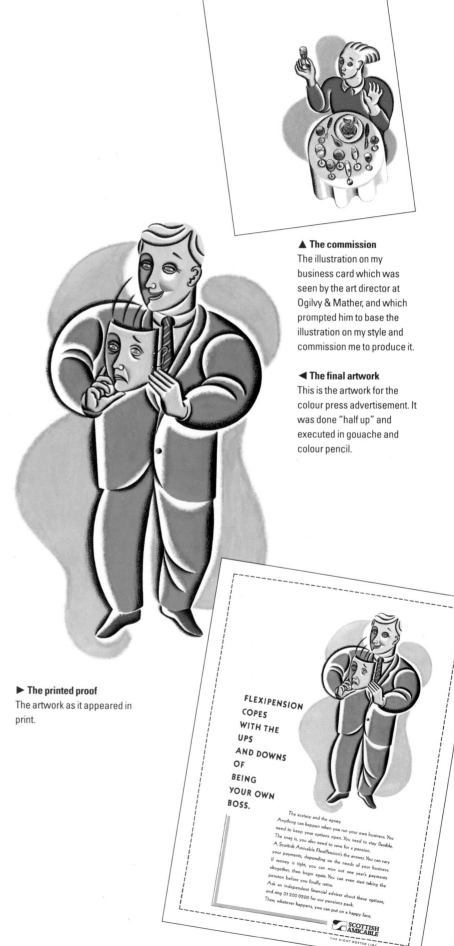

▲ The commission
The illustration on my business card which was seen by the art director at Ogilvy & Mather, and which prompted him to base the illustration on my style and commission me to produce it.

◄ The final artwork
This is the artwork for the colour press advertisement. It was done "half up" and executed in gouache and colour pencil.

► The printed proof
The artwork as it appeared in print.

FLEXIPENSION
COPES
WITH THE
UPS
AND DOWNS
OF
BEING
YOUR OWN
BOSS.

The ecstasy and the agony.
Anything can happen when you run your own business. You need to keep your options open. You need to stay flexible.
The snag is, you also need to save for a pension.
A Scottish Amicable FlexiPension's the answer. You can vary your payments, depending on the needs of your business.
If money is tight, you can miss out one year's payments altogether, then begin again. You can even start taking the pension before you finally retire.
Ask an independent financial adviser about these options, and ring 01 200 0200 for our pensions pack.
Then, whatever happens, you can put on a happy face.

SCOTTISH
AMICABLE
THE RIGHT DOTTED LINE.

142

SET OF PRINTS

CLIENT *3M*
ILLUSTRATOR *Dolores Fairman*
DESIGN GROUP *Addenda*
AGENT *Sharp Practice*
BRIEF *To produce an illustration for a set of limited edition prints depicting 3M's history for its 60th anniversary in the UK.*

This job was one of a series by various illustrators. A different illustration was chosen for each decade of the company's history. I was assigned the 1930s and given a rough layout which suggested a landscape format for the artwork. The brief was open – it was left entirely up to me as to how to illustrate the period. I had only to make the faintest of reference to the company, just enough to give a positive feeling of its achievements and activities during the decade. I was chosen to do the job as I am influenced by the machine age and I welcomed a chance to express myself in terms of machines, architecture and so on. In fact the final style is slightly more derivative of the work of artists of 1907-29.

When I received the final proof I was surprised to find that the format seemed to require a portrait image and my illustration appeared the wrong way up. I don't know how this happened or why I was not told to change it. All the other illustrators submitted a square or vertical image, so maybe they were better briefed initially.

▲▲ The rough
One of the nicest features of this job was that very little change was asked for at the rough stage. "Unemployment" became "Productivity", because 3M wanted to indicate that during the Depression they had still been able to maintain their business.

▲ The final artwork
The artwork in collage and gouache was done fairly large, to fit an A3 sheet, although it was eventually reproduced much smaller.

▶ The final printed proof
The prints were offered both individually and loosely bound into a booklet. Mine was the only illustration not commissoned to a square or rectangular format and so it appears to be the wrong way up.

143

Children's book design

I sometimes give one of our books as a birthday or Christmas present to a child I know, and I am invariably asked the same questions: "Did you do the illustrations?" "No". "Did you write the story?" "No". "What *did* you do then?"

Children are not alone in wondering what exactly the designer's role is in picture books. Children's book design has not really been developed yet as an independent design discipline, and although art schools train students in illustrating children's books, very few offer any training on the design side.

The designer of children's picture books needs common sense, a good sense of timing (to pace a story well), knowledge of production methods, a feeling for type and composition, and the ability to select typography that is compatible with the illustration style.

As far as the design work is concerned, the typography is the strongest element, but the production of the book is crucial too. The more a designer knows about production, the better equipped he or she is to work within its limitations when necessary or to break the rules sensibly to create a book that works.

However, the designer does not work in isolation and all design decisions are the subject of endless meetings. It is, after all, the job of the designer and editor to understand what the author and illustrator want, and to help them achieve it.

The production of the book

Most children's picture books start with the author. It is his or her task to write a good story, which a team of people then turn into a book. Once the story is written, the type is set before the illustrator gets to work, so that everyone is aware of the typography from the start.

Although the author's original idea is rarely altered, the designer and editor are involved in the pacing of the story, and it is the designer's job to commission and organize the illustrator.

The development of the book involves a great deal of discussion. There is usually a development session with

▲ ▶ The Dancing Class
This book by Helen Oxenbury (1982) was one of the earliest ones we produced in the small format. It illustrates the point that when the artwork is as beautifully observed as Helen's is, it needs minimal design involvement. In fact, it is quite hard not to fiddle with the design, and in this case, the simpler the concept, the better able the reader is to concentrate on the story.

'We'll take these tights. She'll soon grow into them.'

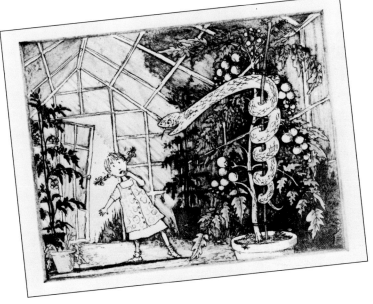

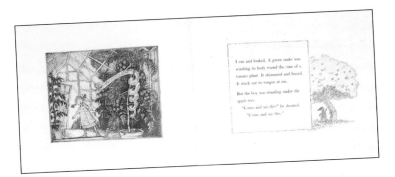

▲ Helen Craig

In the illustrations from *The Yellow House* (1987) we experimented with the way the artwork was produced. Normally the black in four-colour books is made up of the four process colours, but in this instance we wanted the black line to be truly black. Helen handprinted the original black and white etching (top), and then coloured it on the reverse (centre) so that when it was printed (bottom) the black was reproduced separately, giving the book a much more traditional feel.

▲ The Hidden House (1990)

An illustration by Angela Barrett for Martin Waddell's text. This is another very traditional style, done in pencil rendering and very gently coloured with watercolour. The typography underlines the point that this is a serious book, and we used Berkeley Old Style in a fairly large size. The choice and positioning of the typography is a key element in designing children's books, and it is something that is often not sufficiently considered. Sympathetic use of typography makes a considerable difference to the atmosphere of the story.

each story where the characters, the style of the book and the illustrations are all discussed. When we feel we are on the right track, we show the book to prospective foreign publishers. If the ideas are well received, we carry on. If not, we stop and rethink. If, for example, it is felt that the style of the illustrator chosen does not match the story, the illustrator is not simply cast aside. By that time, you have learned a great deal about the way he or she works, and if you believed in the illustrator in the first place, you try to find another story which will work better with that particular style. Half the skill of the designer in producing picture books is to be able to marry the right illustrator to the right text.

The qualities of the designer

When I interview a designer, one of the first attributes I look for is a love of illustration and an appreciation of different, even contrasting, styles. But many other skills are needed, not least a sensitivity towards the authors and illustrators you work with, as well as a sense of humour and patience. The latter is important, because the designer may well have to change ideas right up to the last minute of production.

The ability to work as a team is also important. Our editors and designers work closely together, and the relationship between them and the author and illustrator is crucial to the success of the book.

145

Production skills

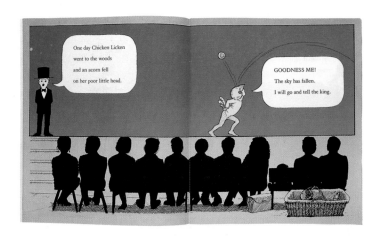

The designer should be the person on the team who is most aware of the demands of production, because production techniques are the real key to the final organization of the book. Some elements of children's book publishing require very specialized knowledge – for example in novelty books where the construction of the books involves skilled paper engineering, which is an art in itself. Even at the presentation stage, when we are still testing the idea in the marketplace, the text and illustrations have to be mounted up properly, and dummies organized, so that the sales team can make their best pitch on behalf of the book.

Much of the production knowledge is acquired by experience, and each book presents a new set of problems for the designer. In the *Chicken Licken* book, for example, the artwork goes right across the gutter on each spread, and because the colours were laid down in stripped-in tints, we ran the risk that they would not match in the printing. In the end, the printer simply had to take particular care, although

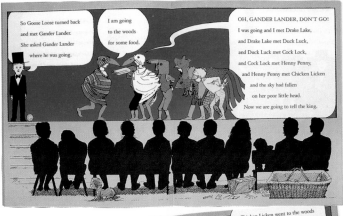

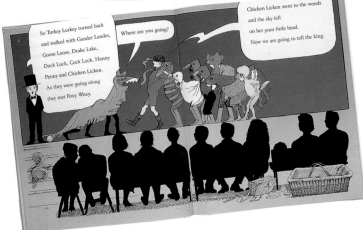

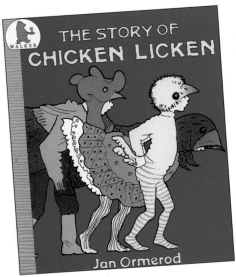

◀▶ Chicken Licken

The cover (left) and (right) a sequence from the story. This is an interesting variation in the way that children's illustrated books are normally produced. Jan Ormerod uses black line and brush and quite a flat painting style. The story (about a baby who crawls out of his basket during a peformance of a school play, and makes his way onto the stage) demanded a similar backdrop for each spread, and rather than ask the illustrator to create this with paint, we decided to get the printers to strip in tints. It was a bit of a risk because there was always a danger that the tints would not match up across the spread. However, it saved the illustrator a lot of time and trouble and also ensured uniformity in the colour.

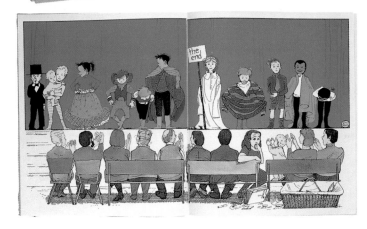

he was helped by the fact that the printing was sheet-fed, so that it was easier to get the pages to marry up than it might have been with a different printing method.

As another example of a production problem, most of our books are sold to the USA where "library binding" is often required because it is more durable. This binding eats up about ¼in (6mm) of the artwork in the centre of the book, so the book has to be designed with the gutter in mind. The printer will have to split the film and open it up, so the designer must be careful that the amount trimmed off the illustration on the far side of the page does not kill the picture or unbalance its look.

Changes in modern technology have created wonderful opportunities for designers. Several years ago when I was working in the USA the artwork had to be prepared for the printer in a certain way and artists went to a lot of trouble to get it just right. Nowadays, the technical skills of reproduction and printing have moved way ahead, and the artist can do almost anything he or she pleases, even collage.

The computerization of the process has also given us wonderful opportunities: for example, nowadays you can have one figure picked out of a large piece of artwork and printed on its own absolutely beautifully. Years ago this would have involved so much hand work that you would have had to go back to the artist and ask for a redrawing, which would have added a lot to the book's budget.

In picture books, the designer often marries traditional skills with modern technology to get the best of all possible worlds. For example, I have been working on a book that uses traditional hot-metal typesetting, because I feel the traditional look really suits the book; but I have still used an Apple Mac computer to play with the organization of the type on the page.

Covers

The covers of children's books are particularly important, and difficult to design, because of the tremendous competition that exists in children's publishing. Above all, the cover has to sell the book, and the design demands it imposes are rather different from those involved in putting the story together. Usually one designer does the story, and another designer will do the cover because a fresh eye is needed to pinpoint the elements of the story most likely to work effectively on the cover.

There are many fine points involved in cover design which the reader would never even notice unless the designer had got it wrong. For example, the cover is a couple of millimetres larger all round than the text pages of the book,

▲ **The Hidden House**
Since most of our books are printed in more than one language, it helps in production terms if the title is contained on a separate black plate, so that the entire four-colour jacket does not need to be reoriginated. In this book, the words were reversed out of the black so that only one plate change was needed for foreign editions. The end papers were designed to be in keeping with the colour and style of the drawing.

and the turnover of the cover colour makes a frame for each spread of illustration. The colour therefore has to be considered carefully so that it complements the illustrations rather than destroys them. (The same applies to the end-papers, which are also seen alongside each page of the book as it is turned over.)

One of the most fascinating aspects of working in picture books is that there is so much to learn in so many different areas. We are constantly experimenting, trying out new ideas, testing new methods of production. The designer possibly has a more subtle influence than in other areas of book publishing where the design controls the appearance of the book to a greater degree. In children's picture books the very fact that you are unaware of the designer's hand at work means that he or she has done a successful job.

case study

CHILDREN'S BOOK
PUBLISHER *Walker Books Ltd*
ART DIRECTOR *Amelia Edwards*
ILLUSTRATOR *Helen Oxenbury*
TITLE Going on a Bear Hunt (1989)

◄ **We're Going on a Bear Hunt** (from the top of the page downwards) The cover (its black and white illustration on a cream background runs contrary to normal cover design), the end papers, the title page and the first colour illustration in the book.

There are some unwritten rules for producing children's books for today's market. They are normally printed in full-colour, with a full-colour jacket, which is designed to withstand handling by small fingers.

In *Going on a Bear Hunt*, we broke all the accepted rules. We used black and white illustration, interspersed with full colour; we made the book 40 pages long, because that was what the story demanded, although for reasons of economy of printing, books are normally designed in 16-page sections; we gave the book a much larger format than usual, which again is expensive to produce, and finally the dust jacket had an unlaminated cream background and therefore had to be shrink-wrapped to protect it.

We did not break the rules for the sake of it, but because we all felt that the book deserved individual treatment. We also broke with convention over the design of the pages. The story builds up to a climax when the bear is finally found (see far right) and then there is a change of pace as the children retrace their steps; we adopted the rather cartoon-like device of repeating the illustrations much smaller, with several to a spread.

The book had a higher cover price than most children's books because its production was more expensive. With all these factors you might expect that the book would not succeed in the market place, but in fact it is a best-seller in several countries, and in the United States it is now in its third printing.

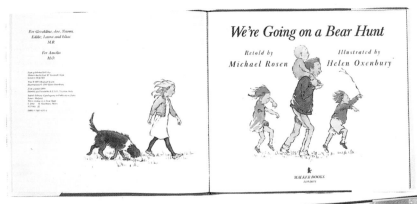

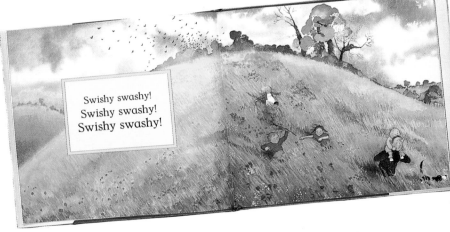

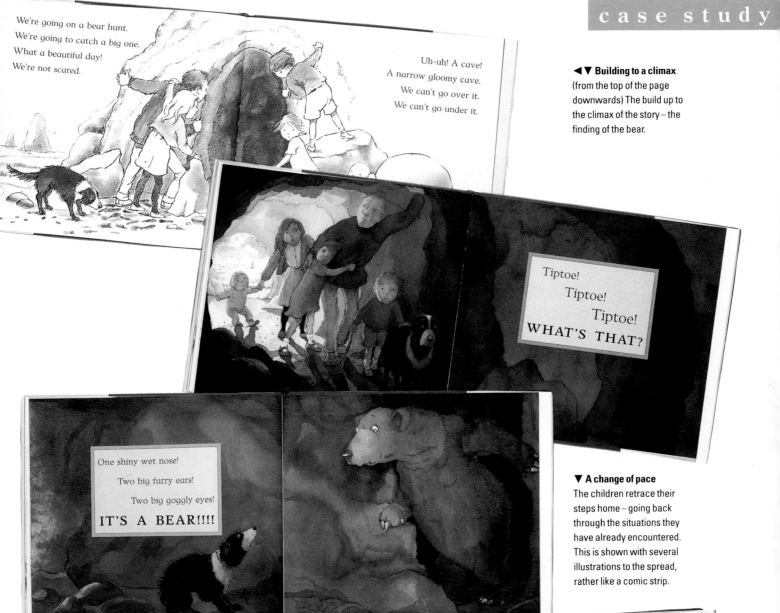

We're going on a bear hunt.
We're going to catch a big one.
What a beautiful day!
We're not scared.

Uh-uh! A cave!
A narrow gloomy cave.
We can't go over it.
We can't go under it.

Tiptoe!
Tiptoe!
Tiptoe!
WHAT'S THAT?

◀▼ Building to a climax
(from the top of the page downwards) The build up to the climax of the story – the finding of the bear.

One shiny wet nose!

Two big furry ears!

Two big goggly eyes!

IT'S A BEAR!!!!

▼ A change of pace
The children retrace their steps home – going back through the situations they have already encountered. This is shown with several illustrations to the spread, rather like a comic strip.

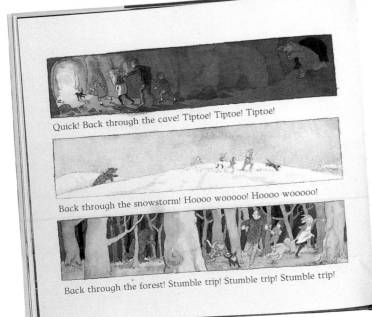

Quick! Back through the cave! Tiptoe! Tiptoe! Tiptoe!

Back through the snowstorm! Hoooo wooooo! Hoooo wooooo!

Back through the forest! Stumble trip! Stumble trip! Stumble trip!

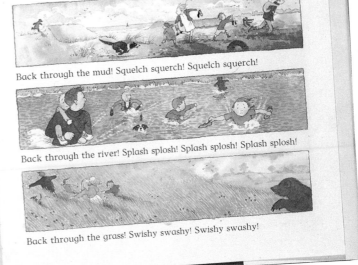

Back through the mud! Squelch squerch! Squelch squerch!

Back through the river! Splash splosh! Splash splosh! Splash splosh!

Back through the grass! Swishy swashy! Swishy swashy!

DESIGN AND TIME-BASED MEDIA

Time-based media depend on the sequencing of information over a period of time. Those that call for graphic designers – film, video and slide projection – all demand that graphic communications be considered as sequences, made up of individual "frames" of information presented to an audience through time.

For the last 20 years graphic designers have been playing an increasingly important role in audiovisual presentations, video and broadcast television. Traditionally, graphic designers worked exclusively with print, producing two-dimensional static images and type to be reproduced by any of a number of different printing processes. Now the situation is different, and the designer's portfolio is as likely to include titling sequences for television and storyboards for commercials as it is samples of printed work.

Introduction

Broadcast television is the largest market for time-based graphics, which make up some 10 per cent of total programming time. Every television company has a "station ident" – an animated logotype – which is broadcast frequently during programming to remind viewers of the station they are tuned to. Every programme includes a title sequence and a credits sequence. Adverts, news, current affairs, and science and technology programmes will feature typography, information graphics (maps, charts, graphs, explanatory diagrams and animations), innovative animated lettering and other graphic devices.

Television is not the only time-based medium that uses graphics. There is a large and growing industry producing video programmes for non-broadcast use – for corporate clients who need promotional, training and educational programmes, and for the domestic consumer. There are specialist companies producing "interactive" training and customer-information programmes on videodisc, film companies requiring titling, credits sequences and information graphics. In addition, a large and successful audiovisual industry produces promotional and conference programmes using a variety of slide and video projection technologies.

What all these media have in common is that to varying extents they rely on the graphic designer to organize the production of all the typographic components involved in the programmes. In television especially (where there is a constant requirement for better ways of explaining the complexities of economics, politics, international affairs, environmental issues and other subjects), it is the graphic designer who is called upon to design diagrams, maps and charts to support the linking commentary.

There are also some technological reasons for the ascendancy of the designer in these media. In the early 1980s television companies began to use "paintboxes" – special-

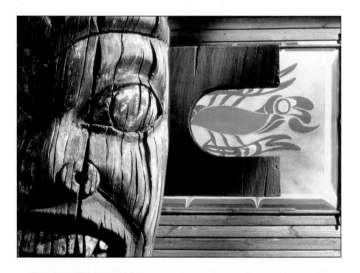

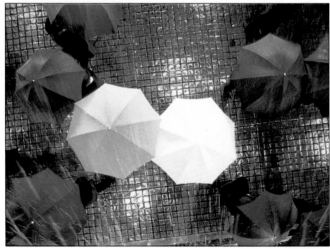

ized computers dedicated to graphics – instead of traditional film-based, print-based and handicraft methods. In the hands of skilled operator/designers, paintboxes are able to speed up the production of a wide range of graphics applications, and additionally to animate them, to integrate lettering, still and motion video images, and to store complete sequences ready for videotape or live output. The designer/operator of the paintbox has become a key component in the production of news and current affairs programmes. As graphics production is now almost entirely digital, the aspiring television designer must be familiar with a broadening range of software and hardware – not only to create graphics sequences, but also to enable him or her to design for their production. Television graphic designers also need a wide range of traditional graphics skills, as they are responsible for the design and production of all the graphics props used within programmes.

In addition to these traditional skills, to be successful in the design and production of time-based graphics the designer must be able to (1) originate sequential presentations of ideas in response to the client's brief; (2) develop these sequences as coherent "storyboards", showing how images and audio will work together to deliver the necessary information content; and (3) understand enough of the technical processes involved in video and computer graphics production to be able to plan sequences to a specific budget and schedule.

THE GRAPHIC DESIGNER'S role varies according to the production requirements of the medium.

Broadcast television: All television companies which produce their own programmes use graphic designers to originate all the graphic content of those programmes. This usually includes an opening title sequence, programme credits, and all graphic props, illustrations, diagrams and animations necessary for the programme content. Further to this, designers are also required to work on sequences that promote programmes. The designer will be responsible to the director or producer of the programme, working as one of a large team of specialists. As most television directors do not have any formal training in the visual arts (most are from a literary or production background), it is the designer's role to interpret graphics in a style relevant to the programme content. Television companies increasingly use independent design or design and production companies to supply their requirements.

Video: While some larger companies employ full-time graphic designers to work on some of their productions, a large amount of graphics work is contracted out to freelance designers and design groups specializing in videographic and computer graphics.

Audiovisual: Digital technologies are blurring many of the traditional demarcations in the audiovisual business. Companies use a variety of photographic, computer and videographic technologies to service product launches, promotions, exhibitions and conferences. Specialist marketing and conference production companies often employ full-time designers, but perhaps use outside design groups for prestigious events. As most slide production is produced using digital paintboxes, audiovisual companies usually employ graphic designers who are also experienced in machine operation.

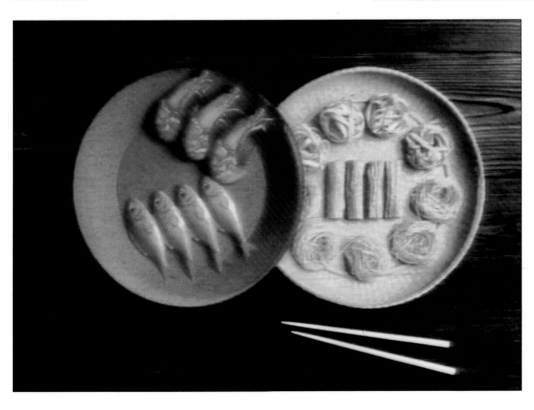

◀ **Access commercial**
In this Young & Rubicam commercial for Access, the agency's concept was to run a campaign based on the actual symbols appearing on the credit card, shown in a suitably international context. The design group English, Markell, Pockett created a storyboard of various international scenarios involving the symbols. After approval by the agency, these were then produced using a variety of different media, including live action, model animation and paintbox. E.M.P. are an outstanding example of what happens when brilliant designers utilize a broad range of the latest image-making technologies to succinctly communicate a set of moods and ideas. The first key frame was also produced as a printed magazine ad.

153

Film and video

While much of a broadcast-television company's output is direct to videotape, film is preferred for quality drama productions, and is still used extensively in animation. And, as much of the basic vocabulary the designer uses is derived from traditional film practice, it is necessary to know something of film animation techniques.

Film

Film has many advantages over video. It is a very high-resolution medium, has a much broader sensitivity to light, and film images do not degenerate through copying as rapidly as video. Programmes originated on film can be telecined (processed onto video) in any of the national TV standards. On the other hand, film requires extensive and expensive processing. Film is projected at 24 frames/sec, while video is displayed at 25 frames/sec (30 frames/sec in the USA) which can create problems when film is converted to video.

Film animation techniques

Animation can be produced in several ways, but the major processes are cel animation, model (or object) animation, and stills compilations. These animations are generally recorded on film, but they can also be made on video, and both the cel and model processes have been used as models for paintbox and general computer animation.

The rostrum camera

This is used to photograph animations one frame at a time. The set-up consists of a film camera mounted on a rostrum, the table of which can be moved in precise vertical, horizontal and rotational increments. Some animation cameras, such as the Oxberry, also allow the synchronized, frame-by-frame back projection of motion picture footage, so that film and animation can be mixed into a composite. A similar technique of back-projection is used to produce "rotoscoping" in which animations are derived from live-action footage.

Cel animation

This process involves producing a drawing for each frame (or every second frame) of film. Drawings are produced on standard-size, acetate sheets known as "cels" (from "celluloids"), which can be superimposed over photographic or painted backgrounds, or over other cels. Cels have holes punched in them, and are held in register with each other by placing them on a peg bar. A series of key frames are developed by the animator describing each main movement in the animation. To link key frames together in a continuous sequence of drawings is called "in betweening".

When the black and white drawings are all complete, they

▶ **Wired titles**

This sequence was produced by Snapper Films from a very loose brief – a title sequence for a music show featuring all types of music, that would be transmitted by satellite. The chosen solution was a computer graphic music carnival set against monochrome live action footage, which was shot from specially prepared models using a motion control camera. The computer animation was carefully storyboarded, and ideas for animation and live action developed in parallel. Next, a short sequence of cel animation was produced to indicate the required style for the computer animation company (Digital Pictures). All these components were married together using the Quantel Harry system.

are photographed frame by frame and the resulting film, called a "line test", is used to check the success of the animation. To complete the production, cels are inked and painted, backgrounds are prepared and a "dope sheet" produced. This gives frame-by-frame instructions to the camera operator on sequencing and superimposition of cels, and background and camera movements. Then a final rostrum shoot is carried out. Animated sequences are often planned to synchronize with an existing audio track.

Model (object) animation

This technique requires the construction of three-dimensional models which are positioned in a purpose-built set. The models are then moved repeatedly according to the requirements of the sequence and each movement is photographed until a complete animation is produced.

Stills compilations and animatics

The production of moving footage from stills can be achieved in a variety of ways using a rostrum camera. Stills can be moved and rotated under the camera so that the camera seems to pan or track across a still image. Zoom-in and zoom-out techniques can focus on a particular detail, or reveal the whole image. These techniques can form part of a finished production, or they can be used to produce "animatics" (see below) – limited animations that reveal the potential of the storyboard ideas. These are extensively used to check the effectiveness of adverts for television.

Computer animation and videographics

Animations or still graphics can be recorded to videotape (or fed "live" into the video edit suite) by using a video rostrum camera. Type (or, more correctly, lettering) can be added to video by this means, but there are two other main methods: using a paintbox (see p159), which allows still frames and sequences of video to be "grabbed" (digitized) and the type added digitally (the paintbox stores hundreds of different fonts). The resulting images can then be manipulated and processed, either individually or as a composite image. Another widely used method is the "character generator", which allows type to be superimposed over motion footage.

General-purpose computers are also used to create complex "solid modelled" animations. Virtual 3D models – such as letterforms – can be constructed and manipulated in space, and recorded frame by frame to film or videotape. Output from smaller computers is generally not good enough for broadcast television, but these machines are increasingly used by designers to try out storyboard ideas.

▼ **Tom Jones video**
A combination of live action video and cel animations went into this pop promo by Molotov Brothers for Tom Jones and The Art of Noise. Tom Jones was shot against a white studio backdrop, into which the two animated components were chromakeyed. Cel animations of the background images were shot on film and then telecined to video, while the typographical sequences were produced in monochrome and then animated direct to video.

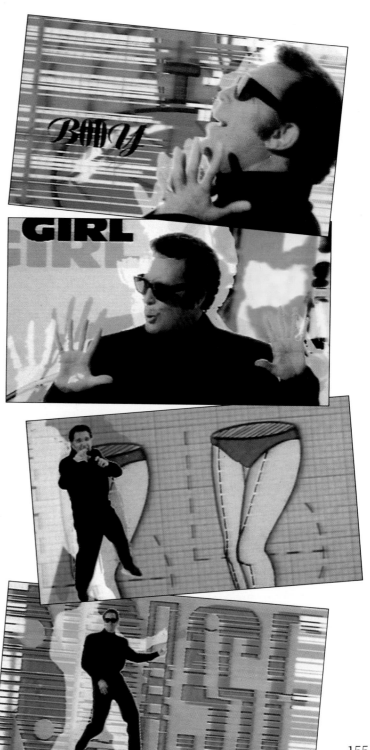

Audiovisual Media

The 35mm colour slide is the standard unit of audiovisual presentations, and is still the best way to achieve high-resolution, large-scale images by projection. Other standard technology includes the rostrum camera (for photographing or digitizing flat artwork, and the Kodak Carousel projector, so called because it accommodates a circular magazine (holding 80 slides). The Carousel can be fitted with a servo-assisted, random-access selector, so that slides need not be viewed in a set sequence. Apart from slide projection, other alternatives are videobeam projection and "videowall", driven from videotaped and live cameras as well as real-time output from a paintbox. The paintbox can also store complete sequences of frames and display these in sequence through a videobeam projector, or through a bank of monitors. Digital transition effects between successive frames can be preprogrammed to an exactly timed schedule, or controlled manually to synchronize with a live speaker or other performance. Slide-based audiovisual sequences can be transferred to videotape (for archiving, or for replay elsewhere) by means of multiplexing. Audiovisual work varies from simple, single-projector sequences for intimate business presentations or for speaker-support work at conferences to vast multi-screen shows.

Storyboard design for multi-screen and multi-projector shows requires a more complex storyboard that shows clusters of screens, so that the designer can build up an accurate visualization of the necessary sequencing. Graphics slides are mainly produced using paintboxes (such as Quantel or Spaceward Supernova) and output direct to 35 mm transparency through a pin-registered RGB camera. These images can then be compiled with other photographic material into multi-image sequences, and their sequencing and timings controlled from a master multi-track audio tape. This tape carries stereo audio and two other tracks – a clock

▼ Projection deck
Over 90 Carousel projectors, each carrying 80 transparencies, all arranged in a deck under the control of a computer program. Massive rigs like this are used in spectacular multi-image/multi-screen presentations.

track which provides timing data for synchronizing all the component images and audio, and a "positrack", which holds digital code from the controlling computer. This code in turn controls the projection devices, and special effects and dissolve units, as well as spotlighting, audio source and amplitude, and so on, for the entire performance.

Audio media for graphic designers

While the graphic designer will not be directly involved in audio production, it is useful to have an overview of the processes involved, as the success of an audiovisual presentation hinges upon the inter-relationship between the images and audio tracks, and in many audiovisual shows the image sequences are driven by a prerecorded audio tape. Whether the audio track is especially composed or made up of excerpts from sound-library material, or is simply a recorded commentary, the end result will be a multi-track recording which can be mixed-down onto stereo channels on a four-track audio tape. Basic techniques for synchronizing images allow the designer to arrange the sequences of images so that cuts (and other image transitions) occur on the beat (or on the off-beat) of any music track.

▼ **Sample frames from an A/V presentation**
These frames are illustrative of the type of sophisticated graphics frames produced on top-end desktop systems and paintboxes. Software, such as Powerpoint and Cricket Presents, provides typesetting, image-making and layout tools for the design of individual frames, and sequencing programs to test the presentation on-screen. The computer images are then output to a high-resolution RGB camera and recorded on 35mm transparencies.

The Design Process

The design process for time-based media is broadly similar to that for producing graphics for print, but the end product is different in some very important respects. Graphics that are shown as sequences must communicate information in a fixed amount of time (unlike books, for example). Also, television and film have a fixed landscape format, and are viewed in very different ways.

Brief: The programme's director will brief the designer. Very few directors and producers have had professional training in graphics, and they may only have a very general idea of what they want and of how it can be produced. Therefore at this stage it is vitally important for the designer to understand the director's requirements – in terms of the ideas and information to be communicated, the amount of time available, and in terms of the style appropriate to the programme as a whole. Apart from listing the graphic requirements, the designer must ascertain how much money is available for graphics production (this will determine the mode of production to be used), and the schedule.

Concept: The designer's first creative task is to produce a range of ideas in response to the brief. These may be talked through with the director and a general approach to the problem agreed on. The concept stage is really one of visual problem-solving, and the range and quality of proposed solutions to the problems set by the brief will be a gauge of the designer's creativity, technical skills and experience.

Design: When a general approach (a concept) has been agreed on, the designer must translate the concept into a storyboard. Depending on the designer's relationship with the client, and on the client's visual literacy, the storyboard may be either a set of rough thumbnail sketches or worked up to a "presentation" standard, with the key frames in the sequence rendered to a very high quality. Each of the frames in a storyboard must be considered both as two-dimensional graphic frames and as part of a sequence of images developing through time.

Storyboard: The storyboard is the means through which the designer's ideas are communicated both to the client and ultimately to the production team he or she is working with. It must do three basic things. First, it must successfully encapsulate the concept and explain visually how this will work as a sequence of images. Secondly, it must give the

▲ **BBC 9 O'Clock News titles**
This sequence by Robinson, Lambie-Nairn was designed to reflect the historical reputation of the BBC news, but also project a modern image. They used 3D computer animation, Pluto paint system and Macintosh desktop graphics, live action and hand animation. Some 250 different layers of images were integrated (matted) together using a Quantel suite of Harry, Paintbox and Encore.

PAINTBOX is a system that comprises hardware and software designed by Quantel, and is linked to a powerful minicomputer. The designer's workstation is the machine's "front end", consisting of a high-resolution colour monitor, a digitizing pad and a stylus. This hardware drives sophisticated graphics and painting software that provide digital equivalents of conventional typesetting, graphic design and paste-up, illustration, airbrushing and retouching processes. Images can be input directly through the digit pad, or input from video tape, or through a video camera.

In addition to the basic Paintbox there are a number of extra Quantel products that are used by most broadcast-television companies and some facilities houses. These include "Digital Library Systems" (DLS), which offer recording, storage, presentation and management facilities for large quantities of still television images. The "Mirage" system enables designers to form television pictures into three-dimensional shapes and move them through space. This can be done in real time (i.e. with motion pictures), either "live" or in the edit suite. Another system, "Encore", also offers video manipulation facilities, including zoom, compression, positioning, rotation and perspective.

The caption generator "Cypher" provides over 1400 typefaces, and offers the designer control over kerning, letter, word and line spacing and justification. Cypher captions can also be manipulated as Encore images. "Harry" and the even more sophisticated "Henry" represent one of the most important innovations in television production. A user-friendly companion to the basic Paintbox, Harry is a real-time video animation system, allowing cel animation, video retouching, matte generation and video rotoscoping. Up to 90 seconds of video can be stored and retouched frame by frame, and the modified result can then be edited and replayed in real time.

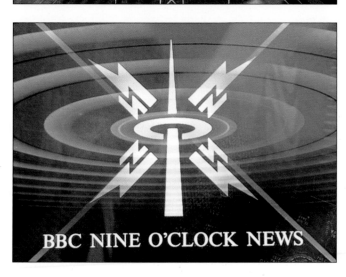

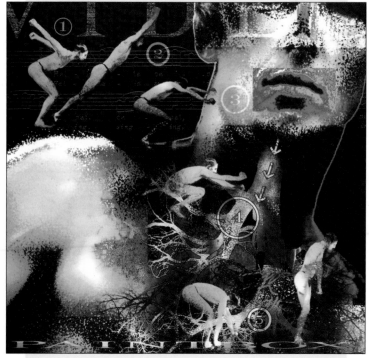

▲ RTL News Ident

This sequence is part of a station identification presentation package designed by CAL for RTL, a cable and satellite TV company based in Cologne. CAL designer Tim Burke specified a mix of 3D computer animation, live action and Quantel graphics to produce this Kandinsky-style sequence, which had to incorporate the client's existing logo.

client (and the production team) a close approximation of the visual style of the finished sequence. Thirdly, it must show how the sequence works through time, and how the images correlate with the soundtrack.

Storyboards are not dissimilar to comic strips in the way they describe a series of events, but the storyboard will also contain detailed timings and descriptions of any camera movements and visual effects as well as indications of any commentary, dialogue, music or sound effects. The component frames must be produced in the correct aspect ratio (4:3 for video, 3:2 for slide film), and include (in separate boxes beneath each frame) a description of what happens in the frame and of developments between successive frames.

Animatics: Widely used in advertising, and often used to test storyboard ideas for expensive titles or promotional sequences for television, the animatic is a relatively low-cost rostrum animation produced using stills compilations, cut-outs and other simple techniques to enliven the storyboard. Often, painted or marker visuals of key frames are especially commissioned from an illustrator, and these are filmed on a rostrum camera together with background and product photographs, graphics of captions, logotypes etc. By using dissolves, multiple-exposure, step-tracking and zoom techniques, the experienced rostrum camera operator can combine all the major components of the storyboard into an animated sequence. When the audio track has been applied the final animatic is ready to show to the client.

Storyboards can also be developed using "desktop video" software; complete sequences can be built up frame by frame and replayed in real time. While these "animated storyboards" will not be of broadcast quality, they allow the designer to accurately visualize the entire motion sequence before committing to major expenditure on production.

Portfolio work: Designers wishing to work in any time-based graphics medium should study the variety of work broadcast. A video recorder (with stop-frame ability) will help in the analysis of titles sequences, idents, ads, promos and programme credits. Acquire a broad knowledge of the major production processes of film, video and computer graphics, and study cartoons, as these predate film as a way of telling a story sequentially. Set yourself some story-boarding tasks, such as designing a new titles sequence for one of your favourite programmes, or ask friends or colleagues to suggest visual problems for you to solve. Potential employers will be looking for a variety of skills, both in conventional graphic design and in storyboarding. If you can use microcomputer animation or presentation soft-ware you will find this a tremendous asset.

TITLE SEQUENCE

Client *Clark Productions for Channel 4*
Designer/director/producer *Andrew Sides*
Design group *Baxter Hobbins Sides*
Animation *Rubicon Studios*
Brief *To design titles and studio set in keeping with* Hard News, *a programme on press harassment.*

Title sequence
The live action was shot on 35mm film using a motion control camera which allowed us to repeat each camera move with accuracy. Only then could the animators start work. The live action and animation were combined and enhanced on Harry, which allows for great flexibility, speed and no loss of picture quality. This enabled us to manipulate the images repeatedly to achieve the stark look we wanted, and to give the live action the dot-screened finish of newspapers.

The producer client on *Hard News* knew that he wanted a unique look for the show, and was concerned that programmes about newspapers can be visually dull. However, he was prepared to let us provide the creative brief rather than present us with a *fait accompli*.

We believe that if you put in enough effort developing an accurate description of the problem – before starting any design work – a good solution tends to present itself naturally. The aesthetics and technique can be decided at a later stage. In this case, we had to find a way to describe the nightmare of press harassment. We decided that we wanted both titles and studio set to depict a nightmare world. The titles had to give a sense of conflict, desperation and the struggle to escape.

Once taken to storyboard we had to deal with the technical complexity of the sequence. We wanted the newspaper text to have a vicious personality. It is not easy to convey personality through movement using computer animation; the text, therefore, had to be hand-animated. The characters had to be real human beings to make the viewer more sympathetic to their plight. This meant live action had to interact very closely with animation – each scene had to be devised very precisely and the live action shot and selected before the animators could be briefed. Next the actors were rehearsed in order to minimize the use of studio time and film stock.

161

TV NETWORK IDENTITY

CLIENT *ITV Network*
DESIGN GROUP *English Markell Pockett and Michael Peters & Partners*
BRIEF *To produce a cohesive "image" for the 15 television companies which constitute the ITV network.*

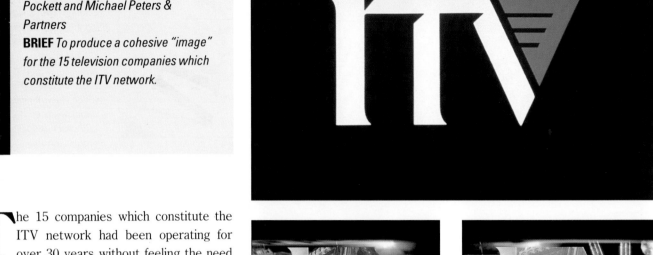

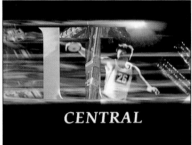

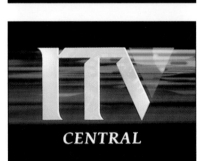

The 15 companies which constitute the ITV network had been operating for over 30 years without feeling the need for a common image. However, in the late 1980s they decided that the time had come for a cohesive branding operation. The new image was to raise the profile of ITV in the eyes of the viewers and the advertisers, to show a united front, and to enable viewers to distinguish between ITV and the burgeoning number of new television channels. The new ITV corporate identity was intended to be mainly "on-screen", but it also led to new head office stationery and an Identity Manual.

There are a number of ways in which designing a TV corporate image differs from designing in other media. To begin with, the logo has to work equally well on and off screen, and also on both black and white backgrounds. The digital nature of television alters some colours drastically and will make other colours unsuitable. "Thin" areas of logos or type may not scan well and parts of the logo or serifs may disappear in the process. The designer always has to work to a 4 × 3 format, which means the resulting loss of flexibility has to be compensated for in other inventive ways.

Each station was given a kit of parts which they could use to brand the new ITV logo and image. The key element of the kit was a "regional logo animation" which meant that the individual stations retained their own logos while becoming part of the new overall image. Other elements included a promotion caption format, a clock format, a new corporate typeface (based on Palatino and specially designed for digital use on screen) and a caption for the end of every programme showing which ITV company made that particular programme while also branding the ITV logo. The new logo was used extensively in an autumn launch campaign, on programme trailers and, off-screen, on brochures and promotional literature.

▲ **The logo**
The general logo was devised so that it could be adapted by each regional station – the sequence would begin with the local station's own logo, be animated through various scenes highlighting ITV's diverse programming and finally resolve into a regional version of the new ITV logo.

CLUB X

YORKSHIRE TELEVISION

◄ **Kit elements**
Other elements of the kit were a "clock" format (left) and a promotion caption format (far left) based on a "cinemascope" idea. This was a short animation that would precede the commercial breaks.

◄ **Specialist logo**
Incorporated into the logo kit were special programming logos for areas such as drama, sport and children's programmes.

▶ **Regional stations**
Each station was able to keep its own identity as well as become integrated into the overall brand image.

SCOTTISH TELEVISION

HTV CYMRU WALES

YORKSHIRE TELEVISION

LONDON WEEKEND TELEVISION

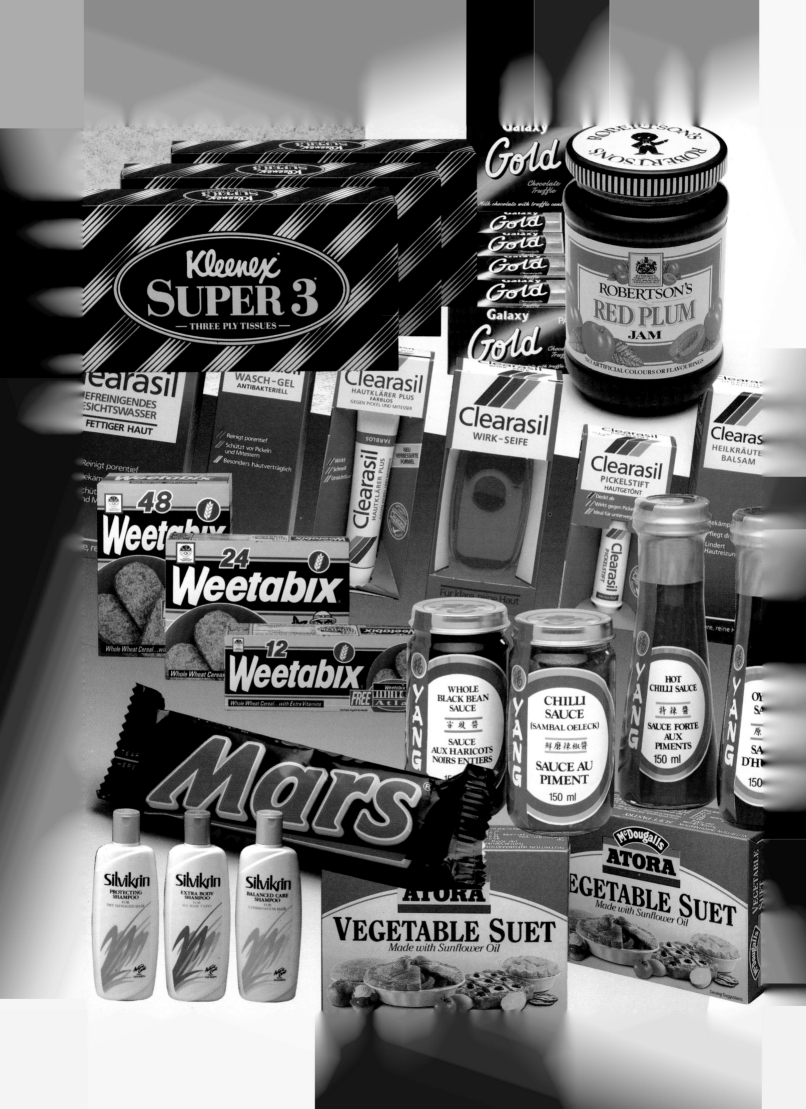

DESIGN AND PACKAGING

P rior to the advent of super-markets the chief aim of package design was a practical and informative one – to tell you what the contents were. Nowadays, the style and form of the packaging plays a crucial role in the marketing strategy and no designer involved in the creation of packaging can afford to ignore this aspect. **Richard Head**, in this interview, explains how Siebert/Head (one of the major international package design companies) handles the various elements of packaging design, such as container shape, typography, illustration, and the marketing strategy that lies behind the decision-taking.

Marketing and design

Successful packaging is a marriage between marketing and design, but there is a complete difference between the thought processes of marketing specialists and those of designers. The result is that over the last 20 years design management – where marketing people and designers work closely together – has become increasingly important.

A designer's mind works subjectively and creatively, which is what the design business is all about – generating ideas. However, the value of such ideas to the business of commercial design lies in the degree to which they can be made to work in practical terms. Tapping the designer's creativity – shaping it to reach the target – is what our business is all about.

In an organization like ours there are many more designers than marketing staff, as you are selling the varied skills of the designers to the client. The first task of the marketing people is to make sure that all the information the

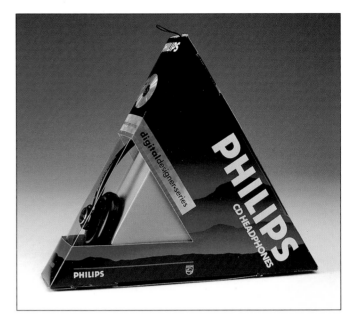

▲ Pack shape
This unusual triangular Philips headphone pack has two immediately obvious practical virtues: it allows the customer to check whether the headphones have the appropriate connecting fitting and it converts an otherwise untidy product into an instantly identifiable pack shape.

▼ Novelty packaging
Novelty pack designs are a relatively recent phenomenon in packaging, and are particularly valuable for marketing children's products, such as confectionery. Classic figures from children's stories and films can successfully be employed to increase the product appeal.

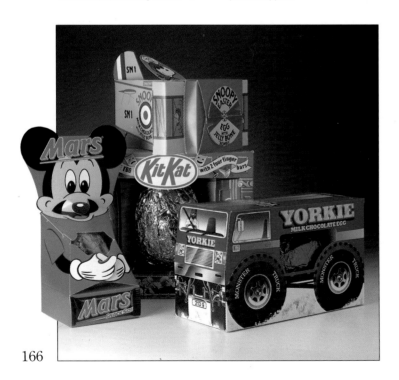

designer needs is gathered in the initial brief. Next they translate the brief into language which the designers readily understand. Then, once the design work is in progress, it is the marketing side's job to make sure that the design meets the particular requirements of that brief. In other words, the marketing people prevent the designers from indulging in private flights of fantasy.

Relating the design to the brief

When we are approached to do work for a client, the first essential is to make sure that the brief is full and accurate. In our company we have produced a checklist of topics that need to be examined in relation to the brief. It includes general information on the market, the product's position in that market, including relevant information such as regionality and seasonality. Producing a checklist of topics to be included in the design brief not only helps the designer to do his work properly, but also concentrates the client's mind on what he wants. Many of our clients find it very difficult to sit down with a blank piece of paper and state the aims and needs of the package design of their product. They find it much simpler, and we find it more effective, for them to answer a questionnaire.

Once we have established what is required, we draw up a worksheet which sets out precisely what is being covered at each stage of the operation, and exactly what it is going to

cost the client. Both the designer and the client have a copy, so they each know exactly what is being suggested. It acts as a control and safeguard for both parties. And, hopefully, when the client finally gets the itemized bill for the job, it matches the work sheet stage by stage. Obviously, the brief does sometimes change in the course of the design work. If so, we produce a new worksheet with a new quote and jettison the old one.

The work of a packaging company

This company is unusual in that it specializes in packaging and the technical side of pack design and production, as well as the graphics. Most design companies are generalists and provide surface design only and deal with a range of work – theatre design, product design, brochures, leaflets, corporate identity studies, package design and so on. We handle only package design, except where the brief starts off with a pack design but then broadens to cover, say, a corporate identity as well. In such cases we see the job right through, if the client requires it.

Our business divides into two distinct halves – a design side and an engineering side – because we are dealing not only with the two-dimensional graphics that appear on a pack, but with the shape, structure and suitability of the pack itself. The part of the company devoted to the technology concerns itself with pack shape, materials, closures (methods of fastening packs) and so on. We employ our own full-time engineers, and can take the design of the pack right through to manufacture, if needed. This is useful because it provides the designers with essential practical information. We have people in-house who can say to the designer, "That looks great, but it won't work because the label is not large enough"; "The colours you want to use will not print well"; or "The quality of reproduction you are hoping to achieve simply won't work with those materials."

International considerations

Because of the systematic way in which we work, we can easily adapt to produce pack designs internationally. There are very definite differences in how design is perceived worldwide, and we try to steer our clients away from fashion, although some packs must have such an appeal

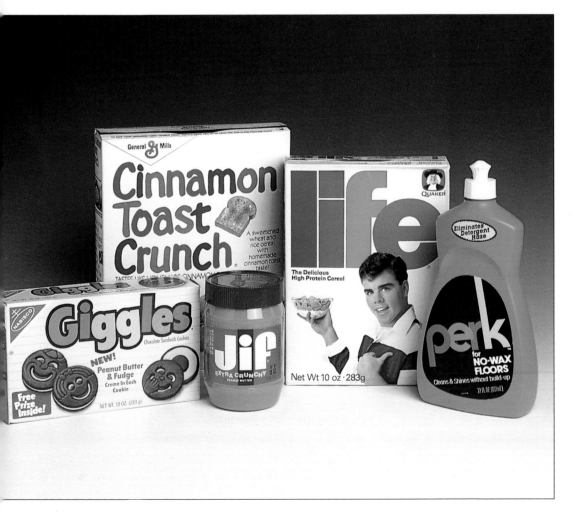

▲ Plastic packaging
This Cosmic Raider's Bubble Bath (Beauty Products Ltd) has made good use of the relatively recent arrival of plastics in packaging. The brilliant shade of yellow has excellent shelf stand-out.

◄ Contents
Brightly-coloured lettering serves two main functions: it provides stand-out and clearly indicates the contents.

167

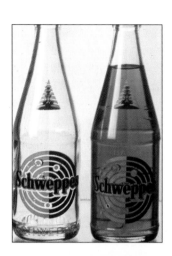

◄ ▼ Pack redesign
The redesign of the familiar Schweppes soft drinks packaging was carried out by Siebert/Head, with a brief to introduce a sense of control and continuity in the design worldwide across a range of products. (left) Examples of the original Schweppes designs, showing how they varied from country to country. (centre) Two of the proposed redesigns. (below) The final design, showing how the different languages had to be accommodated.

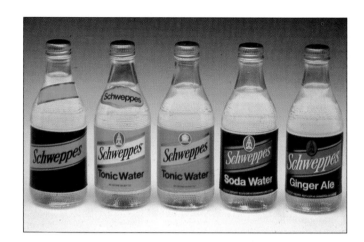

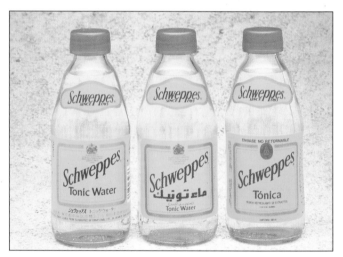

because they are products that have a fashion element, such as facial tissues and shampoos. It is a mistake to produce packs that are too fashionable, because fashions change and it is expensive to update the design frequently.

The Schweppes labels are a typical piece of successful international design. Each country originally met the challenge in its own way, and all sorts of different designs were produced. Even in the UK there was little control and no sense of continuity between the different types of label for the different drinks. The words "tonic water", for example, were designed on a diagonal in sans-serif face while "bitter lemon" was written horizontally in palace script. They wanted one design which would work worldwide and would unify the product's image.

It was important for the image to change very little, but the new design would have to work internationally, which it now does. Even so, there are some things which have to change because of different cultural attitudes. In the UK we have a product we call soda water, and it is traditionally on a black label. In the USA, the identical product is called club soda and is traditionally associated with a blue label. If we were to satisfy different national habits, we could not have provided a single label design. But in general there are few problems of this kind and it is not difficult to find a design which is universally acceptable. Certain approaches should be avoided in particular countries (see box) because they may cause offence.

Materials

As we are involved in three-dimensional work, the materials used for the packs have to be considered very carefully, in terms of both usage and price. Because the technology of raw material manufacture is changing all the time, it is very

important to make sure that we keep abreast of such changes and of any advantages in price terms. We now run an index on current packaging prices, and also forecast likely future costs. This enables us to advise a client who wants to switch, say, from a metal container to a new design, still in metal, that if he changes instead to plastic he will save a considerable sum. A typical example is the case of Knorr Aromat where the client wanted to change his design to something that would be suitable for use on the table. For him we produced a plastic container rather like a peppermill

with three sections. Not only did the redesign in a new material double the client's sales overnight, but it also saved his firm about 13 per cent on production costs.

Research

One of the essential elements in packaging design is market research. Unfortunately, much of this is badly done, so that the client is no better off, and maybe even worse off, than if he had simply licked his finger and held it up to the wind. For many years group discussions, in which a small sample of people are put together to give their opinions about a product in a group setting, have been used to test the validity of a product. It rarely works, because the people concerned tend to say what they think reflects well on them, rather than tell the truth.

Quantitative research, where say 200 people are interviewed individually and in a sense anonymously, is more likely to produce an accurate result. But it is more expensive and a great deal depends on asking the right questions.

Attitudes to pack design

Most design work is two-dimensional, but because pack design is three-dimensional it assumes a much greater importance. Packaging is tactile, it becomes part of everyday life, and people can get very attached to a particular

DO'S AND DON'TS for designing packs worldwide

Europe

France, Holland & Sweden:	Green is associated with cosmetics.
Europe generally:	Designs resembling the swastika are generally disliked.
France:	Red is masculine. To the rest of the world, blue is masculine. Avoid illustrations showing liquor being poured.
Germany:	The use of superlatives in packaging copy is forbidden. "Mist" is the word for dung – the word "gift" means poison.
Holland:	Avoid using German national colours.
Ireland:	Green and orange should be used with care.
Spain:	Bikini clad girls should not be used in illustrations.
Sweden:	Swedes do not like packaging showing gold or blue. Combinations of white and blue, the colours of the National flag, are best avoided. Consumers do not like giant packs. The brand name must be pronounceable in Swedish.
Switzerland:	Yellow means cosmetics. Blue means textiles. The oval is an omen of death.
Turkey:	A green triangle signifies a free sample.

Non-European countries generally

Arab countries:	Take care when using green because it has muslim connotations. Avoid designs incorporating a cross.
Buddhist countries:	Saffron yellow indicates priests.
The East generally:	Yellow means plenty. Yellow and pink together connote pornography.
Eastern Asia:	Avoid the circle as it has connotations of the Japanese flag.
Ivory Coast:	Dark red indicates death.
Latin America:	Purple indicates death.
Muslim countries:	Green is a holy colour and should be used with care. (Most Muslim countries have green in their flags.)

Source: Richard Head, Siebert/Head Ltd.

► ▼ Redesign
Siebert/Head had designed Farley's packaging some six years previously (right). The redesign (below) was the result of a survey in ten countries.

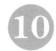
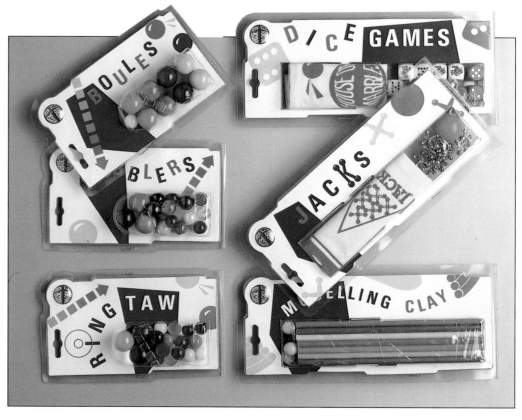

▶ **Content**

In this pack of children's marble games, the pack has a dual purpose. The front part is of transparent plastic enabling the games inside to be clearly seen. (An obvious benefit if young children are doing the selecting.) The pack is designed to hang up, giving it a better than average chance of being clearly displayed at the point-of-sale.

image. For example, when I get home from work, I like to have a gin and tonic – Gordon's gin and Schweppes' tonic. The green Gordon's gin bottle is a signal to me that the day's work is done and I can relax. If they changed the design of the gin bottle or the tonic, I would be furious and dismayed. When a pack has become part of our heritage, you must be extremely careful about how you alter it.

Our redesign of the Schweppes label was sufficiently subtle that the buying public did not notice it had changed. Similarly the redesign of Mars bar wrappers was done so as not to interfere with people's perception and expectation of what a Mars bar should look like. Unfortunately, the old pack design meant that the bars disappeared when displayed. With very minor redesign they now do not, and yet I doubt whether anyone has noticed that the design has changed.

Occasionally the customer is ahead of the designer in wanting or accepting change. For example, when we were working on a redesign for Watney's beers we produced four designs, each differing more than the preceding one from the original. We thought that the market would only tolerate a slight change. However research showed that consumers were ready for a much greater move from the old design.

Who uses package design?

Although the great majority of our work is for large companies, mainly the big food chains, there are many smaller ones who need advice and help because the packag-

ing is so crucial to the image of the product. Our smallest client was an ex-headmaster turned beekeeper who wanted to package his honey well because he had heard it would boost sales to do so, and our firm was recommended to him. Normally we would not deal with such a small job, but we did the work, charging him a nominal sum, a fraction of the normal fee for a package design.

▼ **Imagery**

These distinctive Consilia oil cans designed by Michael Peters have a strong illustrative style which helps to unify the different oil products – sunflower, peanut, soya and maize – while making it clear to the consumer what the contents of each pack are.

The emphasis on packaging is relatively recent. Its real importance in the field of consumer goods, particularly in comestibles, occurred when supermarkets first began to take over from the family grocer in the late 1950s and early 1960s, when packs first had to sell themselves on the shelves. Although grocery products were the first products to be sold in this way, the approach is now much more widespread. DIY materials are the latest products to become self-service.

As soon as you go over to self-service as a means of selling the product, the pack has to conform to particular criteria. We have identified seven of them, which we call SCIDASL:

S= stand-out
C= contents
I= imagery
D= distinctiveness
A= adaptability
S= suitability
L= legality

S The first essential is that the pack stands out. If it lacks stand-out it performs no function at all. In Britain a single product has to stand out against about 9,000 to 12,000 other designs in any typical grocery store.

C Next it must show what the product is. This sounds obvious, but there are packs that do not tell you what is inside them.

I The pack must have the right imagery and the right

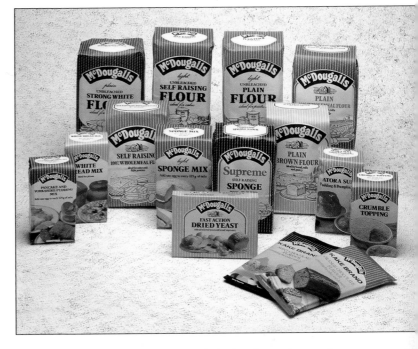

▲ **Standout**
McDougalls wanted stronger standout and branding to cover their full range of flours and mixes. Siebert/Head strengthened the vertical stripe effect, and reversed out the McDougalls' lettering, creating a strong logo for the brand, which was then used across the full range of their products.

character and atmosphere for the product. It does not matter what you do to a detergent because the more garish your design in order to achieve stand-out, the more it is in keeping with the type of product. But with a beer can, say, the better the stand-out, the worse the imagery is. Achieving an effective balance hangs on the skill of the designer.

D The pack must be distinctive and different from other people's, unless you are designing an "own label" brand, in which case you should be as close as possible to the brand leader.

A The design of the pack must be adaptable if it is part of a range.

S The pack design must be suitable.

L It must be legal.

Having identified these criteria, we then draw information in from the brief; for example, finding out what is meant by content identification. In the case of a redesign of a lager, the product has to show that it is a lager, it has to show the variety, and include a claim (or tag line). As it is a quality standard lager, not the maker's premium product, it must seem neither too expensive nor too cheap. We create a "polarity scale", ranging from very good to very bad, to assess how the product performs in relation to these different criteria.

▼ **Distinctiveness**
This own brand, see-through plastic "tin", with a ring-pull opening, for Marks & Spencer, is a relatively recent development in pack design. It allows an attractive product, in this case fruit salad, to sell itself to the customer.

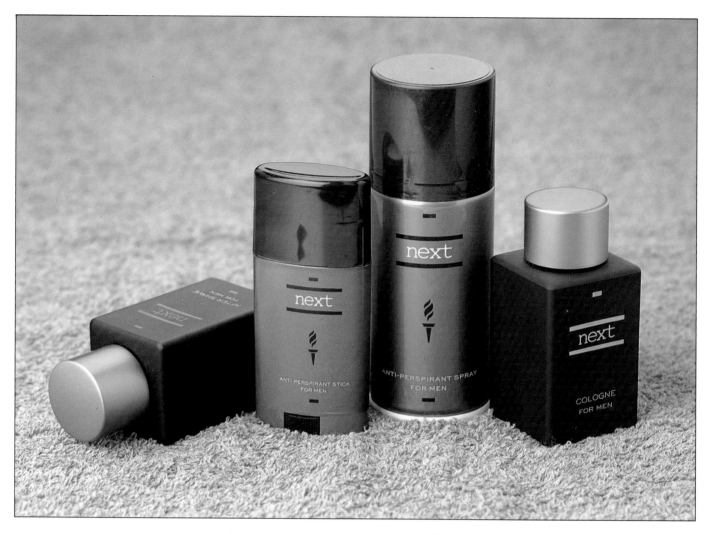

Occasionally the pack design has to marry up with an advertising campaign and in such cases we might, say, incorporate a relevant promotional flash on the pack. This depends on whether the client feels his advertising campaign is strong enough to include a "carry-through" to the packaging. Sometimes the advertising campaign starts from the packaging. We designed the packaging for Marvel dried milk, for example, and one of the main claims on the pack was that the company had found a way of including the health-giving vitamins A and D. We included a symbol of a female figure to convey healthiness and the advertising agency felt that it was so striking that they used it as the basis for a whole campaign.

Recruitment

When we set up in business we were the first specialist package design company outside the USA. That was because in the past packaging had been left largely to the generalists – industrial design consultants, material suppliers and advertising agencies – who would all attempt it.

▲ Current trends
When new products are introduced it becomes particularly important to identify the product with the type of customer at whom it is aimed. In this range of toiletries for men by Next, the chunky pack shapes, masculine colour range and plain black typography are both fashionable and appropriately unfussy.

▼ Visual appeal
Michael Peters' design for this range of Safeway tinned vegetables cleverly gives customers the illusion that they can see inside the tin. The photographic images make the vegetables appear fresh, wholesome and vividly real.

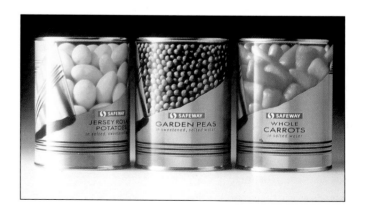

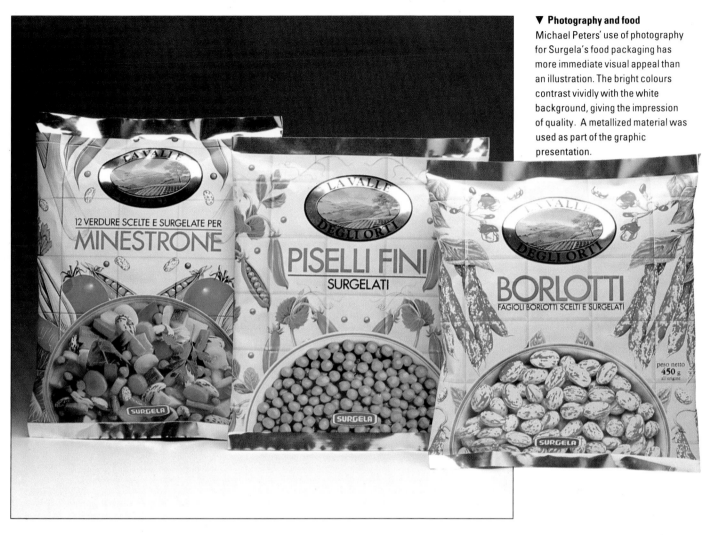

When I was receiving my training in advertising, the art directors were keen to keep the package design in-house so that they could have greater control. But their art directors had no idea about the technicalities of packaging as they were used to working two-dimensionally.

We usually hire people with experience in packaging, but we also have an arrangement with various colleges which send people to us for vacation work, as they are often a fertile source of future employees. Although we see students with portfolios, they rarely have the kind of work on which we could make a judgment.

We are not interested in designing for aesthetic reasons alone. Our business is disciplining design to meet clients' marketing requirements, which is much more exacting. Our design is generally more expensive, as many hours of work are put in by highly paid, highly trained people.

Styles in pack design
Because much of our work is in the packaging of food, we are usually trying to achieve both stand-out and a realistic image.

Therefore we tend to use more photography than illustration, because it can usually capitalize on "appetite appeal" more effectively. If you take McVities Jaffa Cakes, for example, the product is actually very attractive, even when you bite into it. It is important that the pack design conveys this or whatever other attributes the product has.

Illustration tends to be used more when the aim is to increase the appeal of a visually uninteresting product. Soup labels, for example, nowadays often show an illustration of the ingredients, rather than a photograph of the soup itself.

Although there are trends in typography which may appeal to designers, in packaging it is often an error to exploit the trends as it dates the design and can soon appear very unfashionable.

We choose not to compete for design awards in this company because it encourages the designers to design for the approval of their colleagues, rather than for the benefit of the client. In any case, an award-winning design, no matter how aesthetically pleasing, may well fail to sell the product in the way it should.

173

PACK DESIGN

CLIENT *Richard Nash & Co*
DESIGN GROUP *Siebert/Head*
BRIEF *To create a pack design for "Irish Spring", a new sparkling soft drink that combines mineral water and fruit juice without artificial colouring, sweeteners or preservatives.*

◄ The first approach
The first examples of the pack design, showing a wide range of approaches to the brief in terms of the size and style of the brand name, the company name and the depiction of the contents. The taller bottle shape was finally chosen, rather than the more squat form of the original design.

Nash's, an Irish family firm with a long history in the soft-drinks market, was planning to launch the new product first in the UK and then the USA. Part of our brief was that the label design should communicate clearly the purity of the drink, the full fruit flavour and the real juice content. The imagery had to suggest a lively, sparkling drink.

The soft-drinks market is highly competitive and the pack had to stand out well against the competition. Some of the concepts (right) were considered a bit too brash for such a pure product while others were so detailed and representative of the fruit that the image implied a still, rather than a sparkling, drink.

Of the concepts we came up with, those with a loose illustration were thought to be the most effective. We then agreed on a direction for a further development, combining elements of both concepts. One was a label design with illustrations of fruit segments and the other incorporated Nash's name in hand lettering, suggesting a natural product. At this stage, the two approaches were combined into a single label design, and illustrations were then prepared for each of the product flavours.

The branding of Irish Spring was strengthened and the product description made less dominant. We used a script style because we felt it looked more spontaneous. To underline the purity of Irish Spring, the copyline "100% natural" was added.

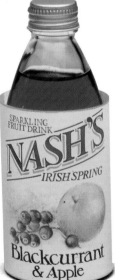

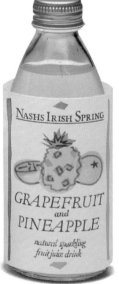

▶ **The short list**
Six designs for the labelling were presented to the client. In the end a combination of the two on the extreme right were used to create the final design.

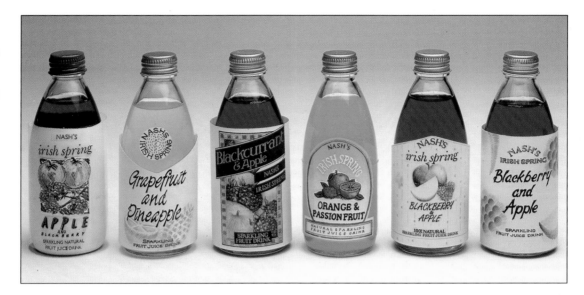

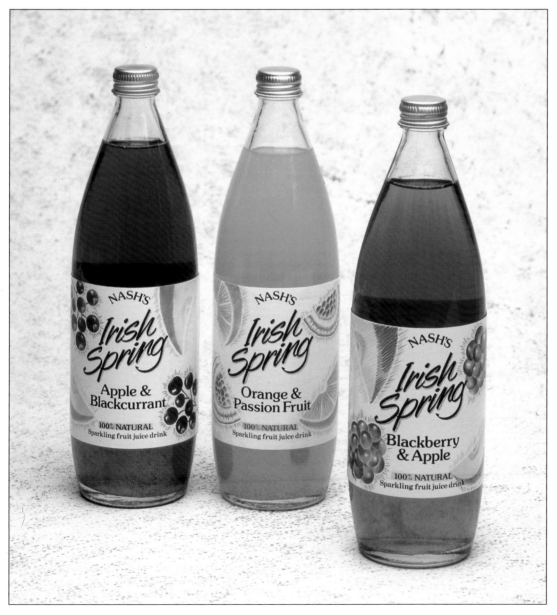

◀ **The final design**
These two approaches were then developed into a single label design.

case study

CONTAINER DESIGN

CLIENT *Alexander Duckham and Co*
DESIGN GROUP *Siebert/Head*
BRIEF *To design a revolutionary 5-litre oil container for Duckham's QXR "super premium" motor oil.*

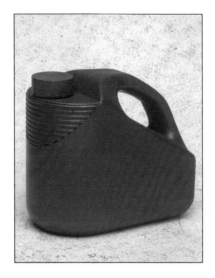

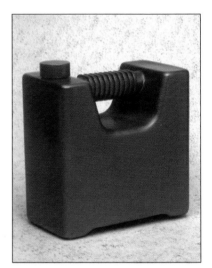

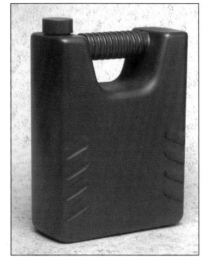

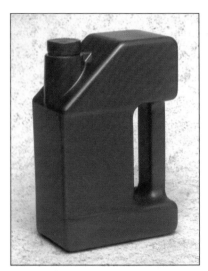

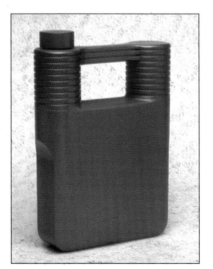

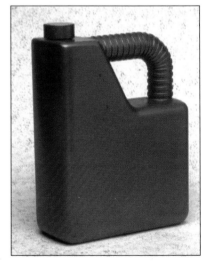

The new product was a technological breakthrough and Duckhams wanted the image and function of the new pack to match the product's high performance. One of the priorities in our brief was to eradicate the problems created by the traditional tinplate oil can, which was difficult to hold, hard to pour from and messy to use. Our package technologists suggested using high-density polyethylene instead, which neither rusts nor dents, and can be custom moulded to any shape.

As the next stage, we came up with a wide range of container shapes (some of which are shown right) and from these a shortlist was drawn up for further testing, to check how practical they were and how the consumer responded to the design.

A clear preference emerged for the pack with a ribbed side handle. Because the handle is hollow, allowing air to escape, the oil does not "glug" out of the container when it is poured out, and the lift-up spout in the neck makes it much easier to direct the flow of oil. The wide base and square body gave the container stability and good merchandizing capability.

▲ **Polyethylene prototypes**
Prototypes for the new Duckham's oil container, created in high-density polyethylene. The example on the bottom right was eventually chosen.

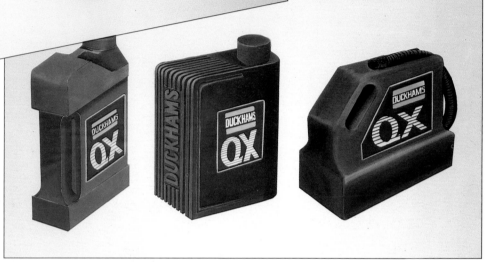

◄▼ Early designs
The early conceptual designs for the container and the lettering styles from which the final version was chosen.

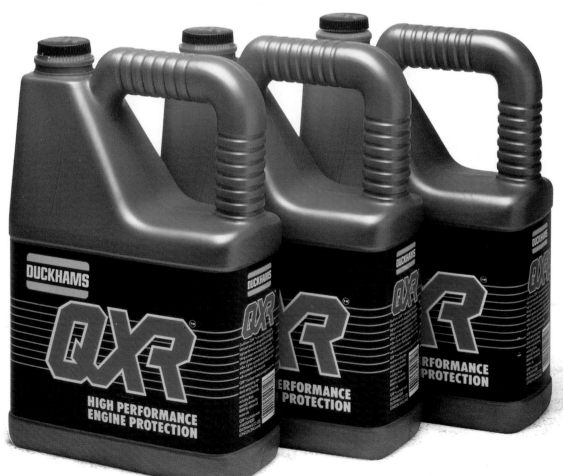

◄ The final product
The graphics and logo chosen for the QXR brand echo the angular pack shape, while dynamic imagery, fitting for a product for high-performance cars, is provided by the speed lines on the pack.

177

DESIGN AND CORPORATE IDENTITY

Every company or business has a corporate identity which conveys an image to everyone they deal with – who they are, what they do and how they do it. The problem for many companies is that their identities are unmanaged and uncontrolled, leading to poor or unfocused perceptions. Corporate identity practitioners combine a number of disciplines including analysis, research and design. The designer is often the catalyst in a corporate identity programme, helping to generate commitment and to demonstrate change. In this interview **John Sorrell**, Chairman of Newell and Sorrell, explains what is involved in corporate identity work and the role the designer plays.

Corporate identity design

The approach to producing a corporate identity could be described as holistic, because it touches on everything an organization does. Design plays a very important part in the whole process because one of the ways in which people first judge whether the organization is any good or not is by what it looks like. But the other senses cannot be ignored, and assume a greater or lesser importance depending on the style of the business. For example, in a telephone mail order firm, the way the business sounds is

▲ Healthfood
Cranks' overall image appeals to consumers' senses – fresh natural wholefoods well displayed, looking and smelling good.

vital; the way it looks is far less relevant, so obviously the approach has to be flexible.

To give an example of how our senses govern our critical faculties; if you go into a supermarket and smell freshly baked bread and roasting coffee beans, you will probably feel much more like buying the other products on sale. Yet if you were to smell rotten eggs, you would leave at once.

While the different senses all play their part in shaping the perception of an organization's identity, once the first impressions are over, it is the way that the organization behaves and operates on which the lasting judgements are made. We can do nothing in the long term for an organization that consistently behaves and performs badly. A successful corporate identity campaign can enhance any endeavour, but it cannot, ultimately, sell a bad product.

To work successfully on corporate identities, designers need to develop all their senses, not just their graphic skills (which, naturally, must be excellent). Designers need an understanding of what makes a business tick, otherwise they are designing in a vacuum – purely for themselves and not for the client. It is not necessary for a designer to be an expert in business studies, but he or she does need to develop good, all-round antennae. The best designers have always been those with a very strong natural curiosity, constantly questioning what is going on around them. Corporate identity is the ideal field for the alert, intelligent designer.

▼ Jazz FM
The Jazz FM logotype visually represents the music played on the UK's first jazz-dedicated radio station. Spontaneity and a sense of randomness is achieved by using the logotype in an animated form or in an alternative colour scheme. Purple and orange were the launch colours.

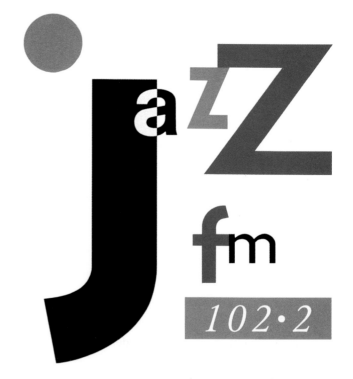

▲ Solidarity
The logotype of Poland's Solidarity movement needs no description – everyone already knows what it looks like.

► Routledge
Academic publishers, Routledge, commissioned Newell and Sorrell to give their titles a new look. Black and white were chosen for the new corporate colours. They have become a major feature and marketing advantage; the spines have tremendous shelf impact.

Logotypes

Graphic elements play an important role in helping people to relate to the company and giving them an image of what it does, and where it is going. That is why it usually helps a business to create a symbol, or logotype or emblem, which also provides a flag around which the staff can rally.

There can be a magic in a logotype if you get it right. Take the logotype of Poland's Solidarity movement, for example. I do not need to describe it, because everyone knows already exactly what it looks like. Another good example is the revolutionary Romanian flag – the national flag with the central circle cut out. It makes a wonderfully expressive piece of graphic design.

The swallow we developed as an emblem for British Rail's InterCity is designed to reflect the warm side of this large organization's personality in a way that a less tangible, abstract symbol could not. We considered a variety of ideas (see p183), including one image of a cheetah but decided in the end that it was too aggressive and unfriendly, even though it did sum up drive, speed and energy.

Small businesses

Corporate identities for smaller organizations need to be approached in a different manner from those for larger companies. A small, start-up business with no background, 181

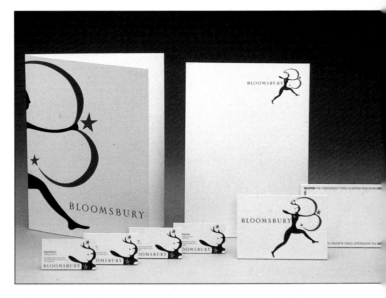

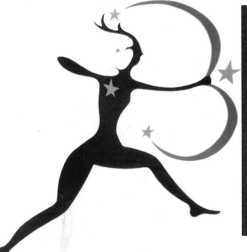

▲ **Bloomsbury publishers**
Bloomsbury's corporate identity was critical in the rapid establishment of the company's image. Newell and Sorrell produced posters, banners, letterheads and business cards for Bloomsbury's first public airing at the Frankfurt Book Fair in October 1986 (top right). Every element of each book jacket was designed to reinforce the image of a publisher of quality, well-produced books (top left). The Roman goddess Diana, hand-drawn, is the symbol for the imprint's colophon (bottom left). Wrapped around the spine of a book it forms the letter "B". The logotype (bottom right) was handdrawn to give the identity a more personal feel.

history or heritage, no existing customers and no existing audience is obviously entirely inspirational at that stage. The analysis and investigation that you would normally do with an up-and-running business is, in this case, limited to the people who are starting up the business and the handful of clients or customers they are initially dealing with.

However, if their business does become successful, they will need an identity that can change as they expand and develop. It is essential to avoid creating a visual identity which will block a company's development by "setting it in stone" at a particular moment in time.

Not all our corporate identity work starts out on a big scale. Quite often clients are not even aware that they need a corporate identity. They will simply come and ask for a symbol or logotype to be designed, and gradually as a result of our discussions, it becomes apparent they need something much more comprehensive.

Corporate identity is a growing field of activity, as more and more businesses become aware of the importance of presenting a good image to their clients and customers. Specific training at art school for corporate identity is limited. In fact, it is better for colleges to concentrate on producing brilliant designers, and on freeing their students' conceptual abilities and imaginations. It is up to the design industry to take their training down paths that will develop individual potential and that are appropriate to business needs. To be a successful designer in this kind of work, the student needs to come out of college with a really good imagination and a truly inquisitive attitude.

INTERCITY IDENTITY

CLIENT *InterCity (British Rail)*
DESIGN GROUP *Newell and Sorrell*
BRIEF *To provide a corporate identity for InterCity, the flagship brand of British Rail.*

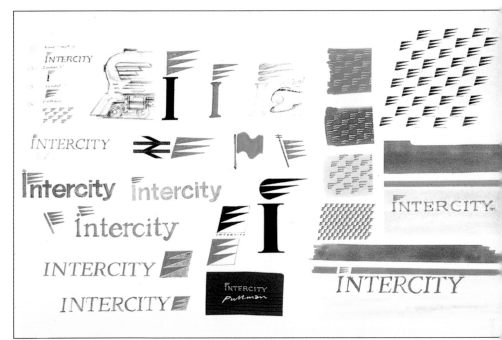

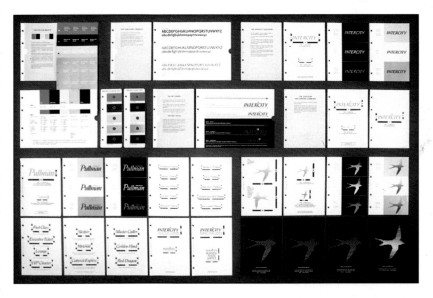

We were first approached by Dr John Prideaux, the Director of British Rail's InterCity division, in December 1986. He had been appointed six months or so earlier and had decided that it was time to look at InterCity's identity and the way it was presented. At the time, British Rail consisted of five operating units, one of which was InterCity, and it was Dr Prideaux's job to turn a £125 million operating loss (on a turnover of £800 million) into a profit by April 1989. He based his turnaround strategy on three key elements – quality, efficiency and growth. To this end he wanted a new image for InterCity, to be perceived not only by the paying customers but, just as important, by the staff as well.

Our first stage of work consisted of discussions, investigation and analysis which led to the development of our initial concepts of how the visual identity might look. The next stage was to develop the basic elements of the identity and to complete the priority applications. The train livery, for example, was started right away because it is a highly visible element. At this point various steering groups were set up to ensure that the identity was applied and maintained properly.

At the time we were first approached to produce the corporate identity, InterCity was presented in a very downbeat way. The logotype was in the same visual language as the signs telling people where the toilets were, and InterCity came over simply as part of an information

system. It did not appeal to people's emotions, it had no personality.

To produce a successful corporate identity, we had to make it clear who InterCity was, what it did, how it did it and where it was going (the key elements in any corporate identity). At the conceptual stage we produced a number of different ideas, some of them developed to quite a finished state. What we finally created was a visual system comprising a number of key elements that can be used in different combinations in various applications – the colour palette, the InterCity logotype, subsidiary brand logotypes, subsidiary typefaces, the red track, use

▲ **Initial concepts**
Many different ideas were explored and developed before Newell and Sorrell came up with the final design for InterCity's new identity (top). To see how initial concepts would appear in print applications, dummy leaflets were produced (bottom).

183

of the British Rail symbol and the emblem. All these came together to present InterCity as the flagship brand of British Rail.

Because the company is so large, the range of applications was equally vast, although the success of any corporate identity depends on attention to the smallest detail. We produced a book of guidelines for the use of the InterCity identity including, for example the range of typefaces that can be used in various situations, as well as the style of copywriting that should be used in InterCity's literature. Copywriting is an important part of the image, since the language used by InterCity needs to be clear and un-bureaucratic. Attention to detail is the key to a successful corporate identity, so we are as concerned with how a letter is written as with the paper it is written on. We are as concerned with the food offered in the bar or restaurant as we are about how the decor of the restaurant fits into the overall image.

InterCity has now turned its operating loss into a profit. Although the corporate identity cannot take all the credit, it has played an important part, both practically and psychologically, in InterCity's turnaround.

Three years after the introduction of its identity InterCity is implementing it as a continuing process across everything it does. New trains, all kinds of corporate and promotional literature, uniforms, environments, packaging and new developments – each and every aspect of the different facets that make up InterCity are now all considered as part of the whole – part of the total InterCity identity.

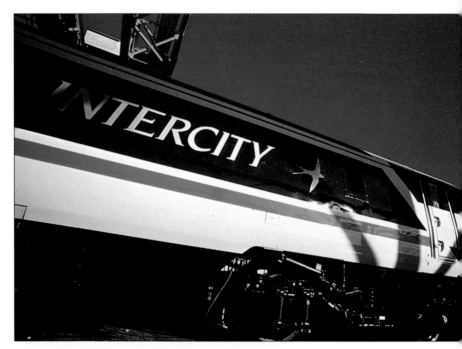

Final design and emblem
The new InterCity train livery was a priority as it is a highly visible element of the identity programme (top). InterCity is a massive organisation. A cheetah emblem would have personified speed, drive and energy, but the swallow was considered to be less aggressive, more friendly and accessible (left).

▶ **Uniforms**
The aim was to give InterCity staff pride and confidence which would be reflected in better service to customers.

InterCity Sleepers
The journey of a nightime

INTERCITY

InterCity Business Travel Service
What it is and why you need it

InterCity Motorail
Your guide to easy motoring this winter

▲ Basic elements
All the basic elements of the identity were developed for use in a variety of applications.

▶ Design guidelines
The guidelines are practical, not a corporate icon, and include references for branding InterCity posters, leaflets, signs and timetables as well as its rolling stock and on-board services.

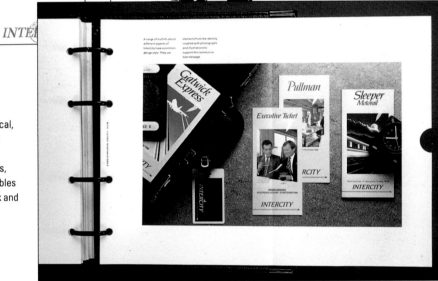

◀ Design guidelines
The colour palette, the typography and other graphic elements which combine to give the InterCity service a distinctive image are defined in a comprehensive book of design guidelines.

185

Glossary

A sizes International system of paper measurement established by Deutsche Industrie Normen (DIN). From AO, the largest size (1 square metre), each subsequent reduction is 50 per cent in area, and is proportional – the sides being in the ratio 1:1.4142.

Animatic An animation prepared from marker visuals and other unfinished artwork using a rostrum camera. Used to test storyboard ideas for live-action adverts before production of a film or video.

Art paper Coated, shiny paper. The higher the gloss, the more brilliant the reproduction of colour or halftones.

Artwork Images and text ready for reproduction. This can be direct output from a DTP system (as laserprint or bromide from laser-typesetter) or with manual additions such as overlays, colour swatches.

ASCII American Standard Code for Information Interchange: computer-coded alphanumeric characters.

Aspect ratio The ratio of width to height of film and television frames: 3:2 for 35mm slides, 3.155:4.34 for 35mm cinefilm 2.94:4.10 for 16mm cinefilm and 3:4 for television.

Bitmapping Method of encoding a graphic image (text or illustration) as a gridded map of black and white pixels/printed rectangles.

Bleed An image that prints to the edge of the paper. A 3mm overlap is usually allowed for trimming.

Body copy The main text of any document; the body of the document. Also refers to any copy that is used to simulate main copy text, for instance in the preparation of presentation visuals. Often Latin texts (or greeking) are used for this purpose.

Box A rectangle formed by printing rules. Border boxes are decorative elements (rules and printer's ornaments) used to surround text, usually display text. Boxes may also contain tints (halftone tints of black or flat colour).

Brief The definition of a graphic design commission, given by the client, and/or formulated by both client and designer.

Bromide Output from a laser-typesetter. Also a traditional printer's term for a black and white line photograph – i.e. not continuous-tone. Typically this will be a reduction print from original line art – either hand-drawn lettering, calligraphy or illustration.

Byte In computer systems, the smallest addressable unit, usually comprising 8 bits (binary digits "0" or "1"). One byte is required to represent a single aphanumeric character.

Camera-ready artwork Artwork in its finished form, arranged with any overlays etc, ready to be photographed with a process camera in order to be made into printing plates.

Cap height The height of the capital letters from the baseline.

Cast off To estimate the amount of space that text will occupy when set in a certain typeface, point size, leading and measure.

Cel (or cell) Transparent acetate sheet of the same aspect ratio as a cinefilm frame, on which one frame of animation is drawn.

Centred type Centred type, or type ranged centre, is set symmetrically around a vertical centreline, with ragged edges.

Character Individual letter, figure, punctuation mark etc, of a font.

Character count Establishing the number of characters in a piece of text – the first step in casting off or copyfitting.

Character generator Machine used to set type (for credits, titles, etc) by superimposition over a video image.

Chromakey Method of "colour-temperature" matting in video, in which one colour or a range of colours is made transparent to allow superimposition of images or text over an image.

Cicero The European Didot Point system's equivalent of the pica unit of typographical measurement. A cicero is 4.5mm.

Clip art Ready-made, copyright-free illustrations available as black and white and colour, both line and tone, in book or digital form.

Coated paper Paper treated with clay (or plastic) to give a hard, shiny or smooth matt surface of low absorbency.

Colour-matching systems The methods by which any flat colour can be specified for printing by selecting the required number from a swatch book of colour samples. Colour-matching systems such as Pantone enable the designer to use matched colours throughout the design and printing process.

Colour separation Separating the components of multi-colour artwork and images into individual colour plates for printing.

Column rule Vertical rule occupying the gutter (margin) between two columns.

Condensed type A horizontally compressed version of a typeface.

Continuous-tone copy Copy such as a photograph, painting, airbrush illustration, watercolour, etc that contains continuous gradations of tone or colour. Such copy cannot be reproduced directly. It must be screened – separated into a pattern of discrete dots of varying sizes – to produce a halftone plate or set of colour-separated plates for printing. The illusion of continuous tone in the printed image depends on the fineness of the screen used in the process camera.

Copy Typewritten or word-processed text matter ready for typesetting or page makeup; or any text, artwork, photographs, illustrations, etc intended for reproduction.

Credits List of performers, writer(s), director, producer and others who have contributed to the making of a film or television programme. Usually shown at the end of the film or programme.

Crop To trim an image to the required size.

Cross-head A subheading, often in bold type, located between paragraphs of body text in a book, magazine, newspaper or newsletter.

Cut-out Simplest form of animation in which cut-out shapes are moved between exposures.

Daisy wheel A "strike-on" character set arranged around the circumference of a metal or plastic disc, used in some electronic typewriters and computer printers. Daisywheels are available in different fonts.

Digital video recorder Hard-disk-based recording system capable of storing short sequences of video as digital data.

Digitizing Converting an image into computer code.

Display copy Headlines, subheadings, etc. that are not body text. Usually refers to copy set in type of size above 14 point.

Dope sheet In animation and TV graphics, the chart prepared for the rostrum camera operator, listing order of the cels or graphic frames, together with camera instructions, number of frames to be shot and other details.

Drop cap Enlarged initial capital letter indented into a column of text.

Drop shadow A tint or solid colour laid under and to one side of a letterform or illustration, to give the effect of a shadow.

DTP Desktop Publishing. A general description of the use of computers, laserprinters, scanners and page-makeup software for graphic design and typesetting.

Dot matrix A grid-like array from which a pattern of dots can be selected to form an image – for example, an alphanumeric character. Dot-matrix computer printers use this principle, as do electronic news displays and some tele-prompters.

dpi Dots per inch: the measure of the resolution of a laserprinted or imageset image.

Electronic publishing The process of electronic page makeup and printing. The term generally refers to the corporate use of computer systems, as distinct from DTP on personal computers (also includes publishing in CDROM, floppy disk or Hypertext media).

Em/en Traditional measurements for word spacing, derived from the space occupied by "M" and "N" type characters. An em is the square of the point size being used – for example, in 12-point type an em would be 12 points wide.

Field chart A gridded chart produced on transparent acetate and used in conjunction with an animator's peg bar to show video-safe areas.

Flat colour Colours or tints of colours that contain no continuously graded tones.

Flat plan A page-by-page representation of a publication, used to develop an overview of the total contents. The pages are shown as "thumbnails" with the page contents indicated by general headings.

Floppy disk A portable electromagnetic storage medium for computer data.

Format The size and shape of the publication – for example, A4 portrait, A5 landscape, 120mm square, etc. Also, to prepare an electromagnetic disk for use in a computer system or typesetter.

Font (fount) All alphanumeric characters and punctuation marks in a particular typeface.

Frame store Random Access Memory (RAM) or disk memory used to store digital video frames.

Four-colour process Method used to produce full-colour litho, silkscreen, letterpress or gravure prints, by printing the image as a set of four colour-separated components. The four colours are the three subtractive primaries (cyan, magenta and yellow) and black.

Grey scale In printing, a printed scale of grey-tones used in photomechanical reproduction to check correct times for exposure and development. In computer systems, the facility of determining a range of brightness for each pixel in the monitor screen, from black ($=0$) to white ($=255$).

Grid The non-printing lines defining page layout options. A grid is used to ensure visual consistency between each page of a document, or between related designs.

gsm Grammes per square metre. Standard measurement of the weight of paper.

Gutter The space separating columns.

Halftone The product of converting continuous tone images to a line image comprised of dots of various sizes.

Halftone tint A monochrome tint comprised of regularly spaced dots. Available in a range of percentages of solid colour.

Hairline A very thin ruled line (less than 0.5 points).

House style/rules Set of design decisions that establish rules for the consistent treatment of the various graphic and typographic components of a publication. Also refers to a guide to editorial practice.

Ident Station identification: the logo or trademark of a broadcast-television company. Also used to describe animated logos used by video or audiovisual producers.

Imagesetter Generic name for laser-typesetters that use a page-description language and can output line and halftone images in addition to typesetting.

Imposition The arrangement by which a number of pages are printed together in such a way that they will be in their correct order when folded or cut.

Indent Space inserted at the beginning of a line (most often at the beginning of a paragraph).

Justification Arrangement of text in which both column edges align vertically.

Kern To add or remove space between certain character pairs that would otherwise appear badly letterspaced.

Keyline Non-printing line or rectangle used to indicate the position of photographs that are to be pasted in at artwork stage.

Laserprinter Standard proofing printer for DTP systems. Laserprinters can produce hard copy with a typical resolution of 300-400 dpi.

Laserscanner High-resolution scanning device for colour separation of transparencies and flat full-colour images.

Laser-typesetter High-resolution output device for DTP typesetting and page images.

Layout Arrangement of text and images on a page.

Leader Dotted line arranged between tabulated columns to lead the eye from column to column.

Lithography (litho) Printing method for low-cost, large-quantity reproduction. The most recent of the three major printing processes, lithography is a planographic technique on the principle that grease and water do not mix.

Line illustration An image consisting of lines and solid areas, as opposed to continuous tone. A pure black and pure white image, with no intermediate grey tones. Continuous-tone images, such as photographs and

paintings, have to be processed into line or halftone images for printing.

Logotype (logo) Company name and/or symbol.

Lower case (l/c) Term used to describe small characters, as distinct from capitals.

lpi Lines per inch – the measure of the resolution of a halftone image.

Margin In DTP, the non-printing area of white space around edges of page. In graphic design, the white space at the head (top), fore edge (outside), foot (bottom) and back (bound edge) of the page.

Mark-up The annotation of artwork with instructions for the printer on scaling, the specification of colours, and any special effects.

Matte Mask used to conceal part of a negative during exposure to allow superimposition of another image.

Measure Width of column of text, usually measured in picas (12-point pica ems).

Motion control Computer control of the camera and horizontal rostrum to allow precise and repeatable stepped movements of camera and rostrum object for multiple-exposure animation and special effects in film.

Mouse In computer systems, a hand-held input device that enables movements on a flat surface to be translated into on-screen movements of a pointer or cursor.

Multiplexing Technique using special projection equipment linked to video camera to record sequences of slides onto videotape.

Negative (neg) Photographic negative as distinct from a transparency, which is a positive image, or a positive print, which is called a bromide.

NTSC National Television System Committee: television system used in the USA, Canada and Japan.

Off-line edit Low-cost edit used to create a rough assembly of video sequences before the "online" edit. Usually produced on cheap, small-format tape.

Offset litho The standard method of litho printing in which the image is offset from the inked plate to a rotating rubber drum, then printed onto the paper.

On-line edit Final edit using high-quality tape format and two, three or four VTRs, often with Paintbox ("Harry") and/or character generator (also "on-line").

Opacity The quality of paper that determines the amount by which matter printed on one side of a sheet will show through on the other side. Also, the quality of printing inks that determines to what degree they will obscure the coloured material on which they are printed.

Opaque To block out part of a film negative in order to remove unwanted parts or blemishes so that they will not be visible on the final printing plate.

Optical alignment Not true alignment, but the alignment that works best visually.

Overlay Transparent film used to carry colour-separated components of camera-ready artwork. Also describes the protective flap covering finished artwork.

Overprint To print one colour over another or type over a halftone reproduction, or to make a printed addition to work already printed.

Overscan/underscan Graphics produced on a computer monitor generally do not fill the screen (this is called underscan). When converted to video (which overscans), some 15 per cent of the edge of the monitor image is lost. Allowance must be made for underscan during graphics production by working within a "video-safe" area.

Page-description language (PDL) Software that converts screen page-makeup and typesetting data for hardcopy printing by laserprinter or laser-typesetter.

Page makeup The process of electronic pasteup and typesetting.

Paintbox Generic term for dedicated computer graphic "painting" systems such as the Quantel.

PAL Phase Alternate Line: British and European (except France) television standard.

Paste-up The process by which text and images are combined on a board as artwork ready for printing. In DTP it is done electronically, on the monitor screen.

Photo-engraving The photomechanical process used to make plates for letterpress printing. Acid is used to produce a relief image from a sensitized plate onto which a film negative of the original (line or halftone) artwork has been exposed.

Photo-gravure The photomechanical production of gravure plates.

Photo-litho The photomechanical production of litho plates.

Photomechanical transfer (PMT) The photographic positive (on paper or transparent film) achieved as a result of photographing pasted-up artwork or other copy with a copy-camera system.

Phototypesetting Typesetting and text composition using photographic principles.

Pica Standard typographical measurement of about 0.166in or 1/6in: 6 picas make approximately 1in.

Pica em (Em) A unit of measurement deriving from the metal spacing units used in letterpress typesetting. The basic unit is the em quad (based on the width of the uppercase "M" character).

Pixel A picture element, the smallest unit on the monitor screen (and so the screen equivalent of the dots per inch of hard copy).

Planographic printing Method of printing in which both the image area and the non-printing area are on the same level surface. Litho is a planographic process.

Point Standard typographical measurement of 1/72 in (0.35136 mm).

Postscript A page-description language (PDL).

Prelims Preliminary pages – the portion of a book that precedes the main body of text. Prelims include half-title, list of publications by the same author, frontispiece, title page, bibliographical note and imprint, dedication, preface or foreword, acknowledgements, contents page, list of illustrations and introduction.

Presentation graphics Graphics designed for "presentation" situations – generally speaker-support graphics. Generic term for software used to produce this type of graphics.

Primary colours The colours from which all other colours can be mixed. There are two related systems of primaries: the additive primaries, red, green and blue (used in computer graphic systems), so called because added together they give white; and the subtractive primaries, cyan, magenta and yellow (these are the additive secondaries, used in colour printing) which added together give a theoretical black.

Process camera Used to photograph finished or camera-ready artwork, in order to prepare a printing plate.

Process colours The colours used in four-colour and three-colour (trichromatic) printing processes. Cyan, magenta, yellow and black are used to print full-colour reproductions of colour photographs and art by means of colour separation. Because the three primaries mix to give an almost complete range of colours, process-colour printing is the most economical method of achieving full colour. Black is used as an overprint in four-colour process printing to add richness and contrast.

Progressives A series of colour proofs, showing each separated colour of a full-colour image as it is printed, individually and in registered combinations.

Proofs First printing on laserprinter, used to check copy for errors. First press proof, used to check for colour accuracy and register. Pre-press (photographic or electrostatic) proofs, used to check colour separations before platemaking.

Registration The exact positioning of two or more printings on a page. Registration marks are used to ensure the accurate positioning of overlays for multi-colour printing.

Repro/Reprographics Repro: generally any copy ready for reproduction. Reprographics: general term now applied to printing and print-production techniques.

Resolution The degree of definition of an image. Resolution in hard copy is measured in dots per inch and on monitor screens in scan lines and pixels.

Reverse out To print type or an image in white on a black background (also referred to as WOB – white on black). Type and images can also be reversed out of any other colour.

Rostrum camera Specialized form of movie camera that films one frame at a time. Video cameras are also used, recording frame by frame by VTR.

Rotoscope Back-projection device allowing display of live-action footage one frame at a time onto a surface through which the animator can make direct tracings. Animations can be produced that exactly match the motion of the original film.

Rule A line of variable thickness used to separate and section off text on the page.

Running head A small headline inserted in the header margin of the page and printed throughout.

San-serif A typeface without serifs.

Scale To enlarge or reduce an illustration or photograph, preserving the original aspect ratio.

Scamp A quick sketch of a layout.

Scanner Photo-electronic device for converting flat art images and transparencies into digital (computer) code.

Screen In repro: a cross-ruled glass plate positioned between the process-camera lens and the artwork to reduce continuous tone art to halftone. In printing: shortened form of "screen process printing". In computer systems: the monitor screen.

SECAM Séquential Couleur à Mémoire: French, East European and Russian television standard.

Set-solid Type set in columns without leading.

Signature In book printing, the letter and/or number printed at the bottom of the first page of each printed section, so that the book sections can be bound in the correct order.

Small cap Capital of the same height as a lower-case letter in a font.

SMPTE time code (Society of Motion Picture and Television Engineers): code that assigns a number to each frame of video. The numbers track elapsed hours, minutes, seconds and frames.

Solid modelling Technique of rendering used in computer graphics to create virtual "solid" three-dimensional models.

S/S Abbreviation for "same size", used as an instruction to a printer or platemaker that the artwork is to be reproduced the same size as the original.

Stills compilation Used here to describe the technique of producing motion footage from still images by using rostrum and camera movements to produce the effect across the images, zooming into them, etc.

Strip in (up) To combine two or more negative or positive (films) together onto a paper, film or glass base ready for platemaking.

Templates In DTP, pre-designed grids (with attached style sheets) and sample typography illustrating design formats for "typical" publications.

Thermography Printing process involving the use of ink additives that expand with heat to give an embossed effect.

Tint A flat area made up of colour or black dots or lines. A solid is an area of 100 per cent solid colour.

Tip-in An illustration glued into place after the printing of the page.

Tone The different strengths of a colour from solid to nearly white.

Transparency A colour positive photographic image produced on reversal film. Also referred to as a slide.

Typescale A ruler with pica and point measurements.

Ultimatte Trade name of high-quality colour temperature matte system, used in production of special effects and composite images.

Upper-case (u/c) Term used to describe capital letters.

Videotape formats Low-cost systems include VHS, 8mm, SVHS. Mid-range systems include UMatic (Low and High Band). The professional range includes Beta SP, 1-in and 2-in.

Videowall Stack comprising a number of television monitors used to display separate images or parts of the same image. Can be fed by a combination of VTRs and frame stores, or by laserdisks, all under computer control. Used for promotions and product launches etc.

Vignette A halftone plate treated so that the edges shade gradually to white background.

VTR Video tape recorder.

Widow A single word left on a line of its own at the end of a paragraph. Also, a short line or single word from the end of a previous paragraph appearing at the top of the page.

Wireframe Computer-graphic 3-D model made up of line tracing edges of all component polygons. Because wireframes can be rendered very quickly, they are often used to test animation sequences in advance of time-intensive solid/modelling animations.

Xerography Electromechanical method of document copying and platemaking.

x-height The height of the lower-case letters measured from the baseline, excluding the ascenders and descenders.

Index

Page Numbers in *Italic* refer to illustrations and captions

Access commercial *153*
advertising 89-90
 growth of 15, 19
 of services 98-9
Agfa Press *38*
Akzidenz Grotesque 20
Albert-Birot, Pierre *111*
Albion Press *14*
album covers 22, 23
animatics 91, 155
 time-based media 152, 160
animation *25*, 154-5
 in desktop presentation
 graphics systems 49
animation cameras 154
architectonic principles 17
art director
 agency vs. editorial work 118-19
 editorial 128-31
 role of 118-19
 working for an agency 120-7
Art Nouveau 15-16
art schools, illustration in graphics
 courses 136-7
artwork *53*
 in children's books *144*, *145*,
 146, 146
 commissioning of *103*
 components of *58-9*, 58
 final (case studies) *141*, *142*, *143*
 paper choice for 73
ASCII (American Standard Code
 for Information Interchange)
 code 34, 35, 36
audiovisual media 156-7, *157*
automatic tracing software
 (autotrace) 37, 40
automation 15

Beall, Lester *21*, 21
Beardsley, Aubrey *16*
Beck, Henry 20, *21*
Behrens, Peter *16*, 16
Bézier curves 40, 41
Bill, Max, Swiss style 20
binary code 34
binding
 library, USA 147
 short-run and long-run 75
bitmap programs *see* draw
 programs
bitmaps 35
Blake, Peter 22
Bodoni, Giovanni Battista *108*
Bodoni typeface *108*, 111, 114
book design, children's books
 144-5
book jackets, paper for 72
brief, time-based media 158
British Association of Picture
 Libraries (BAPLA) 120
British Rail InterCity, new
 corporate identity *183*, 183-4,
 184-5
Brody, Neville 23, *24*, 111, 139
Brookes, Peter 136, 139
Brownfield, Nick 136
businesses, small, corporate
 identities 181-2

calligraphy 22
cameras
 electronic (RGB) 48
 photo-mechanical transfer
 (PMT) 28, *31*, 31, 47, 60, 64
 process 64, 66
 rostrum *36*, 154, 155, 156, 160
carbon tissue 78
Carousel projectors *156*, 156
case (edition) binding 75
case studies
 advertisement *142*, 142
 book cover *140-1*, 140
 children's book *148-9*, 148
 container design *176-7*, 176
 ITV network cohesive image
 162-3, 162

newspaper design *114-15*, 114
 pack design *174-5*, 174
 poster *132-3*, 132
 set of prints *143*, 143
 title sequence *161*, 161
casing-in 75
Caslon type 111
casting off and typesetting 56
catalogues, and graphic design 90
cel animation *154*, 154-5, *155*
Century type 114
Channel 4 ident *25*
charge-coupled devices (CCDs)
 65, 68
charges, scale of 101
children's book design 144-7
 production skills 146-7
client base, protection of 102
client brief 101
client relationships 100-1
clients, responsibility to 94
close-up *128*
CLUTS 49, 68, 69
CMYK colours 46, 47
coated paper 72, 73
code of practice 94-5
cold calling 97
colour, specification of 74
colour bars, standard *70*
colour coding *21*, 21
colour correction 67, 68, 69
colour mixing, additive and
 subtractive *66*
colour photography 66
colour Postscript printers *46*, 46
colour proofing, electrostatic 71
colour proofs, correction of *71*
colour reprographics 66-7
 direct and indirect methods 67
colour scanners 37
colour separation, trichromatic
 theory 66
colour separations
 by electronic scanning 68-9
 photographic 66, 67
colour swatches 74
colour-matching systems 74
communication in print 19
computer animation *25*, 154, 155
computer graphics *33*
computer typesetting 14
computer-aided design 111
computer-graphic solid modelling
 91
computers 34-5, 147
 computer-graphic solid
 modelling 91
 converging disparate media 14,
 38
 digital font design software 56

digitizing pad and mouse 34, *35*,
 36, 37
 inputting images 36-7
 inputting text 36
 page-makeup and graphics
 software 36, 38-41, 42, 47
 presentation software 48-9
 use of and art direction 127
 see also desktop publishing
concept, time-based media 158
"Concrete" poetry *22*, 22
Conditions of Engagement 94
confidentiality 94
contact reports 101
contents, and packaging *167*, 170
contingency money 127
continuous tone (contone)
 reprographics 60, 64
contracts, standard 102
control systems 103
copyright *100*, 100, 102, 103
 photographic 124, 126, 130-1
corporate branding *91*
corporate identity 88, 179-85
 British Rail InterCity *183*,
 183-4, *184-5*
 ITV *162-3*, 162
 need for 182
corrections 47
costings 101
covers *131*
 children's books 147, *148*
 see also album covers; magazine
 covers; record sleeves
Craig, Helen *144*, *145*
creative control, maintenance of
 103
cropping and retouching 127
Cubists 17
cut and paste 36
Cypher 159

Dada movement *17*, 17, 23
database building 98
De Stijl group *17*, 17, *108*
De Stijl magazine *17*, *108*
design
 and corporate identity 180
 and illustration today 137-8
Design Business Association 94
design guidelines book, InterCity
 184, *185*
design process, time-based media
 158-60
design services, integrated range
 of 90-1

back-up teams 124, 129-30
backing up 45
Bailey, David 22, *128*
Barrett, Angela *145*
basic equipment *28-31*, 28
Bauhaus, The 17-19, *110*, 111
 basic design course 18-19
Bayer, Herbert *19*, 21, 111, 139
BBC 9 O'Clock News titles *158*

design skills, basic 52-5
designers
 decisions on type mark-up 56
 need to understand corporate
 businesses 180
desktop presentation graphics
 systems 48-9
desktop publishing (DTP) 9, 24,
 32, 34-5
 advantages and disadvantages
 47
 convergence with desk top
 video 33
 design process 42-7
desktop repro 47
desktop video systems 33
digital font design software 56
digital video workstations 91
digitizing 35, 36, 64, 155
digitizing pads *35*, 36, 37
digitizing scanners 36-7
disks, hard or floppy 45
display lettering 38, 88-9
 software *40*, 40-1
display type and letterforms 88-9
display typesetting 56
Doesburg, Theodore Van *108*
dot gain 70-1, 74
dot-generation techniques,
 electronic 65
draw programs 36, *37*, 40
drawing boards 32
 parallel action 28, *31*
drawing tools 28
 computer 39, 40
drum scanners *68*, 68
Du Maurier cigarette pack *19*

Eckersley, Tom 138
education 15, 24
El Lissitzky *17*, *107*, *110*, 111
electronic dot generation (EDG) 69
electronic page make-up 14, *41*
electronic page-composition (EPC)
 systems 32, 68
electronic publishing systems 33
electronic (RGB) camera 48
electronic scanning 64
 colour separation by 68-9
Encore 159
end-papers 75
engraving, electromagnetic 79
etching, relief printing 80

Face, The magazine *24*
film, advantages over video 154
film animation techniques 154
finishing processes 74-5
flatbed scanners 65
 CCD 68-9
Fleckhaus, Willi *22*, 23
flexography *81*, 81
font design software *41*, 41
fonts *32*
frames
 animated 49
 preparation of 48
Frazer, Eric *64*
freelancers, ownership of
 copyright 103, 124, 126
full-colour output 47
Futura 20
Futurists 17

Garamond type 111
Gestalt psychology 19
Glaser, Milton 136, 138
global village 13
Granjon italic type *109*
Grant projector 28, *30*
graphic design
 applications of 88-91
 convergence in 8-9
 'export system' 9
 software 38-9, 42
 in the USA 21
graphic design process 52-3
graphic designers
 and auto media 157
 changing role of 24-5
 essential attributes of 8
 information available 25
 role in broadcast television 153
 skills and knowledge required 11
 and video 153
graphic technology, future 25
graphics
 greater use of 14
 industrialization of 14-17
 psychedelic *22*
 time-based *91*, 91, 152
graphics interface 14
graphics slides 156
Graphis 20
gravure 78-9
gravure plates 69, *79*, 79
gravure presses 79

grids *54*, 54-5
Gropius, Walter 18, *110*
Gutenberg approach *24*, 25

halftone images 35
halftone principle, gravure 79
halftone screens 64-5, *65*, 69
halftones 44, *45*, 47
 conversion of Contone to 60
 electronic 65
 full-colour, flexography 81
 photographic, production of
 64-5
handlettering 19, *58*, 58
Harry and Henry 159
hatchings *64*
headline setting and modifications
 56, *57*
headline typeface 114
Helvetica 20
Holmes, Nigel 136
holograms 13
Huszar, Vilmos *17*

icons 21, 34
illustration
 and design today 137-8
 and pack design 173
 and typography 138-9
 uses of 139
illustrations 36, 38
 contracts for *103*
 designer's role in
 commissioning of 135
 magazine 136-9
 preparation for printing 60
image assembly systems 69
image input *36*, 36-7
 drawing and painting programs
 36
 scanning images 36-7
images montage 68
image processing, advantages of 47
image resolution, and halftones 35
image scanning 36-7
image-audio track relationship 157
image-makers 106, 111
imagery, and pack design *170*
images 89
 full-colour, processing of 66
 storage of 35

imagesetters 42, 44, *45*, 56
imposition 61
Impressionists 66
in betweening 154
information graphics 152
information technology equipment
 13
ink types 74
integrated design groups 90-1
interactive video 152
International Typographic Style
 20-3
 American developments 21
 expressive limitations 23
 post-Modernism in the 1980s 23
 sixties diversity 21-3
interviewing, successful 102
isotypes *20*
 for non-verbal communication
 20-1

Japanese influence *15*, 15, *16*

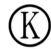

Kauffer, E. McKnight *19*
kerning 41
keyboards *35*, 36
Klimowski, Andre *139*
Kranze, Andrzej *136*, *139*
Kurlansky, Mervyn 138

Lambie-Nairn, Martin *25*
laser scanning 14
laserprinters 34, *35*, 42, 48, 83
 new 44
lasertypesetters *see* imagesetters
LEDs (light emitting diodes) 44
Letraset 40, 111
letterforms 155
lettering
 animated 152
 pressure-sensitive systems 56
letterpress 80
letterpress plates 69, *80-1*
light box *30*
line art *64*, 64
line-art preparation 47

189

INDEX

linotype composer *14*
Listener, The 139
litho plates 69, *76*
 original copy in line form 77-8
litho presses 76-7
 sheet-feed offset *77*, 77
 web-fed offset *77*, 77
lithography 76-8
location shoot *123*, 123
logo scanner 64
logos *162*, 162, *163*, *177*
 design of 56
 newspaper design *114*, *115*
logotypes *180*, *181*, 181
 animated 152
 and corporate identity 88
London Transport Underground
 map *21*
Long, Richard, *A Moved Line in
 Japan 106*
Lubalin, Herb 22

Mackintosh, Charles Rennie *16*, 16
McLuhan, Marshall 13
magazine covers *17*, *108*, *136*, 136,
 138, 139
 New Scientist 64, 136
magazine design 136-9
magazines 22-3, *41*
 design and art 16
 work of the art director 118
mailings *99*
 targeted 98
marketing, rising level of design
 awareness 90-1
marking up, for printing *60*, 60
masks, photographic 67
material, in packaging *167*, 168-9,
 176
memory 34, 47
memory management 45
menus 34
minimalism 22
model fees *103*
model (object) animation 155
Modernism 16, *19*, 20, *23*
 influence of 17
Moholy-Nagy, L. 21, *110*, 111
moiré patterns 66, *67*
Mondrian 19
monitors *35*
montaging 127
Moser, Koloman *16*
mouse 34, *35*, 37
mouse mats 37
multiplexing 156

Neurath, Otto *20*, 20
New Scientist, covers *64*, 136
New Statesman, The 139
New York Daily Graphic 15
newspapers, new national 90
newsprint 73
nouvelle vague cinema 22

Observer Magazine 137
offset litho 76-7
OHP technology 48
Optical Character Recognition
 (OCR) 36
ownership and limits of use *100*
Ozalid proofs 78

pack design 165
 attitudes to 169-70
 international do's and don'ts 169
 styles in 173
 who uses it 170-1
pack redesign *168*, 168, *169*, 169,
 170, 171
pack shape *166*, 167
packaging *91*
 and the consumer market *171*,
 171
 international considerations
 167-9
 marketing and design 166-73
 novelty *166*
 plastic *167*
 recruitment to 172-3
packaging company, work of 167
page description language (PDL)
 34
page printers 42
 high-resolution 44
page-makeup programs 36, *38*, 38,
 39, 39, 42, 47
Pagemaker program (Aldus) 34, *39*
paint images, drawbacks 40
Paintbox *33*, 127, 159
paintbox programs 36, *37*, *39*,
 39-40, *40*, 47, 91, 152-3, 155,
 156
paintbox systems, video 33
Pantone 54, 74

paper 72-3
 categories of 73
 choice of 72-3
paper manufacture, mechanized *14*
paper specifications 72
paste-ups, not including full-colour
 illustrations 60
perfect binding 75
perfector press 77
personal computers *see* computers
perspective distortion 40-1
Peters, Michael *172*, *173*
photo-conductive plates 83
photo-mechanical transfer (PMT)
 cameras 28, *31*, 47, 60, 64
photo-polymer plates 81
photocopiers *30*
photographers
 choice of 121-3
 commissioning of 118, 129-30
 freelance, copyright and other
 rights 124, 127
 packaging 124
 self-promotion *121*, 121
photographic transfer proofs 70-1
photographs 36
 commissioned 120, 128
 halftone, in newspapers *15*
 stock 120, 128
photography *88*, 119
 and food *173*
 location or studio 123
 vs. illustration 119
photojournalists 129
phototypesetting 14, 56
pictograms 88, 89
pictorial and graphical
 communication 20-1, *21*
picture agencies, international,
 directories of 128
Picture Agency Council of America
 120
picture books, for children 144-5,
 147
picture editing 128
picture libraries 118, *120*, 128
pictures, sources of 128-9
pitching 95, 96
plagiarism *95*, 96
platemaking, litho plates 78
platemaking process 69
Pointillism 16, 66
Polaroids, as test shots 127
Pop Art 21-2, 22
popular music, influence of 21-2
portfolio work, time-based media
 160
portfolios
 organization of 96-7
 photographers' *121*, 121, *122*,
 122

portraits *128*, *131*
Post-Modernism 23
posters 15, *16*, *18*, *19*, *21*, 22, 24,
 136, *138*
 paper for 72
Postscript 34
 fonts 41, 46
pre-press proofs *70*, 70
pre-programmed colour look-up
 tables *see* CLUTS
presentation dummies *54*
presentation graphics 48-9
 design and production for 49
presentation material *96*
presentation visuals 42, *55*, 55
presentations *48-9*
 computer-generated 96
press, the, and advertising 98
press-releases 97
prime prospects, criteria for 98-9
printed page, as an interface 14
printers
 colour Postscript *46*, 46
 inkjet 46, 48
 laserprinters 34, 35, 42, 44, 48,
 83
 thermal-wax 46, 48
printing
 new technologies 19
 preparation for 60-1
printing inks 74-5
printing presses, increase in 15
process cameras 64, 66
process colour 66
production, children's books 144-5
production skills 146-7
productivity, improved by DTP 42
professional practice, meaning of
 93
progressives *69*
proof correction *53*
proofing 70-1
 full-colour 47
 on laserprinters 42
proofs
 colour, correction of *71*
 photographic transfer 70-1
 pre-press *70*, 70
 progressive *69*
psychedelic graphics *22*
public relations, role of 97
punk collage *24*
punk fashion *23*
punk graphics 23

Quark XPress *39*

reading matter, continuous 89
record sleeves *21, 23, 24, 24*
　　see also album covers
recruitment 102
reference works
　　type faces for 89
　　use of non-print media 89
Reid, Jamie *23, 23*
relief plates *80*
reply cards *98*
reprographics (repro) 58, 64-5
　　desktop repro 47
　　full-colour 66-7
response rate, improvement of 99
retouching 131
Rogers, Bruce *110*
Roman typefaces 89
rostrum camera *36*, 154, 155, 156,
　　160
rotary presses *78*
roughs 53-4, *140, 143*
　　presentation *55*
　　see also thumbnails; working
　　　　roughs
Royal Mail Special Stamps (1988)
　　112
royalties 131
rules, borders and boxes 58, *59*

Sanderson, Bill *64, 136*, 136, 139
sanserif type 20
Saville, Peter 23, *24*
scamps see roughs
scanners *35, 36*, 49
　　colour 37
　　digitizing 36-7
　　drum *68*, 68
　　flatbed CCD 68-9
　　OCR 36
scanning
　　electronic 64, 68-9
　　laser 14
　　text into computer 36
schedules 101
schematic mapping *21*
Schwitters, Karl *17*
science and technology, influence
　　on art and design 16-17
Scott, Adam *124-5*
screen angles *65, 66*, 66-7
screen printing *82*, 82-3
screens
　　contact (vignette) *65*, 65

glass 64-5
　　halftone *65*, 69
script analysis 49
self-service, influence on package
　　design 171
serif typefaces 89
shoots 123, 127
showcase work *120*
signs and sign systems 88
　　see also pictograms
slide film 48
slide transparencies 48
slides
　　colour 156
　　in desktop presentation graphics
　　　　systems 48
　　graphics 156
　　in portfolios 96
specialization 15
spot colour 74
station ident 152
Steiberg, Saul 22
stencils, for screen printing 82-3
stills compilation and animatics 155
storyboards 156
　　time-based media 158, 160, 161
studio management 102-3
studio shoot *123*, 123
stylus see digitizing pads
Sunday Times Magazine 136
Surrealists 19
Swiss style, typeface 20
syndication 128-9

tablets see digitizing pads 37
team briefing 102
technical documentation, paper
　　for 72
technologies and techniques, non-
　　print 91
technology
　　and artwork 147
　　modern, development in 32-3
television
　　broadcast 152, 153
　　influencing graphic design 25
television graphic designers 153
terms of agreement *101*
terms of business 100-1
text, setting of 56
text input 36
texture mapping 41
thermography 75
thumbnails 42, 49, *52*, 53-4, 158
Till, Peter 136
time-based media 151

Times type 114
timesheets 102-3
tinting *127*
Toulouse-Lautrec 16
Tournes, Jean de *109*
Town 136
trademarks 88
training 47
transport and communications *113*
TV graphics 32
　　technologies for 32-3
Twen magazine *22*, 23
type
　　and image *89*, 89-90
　　as text 89
type mark-ups 56
typeface 20, 89, 106, *109*, 111,
　　114, 184
　　changes in 88
　　choice of 54
　　contemporary 88
　　diverse 23
　　electronically programmed and
　　　　processed 32
typesetters, plain-paper 42, 44
typesetting *53*, 56
　　digital revolution in 32
typographical special effects 40, 41
typography
　　development of 106, 111
　　function of 106
　　responding to fashion 111
　　role of the professional 111

undercolour removal (UCR) 67
Univers 20
USA
　　early importance of graphic
　　　　design 21
　　library binding 147

V & A picture books *113*
Ver Sacrum (1902) *16*
video animation systems 159
video digitizers *35, 37*, 49
video image, composite 48
video post-production and editing
　　91
video presentations 96
video programmes, non-broadcast
　　152

video rostrum camera *36*, 155
videobeam projection 156
videographics 155
videos *155*
videowall 156
vignette screens *65*, 65
visual communication 16-17
visuals 55

Weingart, Wolfgang 23, 25
WIMP environment/interface
　　34, 35
windows 34
wired titles *154*
woodblock prints, coloured,
　　Japanese 15
word processing programs 36, 47
working roughs 42, 49, *52*, 54, *132*
Wright, Frank Lloyd 16
WYSIWYG *42*, 47

xerography 14, *83*, 83

Yellow Book 1894, The 16

Acknowledgments

Quarto would like to thank the following for providing photographs, and for permission to reproduce copyright material. While every effort has been made to trace and acknowledge all copyright holders, we would like to apologize should any omissions have been made.

Key: a=above; b=below; l=left; r=right; c=centre

Page 2 Designers: Keith Sheridan, Craig Warner; Illustrator: Keith Sheridan; Studio: Keith Sheridan Associates, Inc. NY; Publisher: Random House Inc.; p.14 Mary Evans Picture Library; p.15 al Mary Evans Picture Library c Bridgeman Art Library/British Museum; b Robert Opie; p.16 l Design Council r By Courtesy of the Trustees of the Victoria & Albert Museum b Lord's Gallery; p.17 l Lord's Gallery r David King Collection; p.18 David King Collection; p.19 al Bauhaus Archive ar Lord's Gallery br Robert Opie; p.20 *The Crowded Scene* Vol. 111, Ed. Marjorie Bruce Milne, Collins 1946; p.21 l London Transport Museum; p.23 l Jamie Reid; p.24 a Peter Saville Associates l Judge Dredd b The Face; p.25 a i-D Magazine b Martin Lambie-Nairn/Channel 4; p.33 l one point five limited r Quantel Ltd.; p.38 Agfa Gevaert; p.40 br Letraset; p.41 a Octavo; p.45 Agfa Gevaert; p.46 a Océ Graphics UK Ltd.; p.48-49 TBS Colour Slides; p.50 Letraset; p.54 r Michael Peters Brand Development Division; p.55 Bridgewater Design/Pembury Ltd.; p.56-57 Alphabet Typesetters Ltd.; p.58-59 a Dagwood Studio bl Mecanorama r & br Letraset; p.64 bl Bill Sanderson/ *New Scientist* br Mrs Irene Fraser/ BBC Radio Times; p.66 br Mike Tibbs/McBean Orchids p.68 l Itek Colour Graphics r Dainippon Screen UK; p.69 Barbara Nessim, Brian Grimwood; p.70 Agfa Gevaert Ltd.; p.71 Barbara Nessim, Brian Grimwood; p.78 Syndication International Ltd.; p.81 Elopak; p.82 l Lewis Moberly Design Consultants; p.86 Hibbert Ralph Animation Limited/ Director: Jerry Hibbert; Designer: Pat Gavin; Animation: Jerry Hibbert, Pat Gavin, Kim Burdon; Film Editor: Paul Coppock; Rostrum Camera: Peter Jones Rostrums; p.88-89 b Studio Bauman/M Magazine ar Reprinted with permission of Abbeville Press Inc., publishers of *The Bakelite Jewelry Book*, by Corinne Davidov and Ginny Redington Dawes, © 1988 Cross River Press, Ltd. Jacket design by Renée Khatami, Jacket photography by Steven Mark Needham; p.90 Hibbert Ralph Animation Limited/Director: Jerry Hibbert; Producer: Carl Grinter; Animation: Jerry Hibbert, Gethyn Davies; Stop frame animation: Klaybow Films; Rostrum camera: Peter Jones Rostrums; Film editor: Paul Coppock; Video post-production: The Framestore; p.91 l Taylor & Browning Design/ Art Director: Paul Browning; Designer: John Pylypczak; Photographer: Robert Watson; Illustrator: Gordon Sauvé; Design Studio: Taylor & Browning Design Associates r Duffy Design; p.92 – p.103 Fine White Line (p.94 ar The Tindale Collection); p.104 Carroll Dempsey & Thirkell; p.106 © Richard Long; p.107 *El Lissitzky*, Sophie Lissitzky-Küppers, Thames & Hudson 1968; p.108 a & b Private Collection; p.109 By courtesy of the Trustees of the Victoria & Albert Museum; p.110 a Bauhaus Archive; p.111 *The Liberated Page* Ed. Herbert Spencer, Lund Humphries, 1987; p.112 Carroll, Dempsey & Thirkell/ Royal Mail Stamps; p.113 a Carroll, Dempsey & Thirkell Royal Mail Stamps b Carroll, Dempsey & Thirkell/ By Courtesy of the Trustees of the Victoria & Albert Museum /Webb & Bower; p.114 a Carroll, Dempsey & Thirkell b Bill Sanderson/Carroll, Dempsey & Thirkell; p.115, a Carroll, Dempsey & Thirkell bl Michael McGuinness br 'The Independent' Newspaper; p.116 Reproduced by courtesy of GQ © The Condé Nast Publications Ltd.; p.118-119 Mobil Oil/photos Phil Starling; p.120 a Art Directors Photo Library b Elfande Art Publishing; p.121 Bagby Design; p.122 photo Martin Norris; p.123 bl photo David Burch br © Anthony Blake; p.124-125 'The Independent' Newspaper/photos Adam Scott; p.127 Art-Work Stuttgart, B & M Unterweger; p.128 Reproduced courtesy of GQ © The Condé Nast Publications Ltd.; p.129 Pentagram USA;. p.130 al Heller Breene ar © Phil Starling/'Observer Section 5' cl & bl Heller Breene cr 'Observer Section 5'; p.131 al 'Observer Section 5' ar © Phil Starling br Reproduced courtesy of © The Condé Nast Publications Ltd.; p.132 Leo Burnett/Perrier (UK) Ltd.; p.133 © Martin Thompson/Perrier (UK) Ltd.; p.134 Benoit Jacques; p.136 a Andrzej Kranze b © Bill Sanderson/*The Listener*; p.137 l Philip Burke r Sara Schwartz; p.138 l Gary Baseman r Paul Cox; p.139 l Andre Klimowski b Andrzej Kranze; p.140 Jeff Fisher; p.141 Jeff Fisher/Bloomsbury Publishing; p.142-143 Dolores Fairman; p.144-145 Walker Books Ltd.; p.146-147 Walker Books Ltd.; p.148-149 Walker Books Ltd.; p.150 Designed by IQ Videographics; p.152-153 English Markell Pockett; p.154 Snapper Films; p.155 Molotov Brothers/Courtesy of China Records Ltd., London; p.156 Kodak; p.157 TBS Colour Slides; p.158-159 l Robinson Lambie-Nairn:- Creative Director: Martin Lambie-Nairn; Designer/Directors:- Logo: Martin Lambie-Nairn; Title sequence: Daniel Barber (Asst. Rob Harvey); In-programme graphics: Martin Lambie-Nairn & Alison Bryan (BBC News Graphics Dept.); Design & Production: Robinson Lambie-Nairn Ltd (Producers: Sarah Davies & Debbie Darby); Animation: Animation City (Derek Hayes); Paintbox, Harry and Encore work: CAL Video Graphics (Rob Harvey); 3D Animation: CAL Video Graphics (Paul Nightingale); Music: George Fenton; p.159 br Designed by IQ Videographics; p.160 CAL Limited; p.161 Baxter Hobbins Sides; p.162-163 English Markell Pockett; p.164 Packaging designed by Siebert/Head; 166-167 Robert Opie; p.168 'Schweppes' is a registered trademark of Schweppes International Ltd/Siebert/Head p.169 Farley's Health Products Ltd., an associate company of Crookes Health Care Ltd/Siebert/Head; p.170 a Robert Opie b Michael Peters Brand Development Division; p.171 a Mc Dougalls (RHM Foods)/ Siebert/Head b Robert Opie; p.172 a Next; b Michael Peters Brand Development Division; p.173 Michael Peters Brand Development Division; p.174-175 Richard Nash & Co/ Siebert/Head; p.176-177 Alexander Duckham & Co/ Siebert/Head; p.178 Newell & Sorrell Design Limited; p.180 Newell & Sorrell Design Limited; p.181 a Newell & Sorrell Design Limited b Newell & Sorrell Design Limited/Routledge; p.182 Newell & Sorrell Design Limited/ Bloomsbury; p.183 Newell & Sorrell Design Limited/InterCity (British Rail); p.184-185 Newell & Sorrell Design Limited/InterCity (British Rail).

OF